MANGA

FANTASY & SCI-FI DIGITAL ART
ImagineFX

First published in the United Kingdom in 2011 by
Collins & Brown
10 Southcombe Street
London
W14 0RA

An imprint of Anova Books Company Ltd

Distributed in the United States and Canada by Sterling
Publishing Co, 387 Park Avenue South, New York, NY
10016-8810, USA

ISBN 978-184340-578-8

A CIP catalogue for this book is available from the British Library.

10 9 8 7 6 5 4 3 2 1

Reproduction by Rival Colour Ltd, UK
Printed by 1010 Printing International Ltd, China

This book can be ordered direct from the publisher at
www.anovabooks.com

For more information on *ImagineFX* please visit
www.imaginefx.com

FANTASY & SCI-FI DIGITAL ART
ImagineFX
MANGA
The Ultimate Guide to Mastering Digital Painting Techniques

COLLINS & BROWN

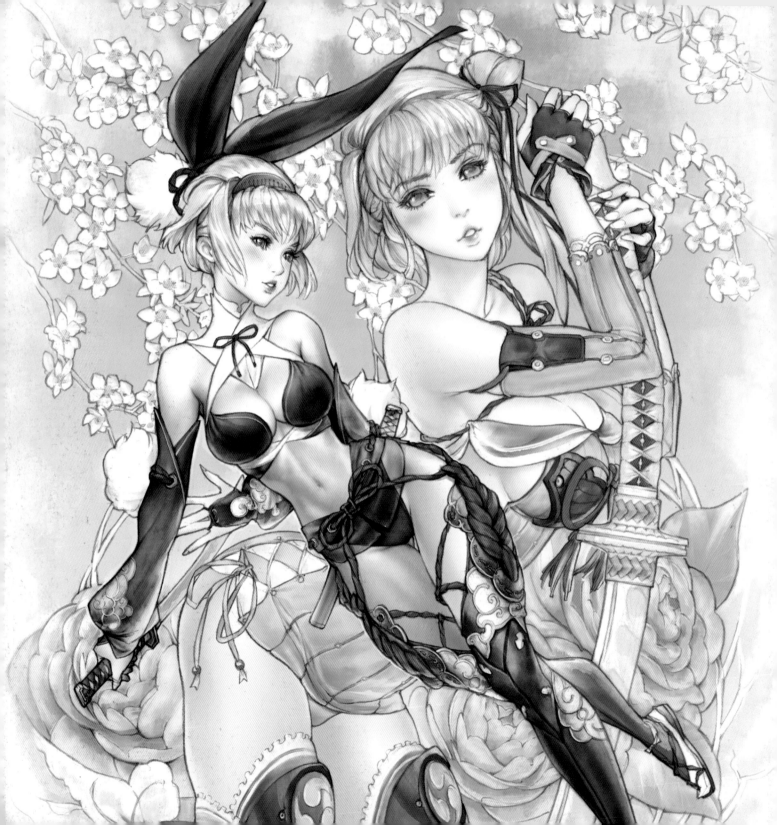

CONTENTS

INTRODUCTION	6
MANGA GALLERY	8
MANGA FOR BEGINNERS	26
CHARACTER CREATION	60
MANGA STYLE	92
FANTASY AND SCI-FI	138
COMIC PANELS	188

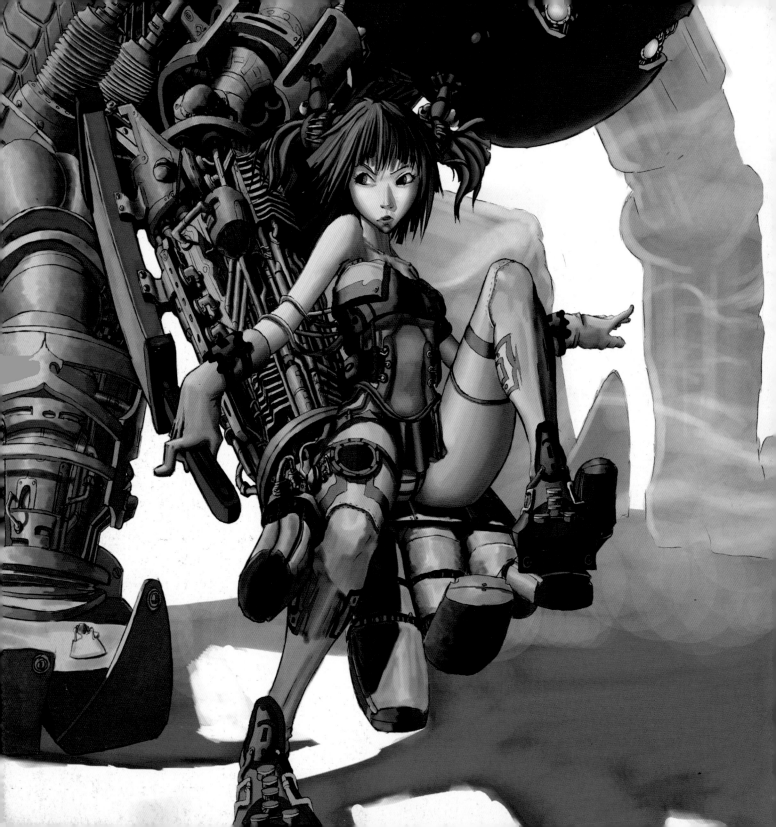

INTRODUCTION

Manga is undoubtedly one of the most popular and mimicked art forms of modern times. It's success lies in its accessible style, which seems to galvanize artists around the world to pick up a pencil and start drawing shapes from simple line drawings through to fully-fledged images.

There are, however, many debates surrounding manga. Some argue that true manga can only be created by Japanese artists in Japan. Others – perhaps ill at ease with its popularity – belittle the artwork as being light on substance. Here, in this book, we proudly celebrate the enduring international appeal of manga and the way in which it encourages new generations of artists to put pen to paper and begin creating their own art.

Whether you're just starting out in manga or need to brush up on your skills, we've brought together some of the world's best commercial manga artists and illustrators to share their secrets and show you how to design characters, paint in a variety of styles and create both stunning illustrations and comic book pages.

To kick things off we'll show you a handpicked gallery of mouth-watering manga art. Here you'll find out more about our delectable cover star Pepper, created by Stanley Lau. What started out as an exercise in character design for him soon became a global phenomenon. Find out more about Stanley on page 19. In our beginner's chapter we'll get you heading on the right path to creating faces and reveal expert advice on starting out in manga creation. If you're looking to discover your own style, from page 92 onwards you'll be inspired by the unique ways you can draw manga. Or, if you're a fan of sequential art, you won't want to miss Jamie McKelvie's masterclass on how to design the perfect comic page in on page 198.

Throughout this book you'll find advice, help and insight from professional artists. If you enjoy this edition, you can also try out the others books available in this series, *Fantasy Workshop* and *Fantasy Creatures*. Happy painting!

Claire Howlett, Editor,
ImagineFX magazine

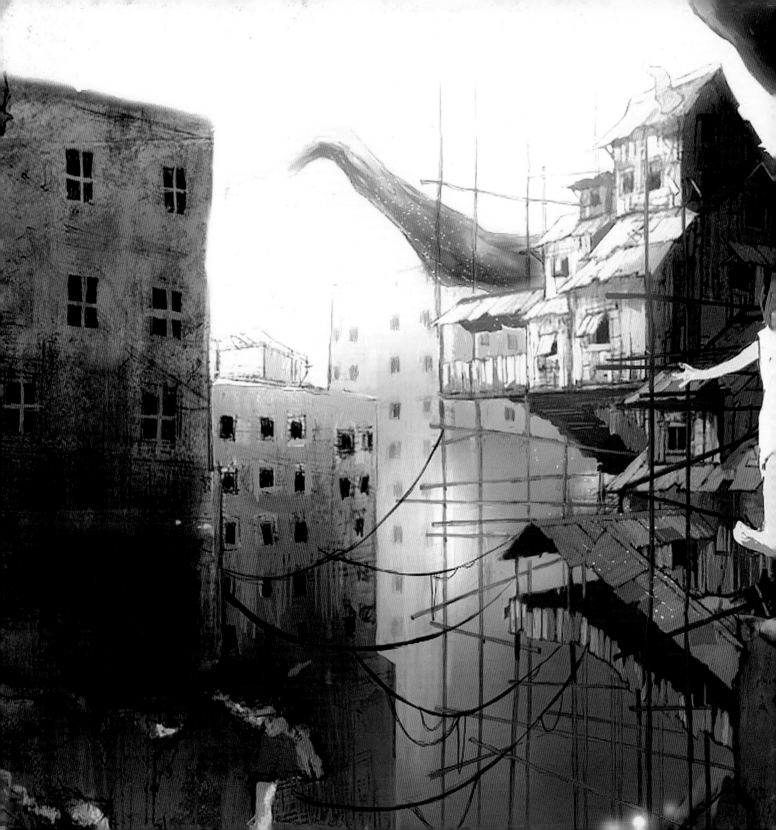

MANGA
GALLERY

GALLERY

CHESTER OCAMPO

LOCATION: Philippines
WEB: www.imaginaryfs.com
EMAIL: chester@imaginaryfs.com
SOFTWARE: Photoshop

Chester says he has been drawing ever since he was a kid, "taking inspiration from comics, cartoons, toys and childhood daydreams". A little later, he got engrossed in videogames but comics remain Chester's first love. Chester says he's proud of the fact that he's self-taught, "although part of me wonders what I could have achieved with formal art training". Several years ago he got acquainted with Photoshop, "but it wasn't until a few years later that I started making artworks straight on to the computer, with a pen tablet".

ARA TWO POINT OH (this page) Originally, this piece was called The Superfluous Anecdotes of a Post-Apocalyptic Third World Teenage Drama Queen – "which pretty much sums up my plans for her in terms of story and setting".

AMBER CRESCENDO (facing page, full bleed) "If war can be likened to a complex dance, then warriors are, in essence, deadly dancers."

OROBOROS (facing page, inset) "Everything evens out eventually," says Chester. This piece is "the result of playing with more binary opposition concepts than I know what to do with".

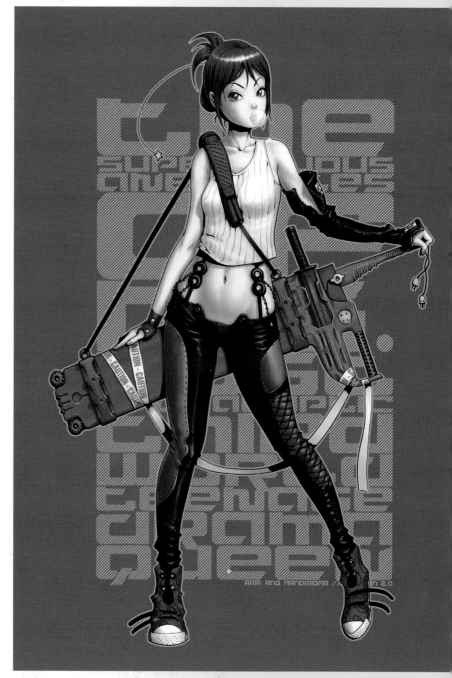

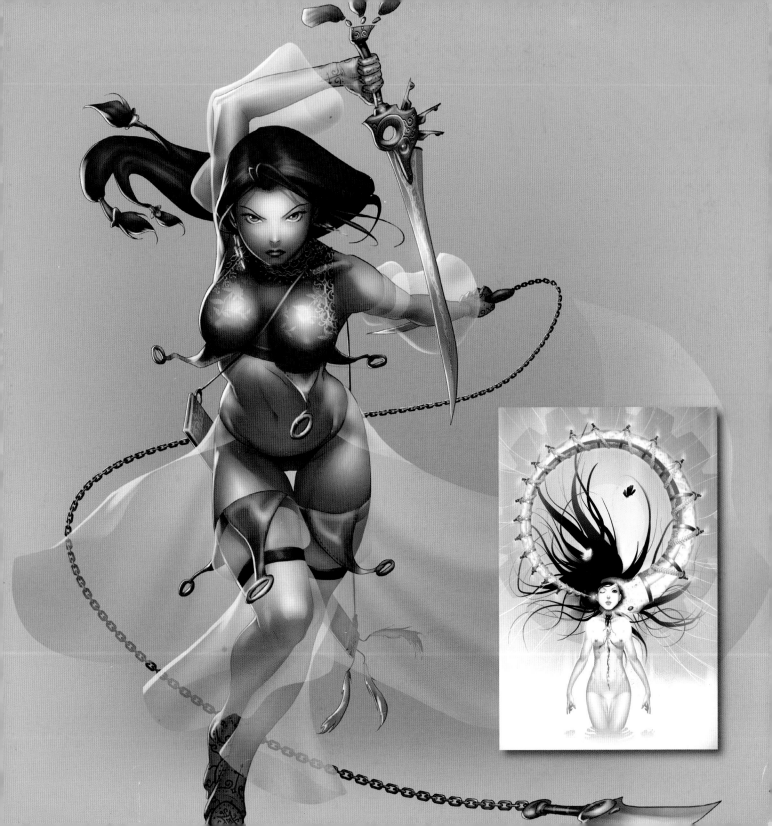

GALLERY

BAGUS HUTOMO

LOCATION: Indonesia
WEB: bagushutomo.blogspot.com
EMAIL: zik_zag04@yahoo.co.uk
SOFTWARE: Photoshop

Bagus has been working as a digital artist for several years. "My first gig was at an animation studio in Jakarta, then I worked as a 2D artist at Infinite Framework, an animation studio in Batam," he says. More recently he painted the artwork for the Radical comic book series *Shrapnel: Aristeia Rising*. Bagus got his first taste of science fiction at college, when he read *Akira* by Katsuhiro Otomo. "I'm actually more into cyberpunk, but you can find several different sorts of concepts and themes in my work," he says. Still trying to explore not only his rendering skills but also concepts in his personal work, Bagus is fascinated by machines, military hardware and complex objects. "They're all things that appear rather frequently in my work."

EINE HOLLE (THE HELL) "My first mecha work, and also my first finished work," says Bagus. "I start by scribbling out a few rough ideas on paper, then edit it in Photoshop. Then as soon as I have the image that I'm looking for, I do a quick colour test to finalise exactly what I want the finished image to look like."

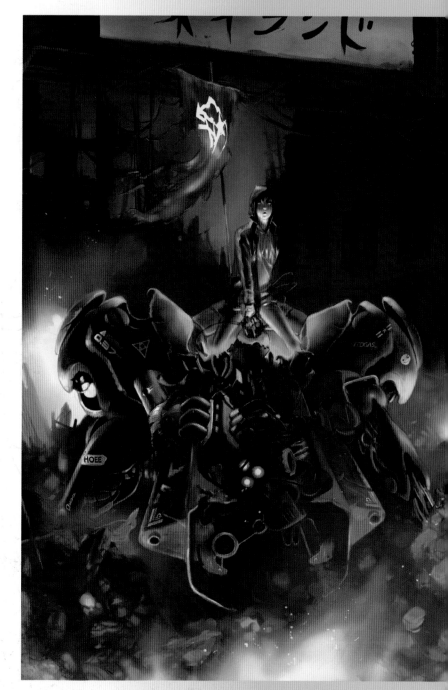

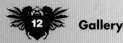

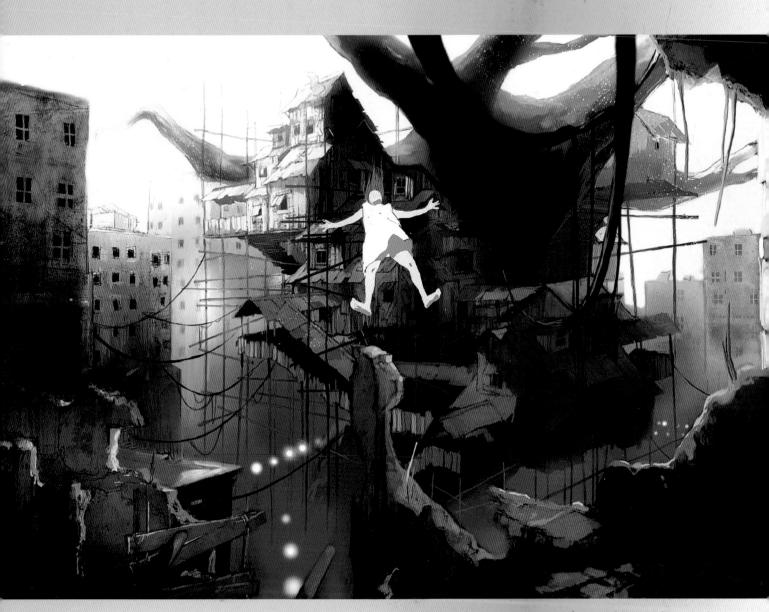

LA-CAIDA Another post-war scene: "A fantasy urban city where people can float."

GALLERY

JOHN STAUB

LOCATION: USA
WEB: dustsplat.deviantart.com
EMAIL: dustsplat@gmail.com
SOFTWARE: Photoshop, Painter

"Ever since I was young, I've always been into things that are very visual," says John. Fantasy art was an important example: "I always saw myself getting drawn to those types of images and found myself inspired by the creativity and look." During high school, John found himself drawing more than ever and, in the process, getting more serious about his art. He draws mostly manga and animé because that's what excites him. "I also enjoy creating worlds that I would personally be drawn to and would rather be in," he explains. Digital art is a relatively new thing to John – "it's easier to apply and express myself, and since the world is now turning digital I find myself getting more and more inspired to do these kinds of images".

COIN DROP "Imagine a hollow mountain made entirely of houses built on top of each other. And within that hollow cavity is a vast city. That's what this image is, in a nutshell."

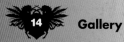

RUSTY GUARD "This image is of a female warrior who has a mechanical guardian who carries her sword for her. She just grabs it from his arm whenever she needs it."

RUNGSAK SONTAYANONT

LOCATION: Thailand
WEB: digitalome.deviantart.com
EMAIL: ome_no@hotmail.com
SOFTWARE: Photoshop

At school, Rungsak liked to follow the works of his favourite artists, both on the web and in magazines. "This inspired me to produce my own digital art," he recalls. And his youthful enthusiasm paid off. He's now working as a character and key lighting designer. "I think my current work is not good enough," Rungsak confides. "It still has to be developed to get a good result in the future."

GOD'S MUSIC FESTIVAL 3 "The musicians are going to travel in the human world and then back to their living place," says Rungsak.

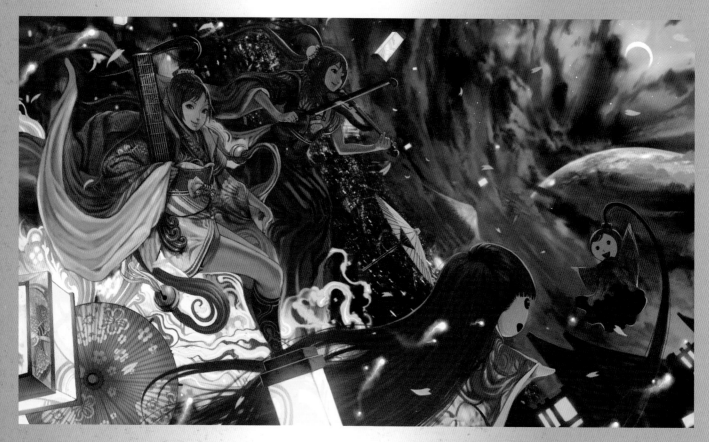

TAOTIE A demon dragon is disguised as a human to devour unlucky souls. "She has a habit of eating and collecting swords. Her bottle can suck anything in and turn it into liquor."

GALLERY

YAGATAMA

LOCATION: Japan
WEB: yagatama.deviantart.com
EMAIL: yagatama@msn.com
SOFTWARE: Photoshop

NO FINAL FOR FANTASY Having watched speedpainting on YouTube, Yagatama tried to do the same on this pic – "but it took me nearly two hours just for the background!"

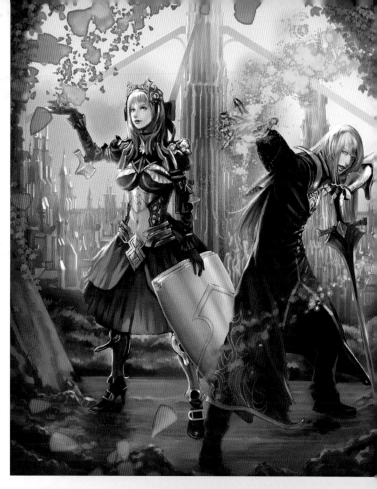

PSYCHIC FORCE "I intended to draw a piece of fan art for Biomega, the Tsutomu Nihei comic," says Yagatama, "but I changed it into my own world."

"Unlike some famous artists around the globe," says the artist known as Yagatama, "I only started painting when I was about 20 years old. So I don't have that much experience yet." Yagatama was put on to digital art by his teacher, who suggested digital colour as a better route for the young artist than acrylics. "I was living in New Zealand then." Yagatama chose an art school called Amusement Media Academy because it was the closest one to where he lives. "I loved watching movies like *Aliens* and *Ghost in the Shell* when I was little. As for fantasy, I found *The Never Ending Story* to be very inspiring."

STANLEY LAU

LOCATION: Singapore
WEB: artgerm.deviantart.com
EMAIL: info@imaginaryfs.com
SOFTWARE: Photoshop

Stanley's original concept was an exercise in character design – a character whose features never stayed the same but whose fixed personality should shine through any change of appearance. Soon, Pepper became a phenomenon, people started to produce their own version and some even began cosplaying as the character. Many thousand images of Pepper appeared on the net and the best efforts were put into a book *The Pepper Project*.

PEPPER The cult success of Pepper soon made it clear that she was no longer Stanley's exclusivity, but had a life of her own.

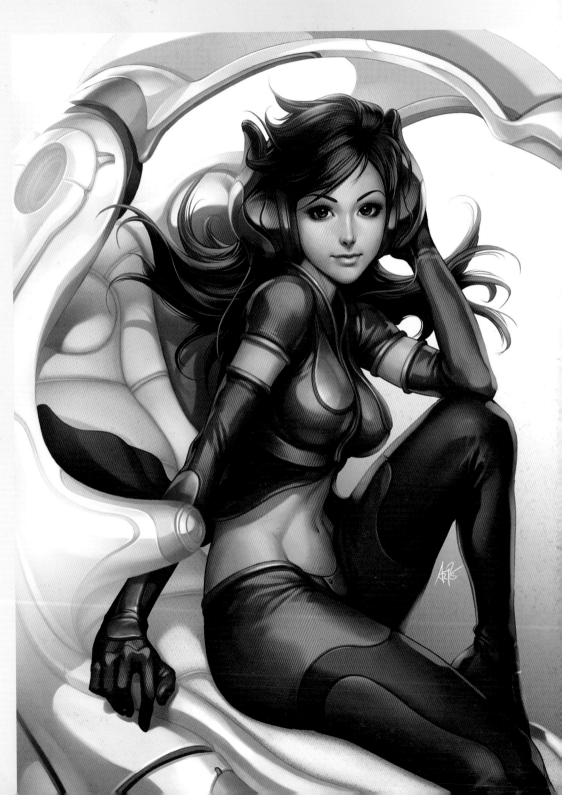

GALLERY

ASHLEIGH HETRICK

LOCATION: USA
WEB: www.saiseki.org
EMAIL: ashleighfirth@gmail.com
SOFTWARE: Photoshop

"I got into using Photoshop because I really wanted to get an animated, cel-shaded look to my art," says Ashleigh. "I like my work to be vibrant and light, and for my characters to have lots of personality. I try to make the most creative colour choices possible. I really hope to use my art to tell great stories."

SUSHI (this page) "This picture features Aarow, a character from a comic that I have in the works," says Ashleigh. "Initially, I used more muted colours for her but, after a few experiments, I came up with this palette because it suited her character better."

DOWNRIGHT FIERCE (facing page) Udon invited Ashleigh to enter an image for its Street Fighter Anniversary tribute book, which pleased her plenty. "I've always been a huge Capcom fan, so being able to draw some of my favourite characters was an immense honour."

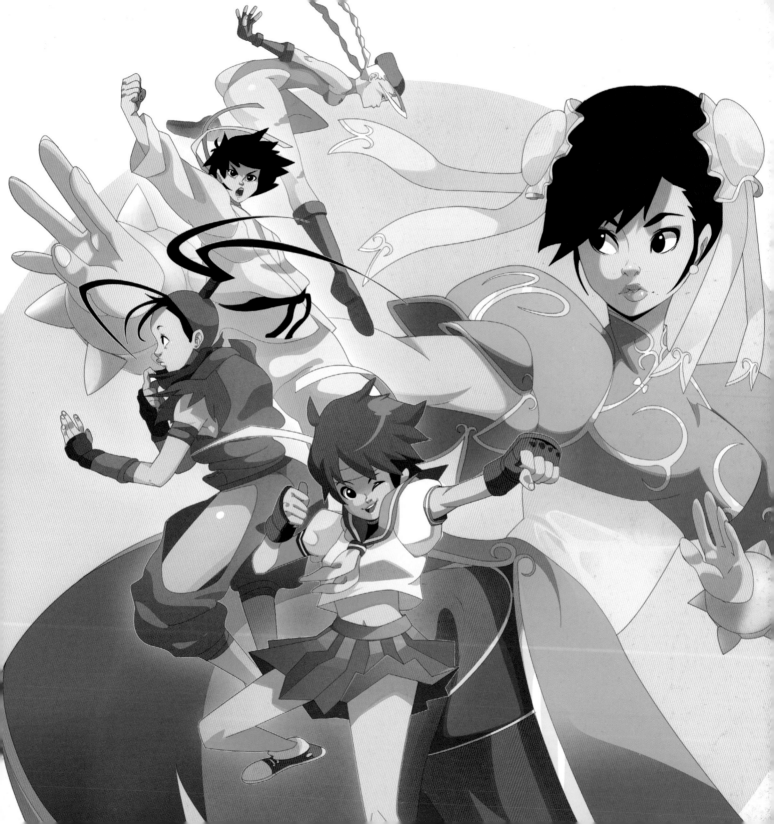

GALLERY

PATIPAT ASAVASENA

LOCATION: Thailand
WEB: asuka111.deviantart.com
EMAIL: digiemo@gmail.com
SOFTWARE: Photoshop CS3, Painter X

"I'm a fan of the famous animation *Evangelion*," says Patipat. "The first time I watched it, I was stunned!" And when the shock wore off, he started drawing. Participating in online communities, Patipat quickly made friends, exchanging critiques and pursuing collaborative projects. Eventually, through practice, a new, more realistic style began to emerge. "And through self-study in art, I still keep learning new things every day I can," he says. After a year working as an art director for a local games studio in his native Thailand, Patipat opted to work as a freelancer for a while, and is better known as Asuka111.

PERFUME HARVESTER Patipat was involved with a group of Thai artists on a calendar project. "My theme was Perfume City," he explains. "Personally, I love the colour of this piece."

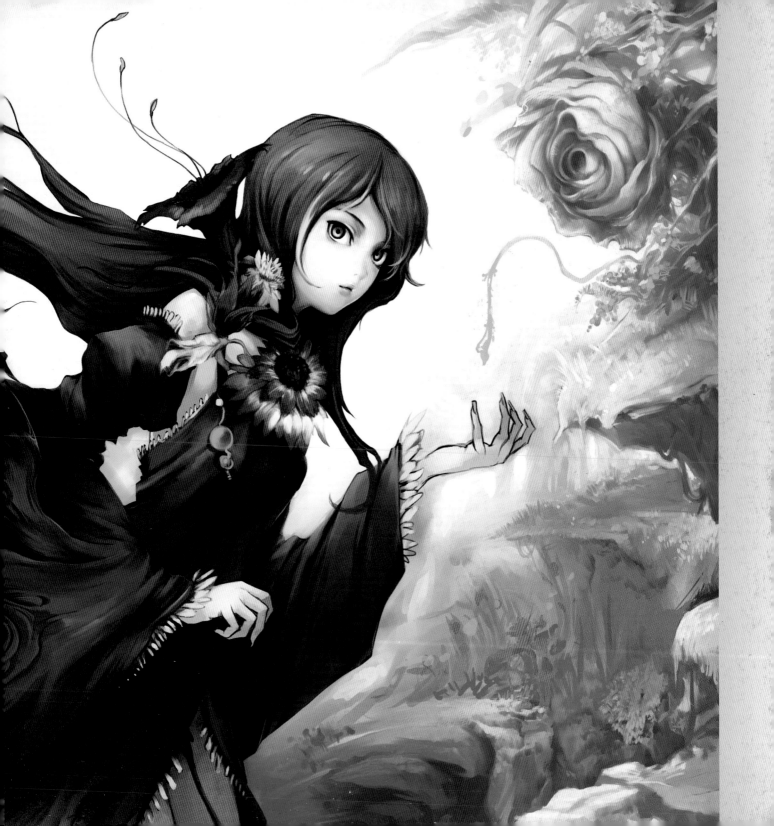

GALLERY

GREED The theme here is 'the couple'. Patipat explored this with the pairing of 'human' and 'greed'. The mechanical butterfly wings attached to her back represent the desire of humanity to conquer the laws of the nature. "They seek perfection, but don't care about the method," Patipat explains. "So they destroy everything around them, including themselves."

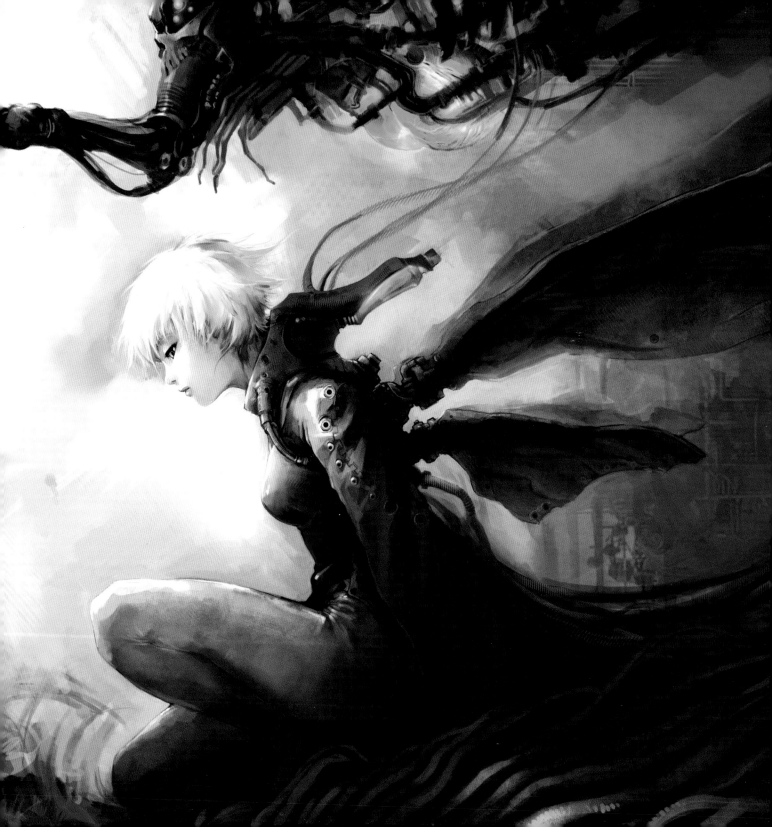

MANGA FOR BEGINNERS

ARTIST **PROFILE**
SAEJIN OH

COUNTRY: Canada
WEB: www.saejinoh.deviantart.com

Saejin is a freelance illustrator who loves creating concept art and character designs.

ARTIST INSIGHT

GET UNDER THE SKIN OF MANGA

Saejin Oh has some invaluable advice that will help you draw and paint better manga

Big eyes, small mouth and fancy hair: this unique style originating from Japan boasts immense popularity with its most loyal fans. People love manga for its fantastic imagination, lovable characters and the inspirational quality that can only be defined by the Japanese word 'moe'. Manga has captivated audiences around the world.

There's just something about manga. It could be the big puppy-dog eyes or the puffy red cheeks, but it's a visual style that makes an instant connection with its viewers. You don't need to know who the character is or where they're from to know you like them. Such emotional connection is difficult to achieve with other styles.

The effect that manga has on people is easy to experience. It's almost impossible to go to a convention without seeing someone cosplaying as Yoko or Cloud, while the artists at their tables hand out posters of their own big-eyed characters. The style is undeniably extremely popular, but how can you draw it effectively?

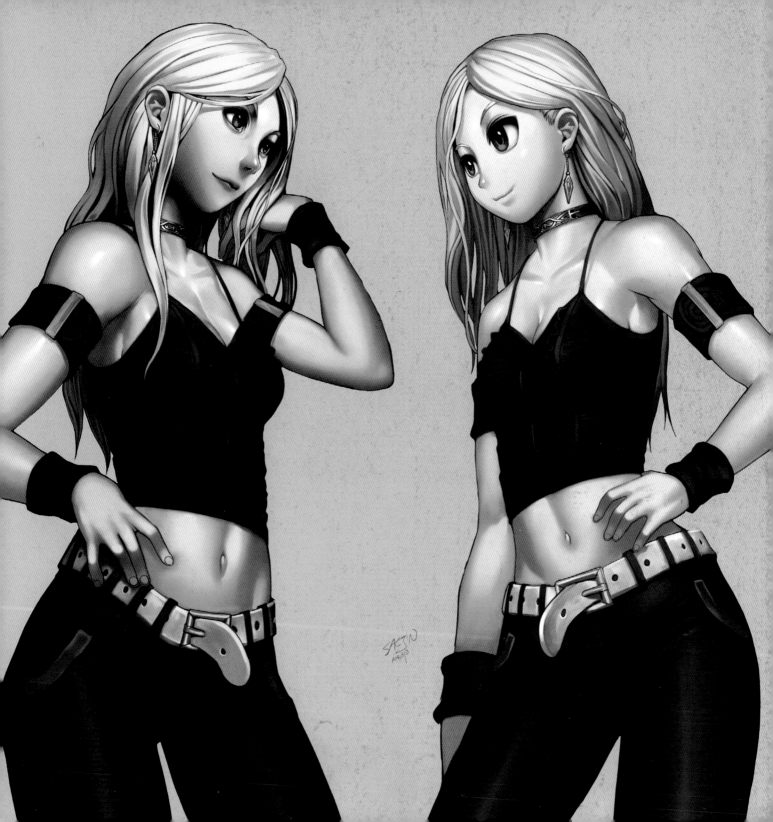

1 THE EYES HAVE IT

Large, shiny eyes are the defining characteristic of a manga character. They go beyond the anatomical capacity of a human skull. A manga eyeball, if it was real, would be non-spherical and would crush the brain. Yet reality has no place in manga. It's an aesthetic style, an exercise in the simplification of the human physique to accentuate what's considered beautiful. Manga characters aren't meant to be real: they're symbols, like an emoticon or smiley. But what does it mean to draw one?

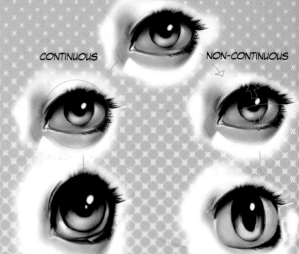

CONTINUOUS NON-CONTINUOUS

2 NOT ALL EYES ARE MADE THE SAME

Few people realise that there are two distinctive styles of manga eye, and the results they achieve are staggeringly different. One is called continuous style, while the other is non-continuous style. Continuous style attempts to exaggerate the eye while obeying the rules of human anatomy; in contrast, non-continuous style completely disregards reality

Non-continuous style eyes are easily recognisable because the character's upper and lower eyelids are detached from one another. The line that runs around the outside of the eye is therefore disconnected. Both styles have advantages and disadvantages, and recognising these will enable you to draw more effective manga-style characters.

3 PROS AND CONS OF THE STYLES

Continuous style looks relatively realistic, but is still aesthetically pleasing. However, you need to know the structure of the eye before you can draw this way. And because you're using relatively realistic proportions, you can't make the eyes too large. Size isn't an issue for non-continuous style because such eyes don't have a fixed dimension. However, non-continuous style is limited to larger eyes and simple facial rendering – it doesn't fare too well with complex painting and shading.

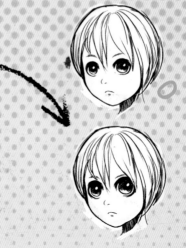

4 FACIAL EXPRESSIONS

Manga characters have simplified facial features, but even subtle changes in eyebrow height, eye size and mouth shape affect the entire mood of the piece.

Manga eyes often don't have much anatomical detail, so artists use shape and size to show expressions. You can only change the shape so much without a muscular structure to support it. These expressions are so widely used, it's hard to define manga without them.

5 ON THE NOSE

Fictional people can't breathe, so what's a nose to a manga character? While reading your favourite manga, you've probably wondered why the nose is so simple. There's no nasal bridge, no nostrils, no bones – just a dot! It sounds strange if you put it like that, but in manga you have to discard unnecessary details for the sake of aesthetics. This is a manga character, not a ZBrush render. When you have so little detail on your character, every position, line and dot is crucial. You can, however, add a realistic nose if you know how to stay within the style.

6 CONTINUOUS VS NON-CONTINUOUS

The battle still rages on here. A dot nose is the prime example of a non-continuous style, in that it has no anatomical connection as we've previously described. The nose is broken off from rest of the facial features and is essentially hovering over the centre of the face, connected only by a colour that resembles flesh. It's a strange way of dealing with reduced details, but it works. If a character looks great with a dot nose, it's difficult to argue with that.

The continuous style, however, adopts the more subtle approach of discarding only the worst-offending details. This style attempts to use nasal bridges and other elements as much as possible, without becoming overly complicated. This style also works brilliantly but, again, it requires a better understanding of anatomy.

It's important to avoid mixing elements, such as continuous style eyes with a non-continuous style nose, and vice versa. You can try it, but you must remind yourself that you're mixing flat 2D style with a full 3D style. It may work in the end, but you might find that you've sacrificed one of the styles without even noticing it.

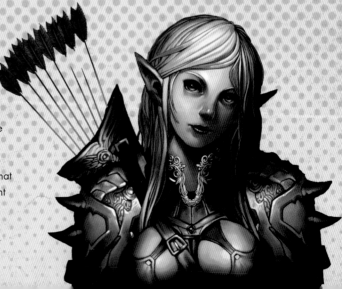

7 MAKING MOUTHS

Manga has little to say about the mouth, although it's one of the core details of a manga style face, along with the eyes and nose. A manga mouth is usually nothing more than a single line without any indication of lips, tongue or teeth. It works brilliantly, of course, thanks to the simplified style that goes along with it.

8 LIP SERVICE

When it comes to lips, all that's required to draw an older character is a single line by the mouth. Depending on how they're drawn, lips can turn an innocent character into a mature onee-san (big sister).

Realistic lips are the bane of manga characters' existence. They're simply not made for each other. Manga deals with the problem by treating the whole mouth area as a flat surface. Interestingly, both continuous and non-continuous styles treat the area in a rather simplistic manner, and even a small detail will stick out like a sore thumb. The lips are usually eliminated to harmonise the facial features but, if the character has more dynamic face contours, then bulging lips won't be a problem.

9 I AM WOMAN

The manga style is used almost exclusively for androgynous male characters, female characters and children. A man drawn in manga style is just a man. There may be a degree of androgyny in the male character, but you wouldn't notice if someone ported Kratos over to Bleach and gave him some celshaded colours. At its heart, manga is an art style for female characters or any character that resembles a female. The males are left with a relatively realistic style that's indistinguishable from reality, apart from cel-shaded colours.

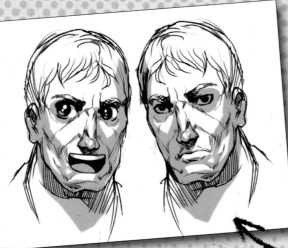

10 MODEL SOLUTION

The manga style is easy to break – you must know precisely where your character's eyes, nose and mouth are. However, maintaining consistency becomes difficult as you progress with your character. No doubt you'll soon need to present a range of emotions as you depict them reacting to a certain situation.

There is a straightforward solution, however. You can have a replacement model – a different version of the same character for expressing extreme facial expressions. This frees you from the responsibilities of keeping your character consistent, and also allows for a greater range and depth of behaviours. There are often different versions of manga characters for certain situations. A serious character, for example, may have a non-continuous style version for comedic scenes. That way, the character can express different emotions while staying within the established style.

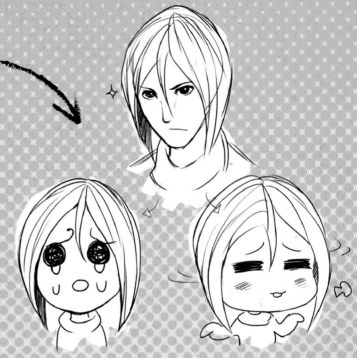

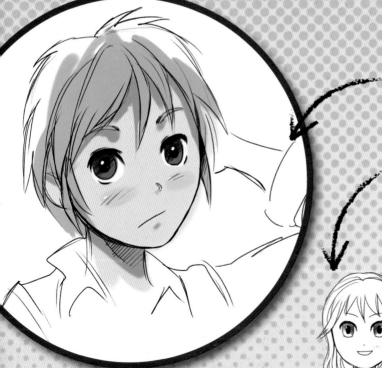

11 LET'S FACE FACTS

Manga characters are fragile and tend to change with the slightest modification. Here, you can see just how drastically a slight change can influence the way a character is perceived.

One of the most important factors determining personality in manga is the relative location of the eyes, nose and mouth on the face. The effect is subtle, but the changes are significant. Unlike western cartoon styles, where characters' features are constantly changed by stretch-and-squash methods, manga has very little tolerance for dynamics. This factor is key in keeping characters consistent.

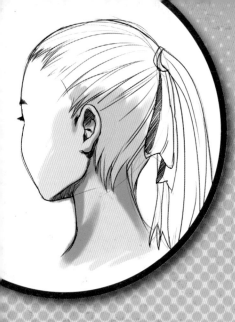

12 LISTEN UP

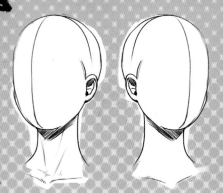

The neck is important because it connects two different worlds: the face, which is in the realm of manga, and the body, which falls into the realm of reality. It's up to the neck to create harmony between two ways of thinking. As such, it must never be too simple or too real, too thick or too thin. It needs to strike a balance.

You have more freedom with the character's ears. These can often be neglected in favour of more important details, but you can also draw them realistically without affecting your manga character in a significant way, provided you paint or shade them in the same way as the rest of the piece.

13 A FATAL FLAW

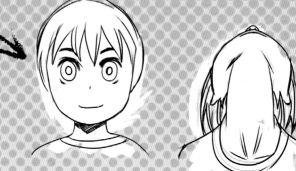

Manga is a style of specific viewpoints. Front, side, three-quarter and the intermediate angles all work, but there are a few perspectives that the style can't handle on its own. The prime example here is the bottom-up view, where the face disappears and the jaw bone determines the facial contours. Manga was never designed with jaw bones or jaw lines in mind and has no answer for this shortcoming, so the artist is forced to bring the character back into the realm of reality. There is, however, a western approach that treats the entire head as a solid shape. This works better for non-continuous style manga.

WORKSHOP BRUSHES

PHOTOSHOP
Custom brush: Penciller Large
This brush mimics the flow of a 4B pencil, so it's perfect for manga line art.

14 THE END RESULT

So our journey into the world of manga has finally come to an end. We've learned so much here – not only how to draw spheres here and there to recreate something that resembles a manga character, but why those manga characters are fundamentally the way they are.

Manga style is very simple to draw. There are thousands of aspiring manga artists who start their drawings with big eyes and a small nose, but as we've learned in this workshop, there's more to it than that. The style is easy to pick up, but hard to master.

You need to be able to draw something in detail before you can condense it. Manga may be tempting as a quick way into the world of art, but you'll still need to understand human anatomy before you can simplify it. How else will you know if you're doing it right?

ARTIST Q&A

Q | How can I make my characters look more manga-like?

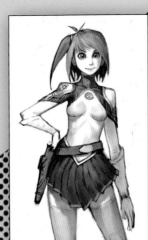

LEFT: Keep the facial features simple and clean to achieve the perfect manga style.

A | SAEJIN OH REPLIES

The way that characters look and feel 'manga' is all in the simplification and exaggeration of their facial features. However, that doesn't mean the style is loose or unstructured: it's actually quite the opposite, and requires you to nail down exact positions for each line you draw. Here are a few pointers.

First, minimise the complicated structures of the nose and lips, and reduce the size of the sidewall of the nose as much as possible. The nasal bridge must be shallow or flat. Remove the upper lip and either simplify or subtly indicate the bottom lip with a simple shadow.

Exaggerate the eyes. They don't have to be large, but you do want to make them aesthetically pleasing. Minimise the white of the eye while exaggerating the pupil.

Finally, make the head a bit larger than a real person's in relation to the character's shoulders. This is especially true for drawing female characters. You should also completely remove subtle features such as facial grooves and wrinkles. Manga is all about replicating youthfulness in the character.

The only thing that really separates manga and more realistic styles is their facial features. Beyond that, manga characters can be quite realistic.

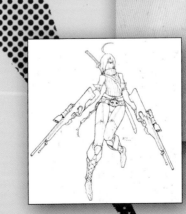

RIGHT: When colouring, try to avoid adding any extra facial features you didn't plan in the first place. Rough skin textures are a big no-no.

ARTIST **PROFILE**
JOANNA ZHOU

COUNTRY: UK
CLIENTS: Animexx eV, Raptor Publishing
WEB: www.chocolatepixels.com

Joanna is a freelance illustrator and graphic designer. She has 10 years' experience drawing manga with professional exposure in the UK, USA, Austria and Germany. She is also a member of the well-known UK manga group Sweatdrop Studios.

ARTIST INSIGHT

ESSENTIAL MANGA TIPS

Joanna Zhou reveals 26 gems of wisdom for creating art that's unmistakably manga

Without a doubt, manga is one of the fastest growing art forms among young people across the globe. Most artists discover this hobby in their teens and face the challenge of self-directed learning alongside school or university.

I've never seen manga as work, but a fun refuge from the actual stresses of daily life. I hope that other aspiring mangakas (manga artists) will see it in the same light, because with this attitude, artistic improvement will become an enjoyable and effortless process. Don't listen to people who say that manga is a useless hobby. Any form of visual creativity is infinitely more productive and satisfying than many other pastimes that spring to mind.

Despite its stylisation, manga techniques incorporate perspective, solid proportion and colour theory, which benefit a huge variety of careers or life situations. Hopefully the tips I'm going to give you over the coming pages will inspire and encourage you to delve deeper into the fascinating world of Japanese comic art.

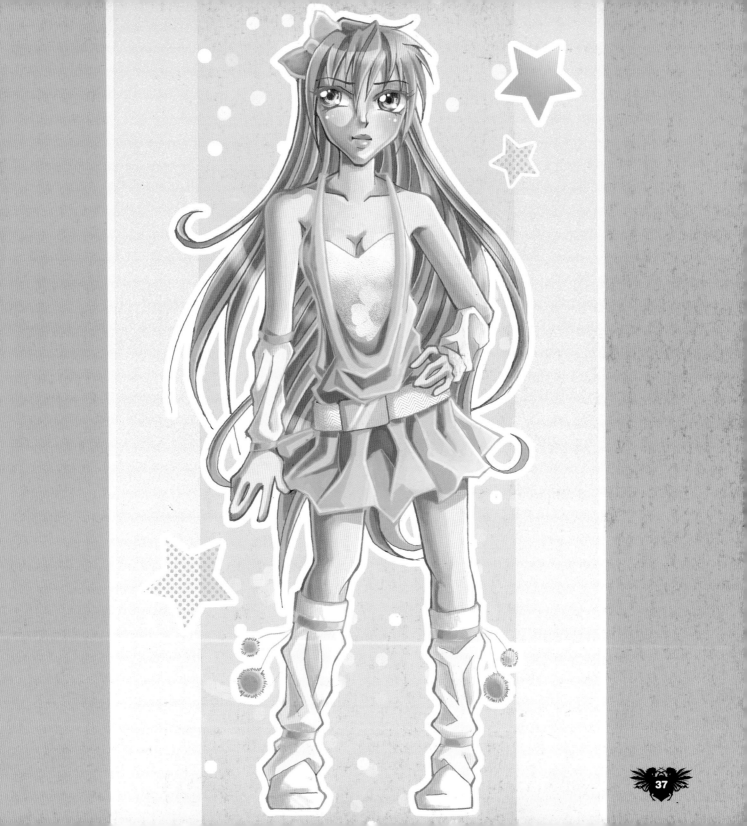

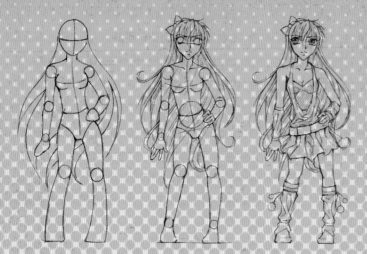

① LEARNING FIGURATIVE PROPORTIONS

In manga style, the human body is often used metaphorically to express dramatic or comedic impact. Take a look at any manga comic and you'll find a figurative fluctuation between body shapes – even of the same character between one image and the next. Mastering each proportion greatly enhances your flexibility as a visual storyteller. You may even end up adopting a certain body type as your signature style.

② SUPER DEFORMED STYLE

When drawing chibis (in manga, a chibi is basically a cute, small, childlike version of an animé or manga character), you should constantly remind yourself to keep the torso, arms and legs as short as possible (erasing any excess if necessary). Because our sense of regular anatomy is so deeply ingrained, it's all too easy to make the limbs longer than they need to be, resulting in a child rather than a chibi! Bright or pastel colours are well suited for chibis because they enhance the dynamism and cuteness of each character.

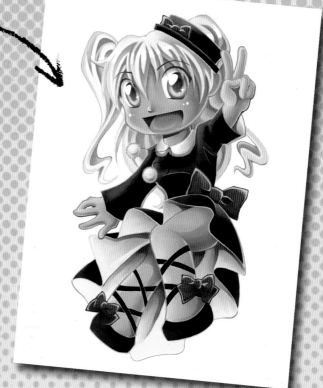

③ GUIDELINES ARE VITAL

Use guidelines wherever possible! They only take a second to draw and can drastically reduce the amount of unnecessary mistakes, such as eyes not being level or hair not following the shape of the head. 'Ball joint' bodies enable you to see at a glance if certain limbs are the same length. Guidelines can also be used to denote the 'twist' of a body posture in a dynamic scene.

④ FROM ROUGH TO DETAIL

Always work roughly to begin with and gradually build up the level of detail in your image (see the three rough sketches at the top of the page). If you start adding intricate sparkles to an eye before even completing the face, you may discover later that the whole eye is in the wrong location and needs to be erased. Never leave a mistake if you've already identified it, even if it entails a lot of redrawing. Guidelines and rough sketches promote maximum efficiency and accuracy when drawing. They also force you to think carefully about the technical composition, which has to be good.

5 DESIGN MEMORABLE CHARACTERS

One of the most unnecessary mistakes in comic drawing is to lose your readers' interest because they can't tell your characters apart. Each character should have significant differences in hair, eyes, height and clothing (unless the storyline dictates otherwise, of course). Consider how colours, hairstyles and accessories can be used appropriately to represent certain personality traits. Also, adding background, props or narrative creates a stronger context for your character.

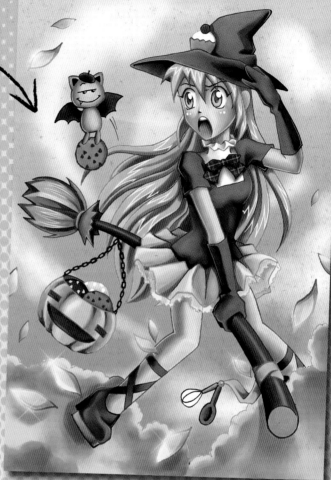

6 DIFFERENTIATION (ISN'T JUST A HORRIBLE THING IN MATHS)

A more advanced technique for varying your characters is to draw different eye shapes and facial outlines for each one. This requires some practice but if done correctly and consistently, it becomes a subtle yet very effective way of differentiating characters.

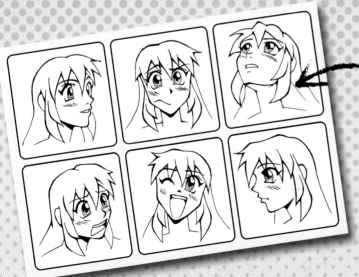

7 360 DEGREES

As you practise, remember to draw the head from different angles. Don't fall into a rut of always drawing the same tilted head facing the same direction. A full-frontal face is actually quite challenging because you have to make sure that both eyes are absolutely identical. If you hope to take your manga drawing further, one of the first things publishers look out for is the ability to draw the same face from many perspectives.

8 CREATE ORDER USING CHAOS

Exciting manga hairstyles have thick and thin strands arranged in a seemingly random manner, yet still form a pleasant shape as a whole. The same principle applies towards clothing folds. Practice drawing 'randomly' but with enough critical judgement so it doesn't become a mess. Hint: curved lines look best when they're drawn in one single sweep. Holding your breath could make your hand momentarily steadier! Try it...

9 BE CONFIDENT WITH YOUR MARK-MAKING

A good piece of advice I've had is to turn my scruffy pencil sketches into a single beautiful line. A single line in the right place can project beauty and power, whereas a mass of scratchy outlines only reflects hesitance. With rare stylistic exceptions, manga drawings should always contain crisp, confident contours.

10 THE SECRET OF ELEGANT LINE ART

Always vary your line width when inking to create an appealing, dynamic image. Use thicker lines to emphasis contours (such as the face shape) and thinner lines to suggest distance (billowing hair strands). Having the same line width everywhere creates a static and slightly sloppy effect. Manga art is traditionally inked using a nib pen (as seen on the image right). Fineliners and digital inking are viable alternatives, as long as you take care to alter the line weight.

11 HOW DO I DRAW HANDS?

As with the human body, you have to be thoroughly familiar with their physical structure before being able to create poses from scratch. Study and draw your own hand to understand digit length, how they bend and which fingers tend to group together in certain positions. Manga hands place emphasis on grace, so detailed nails and wrinkly knuckles are usually blended out.

12 QUALITY OVER CONVENIENCE

Sometimes it's tempting to sit and fidget over an image instead of getting up to look for references. But at the end of the day, you've wasted more time trying to fix it yourself – and chances are it still looks worse. It only takes a second to take a photograph of your own hand or yourself wearing a certain garment with clothing folds. You will learn much more by copying correctly than by free-styling incorrectly.

13 THROUGH THE LOOKING GLASS

Holding your drawing up to a mirror is an effective way of spotting mistakes. The results are often quite sobering – what looked perfect during sketching could have hideously asymmetrical eyes and other anatomical mistakes. Keep correcting the image until you are happy with the reflection.

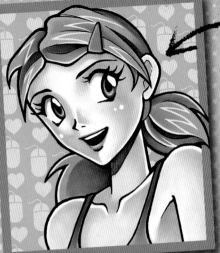

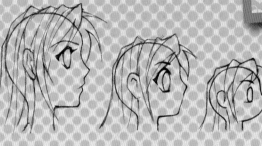

16 FEMALE BODIES

Manga female body proportions are usually very petite, reflecting the beauty ideal of Japanese women. Depicting defined muscles or an Amazonian build is less aesthetic, and definitely less mainstream. It's common, however, to add voluptuous breasts in order to differentiate women from girls.

17 BUFF BISHONEN!

Male bodies fluctuate between heavily muscled forms and an almost androgynous beauty. Ironically, the latter is more popular with female artists. Bishonen (beautiful boy) style simplifies the male body into a slender form, with graceful indications of muscle and a notable lack of nipples or body hair.

14 IN YOUR FACE!

The face is where you can make or break an emotional connection with the viewer. The face is a good place to express style. Maybe you have a certain way of drawing eyes or mouths that will eventually become your trademark. Think about how the mouth, eyes, pupil size and eyebrow position express a certain emotion. If in doubt, look at yourself in the mirror and notice which areas of your face move. Practice making as many expressions as you can – just make sure no one's watching…

15 THE PROFILE

Manga profiles are usually bottom-heavy with the nose and mouth jutting further outwards. Practice drawing an eye from the side and remember to position it in line with the ears and the 'dip' between nose and forehead. Males have a more pronounced and angular jaw line than females. Body proportion will also affect the profile of face, hair and eyes. Drawing the bald head first ensures the correct placement of hair.

18 SPEED UP YOUR PROGRESS

The fastest road to improvement is to know your own strengths and weaknesses, through critical self-analysis and the constructive opinions of others. Create a clear mental plan of areas you need to tackle, as well as areas in which you do well and can develop to your advantage. Doing something simple well is more morale-boosting than always aiming (and failing) at unrealistically difficult tasks. Bright bubbly colours and chibi characters can deftly hide the fact that an image (see the various postcard images above) does not involve advanced knowledge of proportion or perspective.

19 THE JOY AND AGONY OF CLOTHING FOLDS

Copying from fashion magazines is a great way of training your eye to differentiate visually important folds from insignificant crumples. You'll get an inherent understanding of how different garments drape over the body, which is a vital foundation for designing your own clothes using a variety of fabrics and cuts. When in doubt, it's better to have a few simplistic lines indicating folds rather than a jumbled mass of incorrect zig-zags just for the sake of detail.

20 DRAWING OLD PEOPLE

The standard manga face is poorly suited to adding wrinkles. In order to create a realistic older person, you have to alter the entire facial outline to correspond with the sagging and wrinkling that occurs with the ageing process. The eyes become smaller and the distance to the mouth increases.

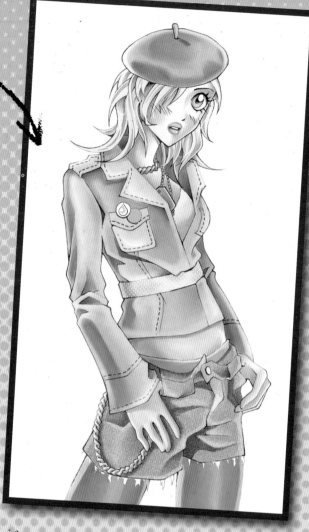

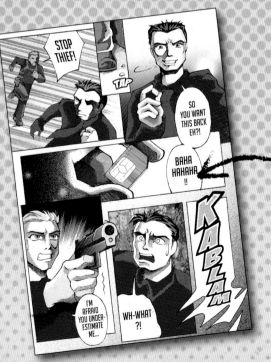

21 COMIC CONVENTIONS (NOT THE SMELLY ONES)

There are many rules and icons specific to manga style when it comes to expressing certain moods or situations. For example, speed lines can be used literally for movement or figuratively for emotional shock. Study various mangas to identify these narrative devices and try to incorporate them into your own work. Manga page layouts are a lot more dynamic than the box panelling of many western comics. However, take care not to let a complicated layout hinder the reading flow.

22 THINK BIG, BUT DRAW SMALL

Thumbnails provide a vital overview of your page and enable fast editing of various elements (panel shape, speech bubbles and so on). Not only is this much more efficient than making large-scale corrections, it also ensures that your final comic sheet is subject to far less erasing and redrawing, which could affect the final image quality. Your thumbnails can be as rough or as detailed as you feel is appropriate. But they must show the panel arrangement, speech bubble location and character shots.

24 WORK IS PLAY

The only way to improve is to practice, and you can only practice a lot if you enjoy it. Drawing is a therapeutic hobby, and you should do whatever makes you feel good. If you only draw to beat others, then you'll end up frustrated if success doesn't come.

23 NARRATE, AMUSE AND ENTERTAIN!

Manga style isn't always about creating a glossy-eyed pin-up. Try using character interaction to create a dynamic snapshot with one or many punch lines. This works well with chibi style but can also be done with regular proportions for a darker narrative. Imagine yourself as a manga journalist, not a fashion photographer. The more detail and narration, the longer someone will want to look at your image… and that can only be a good thing!

25 RULE-BREAKING

There are rules to manga, but you're not obliged to follow them. In manga style, creativity is often forgotten in the drive to draw things realistically or learning to colour like a certain artist.

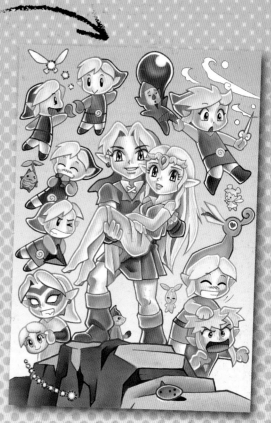

26 DO YOUR OWN THING

Experiment with media and techniques to challenge the stereotype of what people imagine manga can be. This image is a Photoshop collage of a soft pastel background and two manga characters. The effect is entirely unlike the slick CG effect that you might usually associate with manga illustration.

ARTIST Q&A

Q Can I do Photoshop line art with a brush instead of paths?

A ## SAEJIN OH REPLIES

Let's start by doing a rough drawing – you know, the usual. Start with simple structures: head, neck, chest and limbs in rough cylindrical forms. Next, create another layer on top, fill it with white, change the Opacity so that your rough lines faintly show through, then merge the layers. Alternatively, you can use brute force – as I do – by enlarging your brush and lightly painting over your lines with white.

Now you can draw in more detail, such as clothing and hair, repeating the process above to clarify your line art bit by bit.

Once you have a rough drawing that's closest to your final line art, you can fade out your line for the last time.

When you start your final line art, try hard not to break the lines, and keep them continuous. If you draw the line too long, erase the end where it sticks out.

Curvature, too, is something you just have to get right in order for your pictures to look decent, so use the Undo function liberally until you do. Remember, persistence is required for a good result. It will take some effort the first time around but, if you practise, then you'll be able to do a masterpiece in no time!

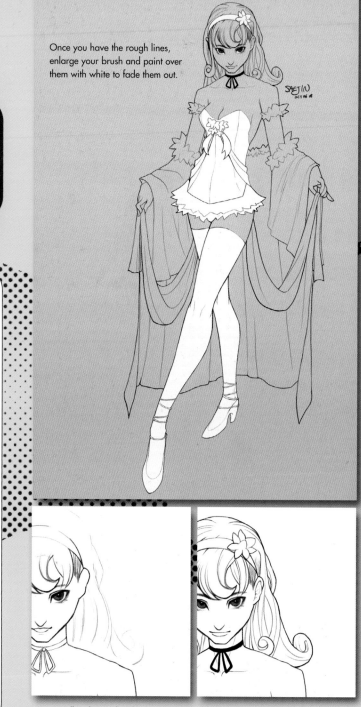

Once you have the rough lines, enlarge your brush and paint over them with white to fade them out.

Use a smaller, thinner brush to paint the lines manually. Try to keep them clean, and use Undo liberally when necessary. Repeat until done.

ARTIST PROFILE
JOANNA ZHOU

COUNTRY: UK
CLIENTS: Animexx eV, Raptor Publishing
WEB: www.chocolatepixels.com

Joanna is a freelance illustrator and graphic designer. She has 10 years' experience drawing manga with professional exposure in the UK, US A, Austria and Germany. She is also a member of the wellknown UK manga group Sweatdrop Studios.

PAINTER & PHOTOSHOP
THE CHERRY BLOSSOM GIRL

Joanna Zhou explains the basics of creating an illustration in a manga style using Photoshop and Painter

Manga artwork often suffers from the unfair stigma of appearing all the same. Although there are general stylistic conventions, as we've seen, every artist interprets these differently, creating a host of distinctive styles. The more you draw, the faster you will discover your own style, both in character design and colouring.

This tutorial guides you through the process of drawing and colouring a manga picture. The colouring technique outlined here was done in Photoshop and Painter. I also used a graphics tablet, which is an invaluable tool for anyone going into digital art. Wacom tablets often come with a free version of Painter Essentials. Although it's not as good as the full version, the effects demonstrated in this tutorial can be recreated (with a bit of practice) in Painter Essentials.

I like to sketch and ink by hand, then scan the outlines and colour them on the computer. Great care should be taken over the sketch because it forms the backbone of your work. Even the best colouring technique won't be able to salvage a poor, out-of-perspective drawing. When sketching, I check for mistakes by holding the drawing up to a mirror. Inking is done in black ink, with a thin fineliner or nib pen.

When working digitally, my files will most likely be in PSD format to support layers. The final image is then flattened and saved as a TIFF or JPEG (at least 300dpi). TIFF is better quality for print, but has bigger file sizes. JPEG has a very small file size, making it suitable for pictures on the web.

① STYLE CONVENTIONS

I begin by sketching out the image using a 2B mechanical pencil. I use a putty rubber because regular erasers can damage the paper surface and leave dust. A good trick for creating an instant, dynamic composition is to use a simple pose but draw it with the paper tilted.

Some manga guidelines to bear in mind are the conventions for mouth, eyes and hair. The mouth is kept very small, like a rosebud, particularly when you're drawing female characters. Eyes are definitely the number one manga trademark. They should be large and expressive, with graceful eyebrows and lashes. I like to draw hair as thick, almost three-dimensional strands: I find it a lot easier to colour in later on if I can see where the separate layers of hair begin and end.

Female manga body proportions are usually petite, with skinny wrists, tiny waists and thin legs; albeit frequently with large breasts!

② SCAN THE IMAGE

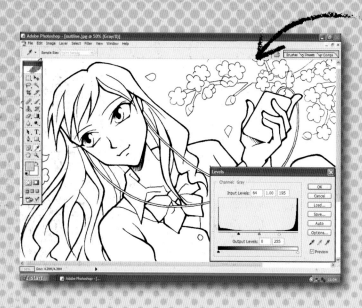

The sketch is inked with a thin nib pen and drawing ink. I often vary the thickness of the lines to create a feeling of depth. For example, the contrast between the girl's thick outline and the thin cherry blossoms immediately indicate foreground and background. After inking, I scan the image at 300dpi and open it in Photoshop to adjust the contrast. Sometimes it's enough to go to Image>Adjustments>Auto Levels.

To gain more control, I then select Levels so that I can manually tweak the contrast. Ideally, you should have a crisp black outline (but not overly jagged), with no traces of pencil. This is now ready for colouring in.

PRO SECRETS

COLOURED OUTLINES

Go to the outline layer and change it from Multiply to Normal. Select all and copy. Then create a new layer right above that and fill it in with black. Turn this layer into a Quick Mask by clicking the Quick Mask button on the toolbar. Paste the outlines to get a red-on-black mask. Remove the Quick Mask and delete the selection. The outlines are now on a transparent layer. Select Lock Transparent Pixels (or Preserve Transparency) and you can now colour freely into the outlines.

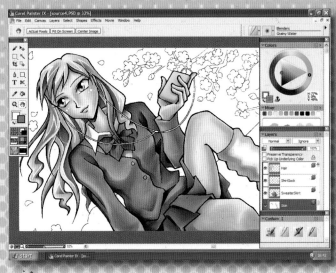

3 OUTLINE WORK

The outlines are opened in Painter. I like to copy and paste the outlines to a new layer, and set this to Multiply. This enables me to colour freely but still retain the black outlines, which show through. I also keep a completely white layer under the outlines to act as a backdrop.

4 GATHER YOUR TOOLS

Before beginning to paint, I drag my choice of tools into a custom palette so that I'll always have them on the screen. For this project, I chose Digital Watercolour>Broad Water Brush, Blenders >Grainy Water, Airbrushes >Digital Airbrush, and Gouache >Opaque Smooth Brush 10.

SHORTCUTS
DRY WATERCOLOUR
Ctrl+Shift+L (PC)
Cmd+Shift+L (Mac)
Used after watercolouring each area in Painter. If you forget, you won't be able to use the Blender Tool.

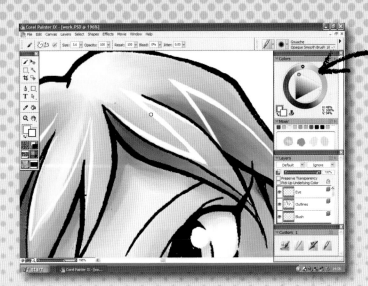

5 COLOURING

I begin by colouring the face using Digital Watercolour. First, I cover everything with a light skin tone. I then introduce shadows with a medium skin tone and create some depth with a very dark tone. The mixer palette in Painter enables you to paint swatches of a chosen colour so that you always have the right hue at hand.

The shading can be rough and scribbly, as that's where the Blender Tool comes in handy. Before using it, I have to dry the watercolour (Layers>Dry Digital Watercolour, or Ctrl+Shift+L). Then I take the Blender and smooth over what I've just drawn to create perfectly blended shadows.

6 AIRBRUSHING

The rest of the image is coloured in using exactly the same technique. The Airbrush can be used to create blush on the cheeks, add highlights to clothing or correct mistakes.

7 GOUACHE WORK

The Gouache brush is used for zigzag hair highlights, which are another typical feature of manga illustration. I also like to add single, wispy strands of hair, in which case I work above the outline layer.

8 FINAL POLISH

When the colouring process is complete, I save the file in Painter and open it again in Photoshop. You can give the illustration a final polish by using the Hue/Saturation/Colour Balance editors in Photoshop, colouring the outlines (see the Pro Secrets box on p. 46), or re-sizing and cropping. Once everything looks good, Flatten (or Merge Visible and discard hidden layers).

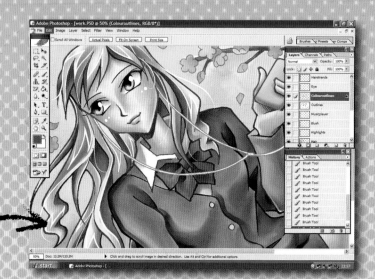

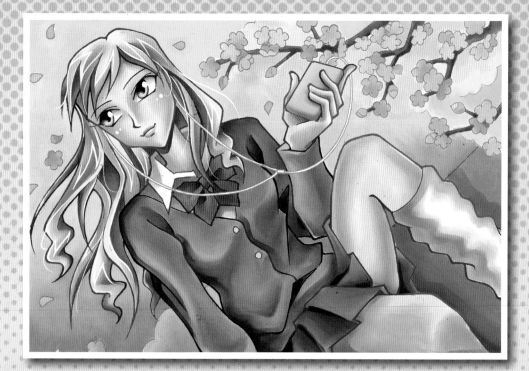

ARTIST Q&A

Q What's a good way to render a manga-style mouth and lips?

A | JOANNA ZHOU REPLIES

Manga mouths are understated yet emotive. When drawing, I try to emphasise the inner contour separating teeth and lips rather than the outer lipline. For illustrations, I like to use a colouring process similar to applying make-up in real life. First, I render the face and lips in skin tone. Then I blend in pink tints with a soft translucent brush to mimic lipstick. Finally, I create a new layer and use a harder-edged brush to dab on highlights.

Manga faces are very flat, so mouths appear almost stuck on. I try to be quite restrained when shading the lips, so the edges are small. Unless the character is viewed from an angle, the mouth rarely affects the contours of the cheeks and nose. Lips are trickier to shade when the mouth is wide open. Trying to paint all the way around a large manga mouth will look clownish so I often just give an indication of colour for the bottom lip, or leave it out altogether.

When it comes to painting mouths in the manga style, less is more: don't try to include every detail.

ARTIST **PROFILE**
LOIS VAN BAARLE

COUNTRY: Holland
WEB: www.loish.net

Lois has been drawing ever since she could first hold a pencil. She has only developed preference for digital and animation in the past few years.

PHOTOSHOP

BRUSH UP ON YOUR PORTRAIT SKILLS

"To paint a strong, fashionable female, you need a bright, warm colour palette and a few decorative elements," says Lois van Baarle

Female portraits have been around forever, showing that, at the very least, women are enjoyable to paint. In this tutorial, I'll try to create a picture that brings out the ladylike qualities of the subject, using elements like fashion sense, colour palettes and supplementary figures to make the image more than just a forward-facing depiction of a girl.

One aspect of making such a piece is to consider how you'll approach the project concept-wise. Personality plays a crucial role, and the image should have flair and attitude. Adding decorative items can give the piece more interest and

the character something to interact with, giving you a chance to play with expression and pose.

The most important technique in this tutorial will be the painting process. I'll work with a rough, chunky brush and use prominent, solid brush strokes. Textures will also be used, helping to create a traditional feel. Intuition will play a key role; I'll start with a basic concept and see where it takes me. The final result will be a portrait that, after having undergone numerous changes and modifications, will convey the personality and feminine touch I'm aiming for.

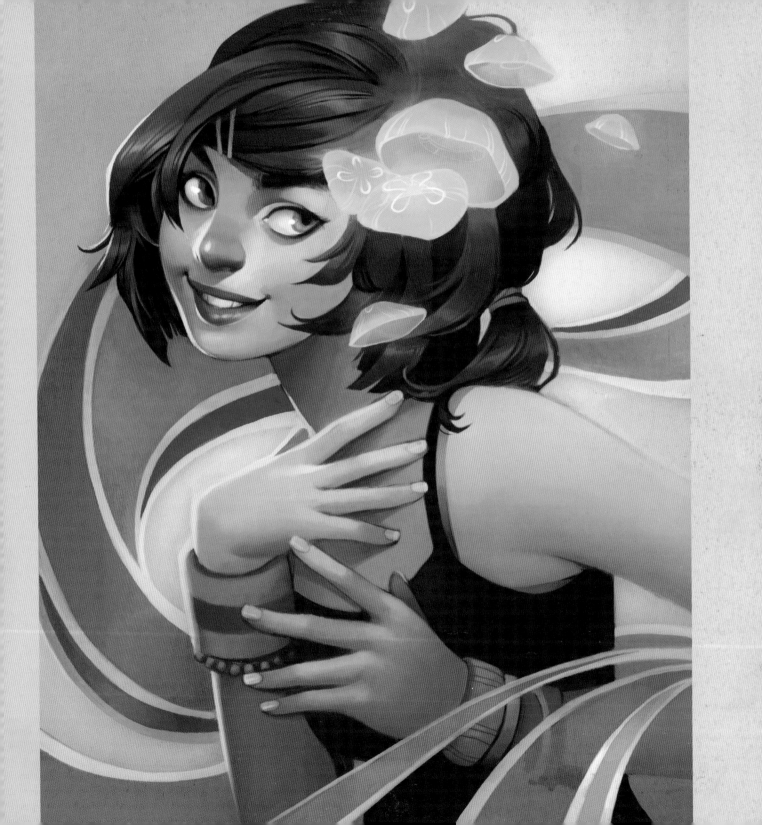

 ## MAKE A ROUGH SKETCH

When starting your piece, work loosely and don't get hung up on details. Keep in mind that you don't have to adhere to every detail in your original sketch; see it more as a starting point. Focus mainly on the composition, proportions and pose. I've chosen to include jellyfish to give the subject something to interact with and add a surreal touch. I've also added thick, loose hair and a number of bracelets to give her a youthful, playful style.

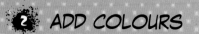 ## ADD COLOURS

On a separate layer, add your first colours to the sketch. Fill the layer with a dark, deep hue and paint some lighter shades on top with a chunky brush set to approximately 60 per cent opacity. Starting with a dark layer adds volume and a painted feel. The colours can be changed many times during the process, so just throw some on there and play around. It helps to decide on one aspect, such as making the jellyfish blue or green, and get the other hues to work with it.

3 CREATE TEXTURE

While you're playing around with the colours, add a layer of texture. Colourful concrete ones are ideal because they have an organic, grainy quality and can have a unifying effect on the shades in your piece. Add the texture on a separate layer and play around with the opacity, hue and layers to see how they affect your image; I've chosen Soft Light. The texture is important because later you'll be picking colours off the canvas with the Eyedropper tool.

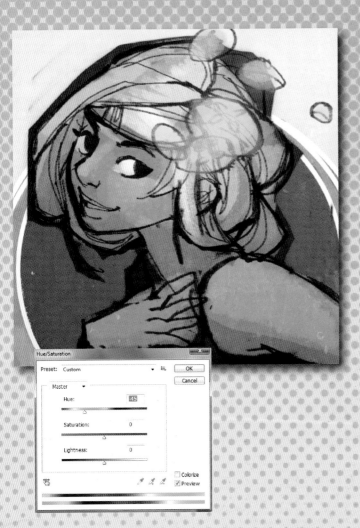

4 MODIFY THE PALETTE

A huge advantage of working digitally is the array of colour-editing tools you can use to get a palette you feel good about. In Image>Adjustments, you can choose from Hue/Saturation, Colour Balance, Selective Colour and Replace Colour to tweak all or part of your drawing. I like to use Colour Balance to give an image more warmth by adding red and yellow. Selective Colour also makes certain tones pop. Remember the personality you want to convey, and try to work towards a pleasing colour combination that achieves this.

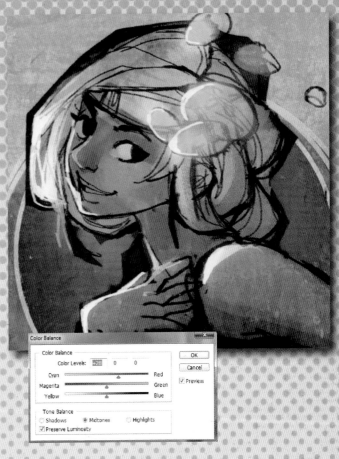

5 CHANGE THE HAIR COLOUR

At this point, I feel the blonde hair isn't working. Using the Lasso tool with a feather of 20 pixels, I make a rough selection of the hair and use Replace Colour to make the subject brunette. If you feel that you must change the shade of one part of the image drastically, it's ideal to do it early on in the drawing process: at this stage you haven't put in too much detail, giving you more room to experiment.

6 MERGE THE LAYERS

I prefer to do everything on one layer. When I feel ready to start painting, I merge all the layers, and then only use them to make adjustments or add textures, merging these when alterations are complete. Now I'll begin painting over the line art, rather than under it.

7 USE THE EYEDROPPER TOOL TO SELECT COLOURS

When you start feeling good about where the image is going, begin painting in some detail. Before doing this, make sure you choose the right colours by using the Eyedropper to select the base shade from the canvas. Then manually select a lighter or darker version of it from the Colour Window. This keeps the colours unified and helps you choose hues that enhance your palette, rather than flat ones that don't match what you've created.

 ## PAINT ROUGH DETAILS

Start to add some detail with the same chunky brush you were using earlier. Change the size, opacity and flow based on what works for you. I like to use anything between 40 and 70 per cent opacity, and vary the flow according to the effect I want to achieve. At this stage, try to sculpt with your paintbrush by adding volume and shape. Don't put in too many details, and avoid zooming in too much, so you can focus on the big picture and have a good overview of the image.

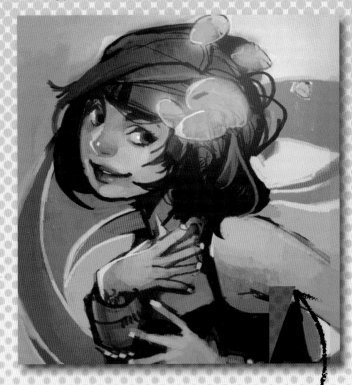

 ## CHANGE THE PALETTE

Getting the right palette is a gradual process. You may have to change it numerous times until you're happy with the colours you've chosen. Intuition plays a crucial role: you have to feel good about the hues and get them to suit the aim you had from the outset – to make something fun, feminine and vibrant. Don't be afraid to use the colour-editing tools or lay down new shades during the process. In this case, after painting in some details, I switch to warmer, more earthy options.

SHORTCUTS
ACCESS THE EYEDROPPER TOOL
Alt+Click (PC & Mac)
This temporarily activates the Eyedropper tool, so you can quickly pick a colour.

DISTRIBUTE COLOURS

The colour combination isn't the only important thing: the way you distribute it also matters. One way to approach this is to have a calm base colour with bright accents. I've changed the palette to consist of cool browns and purples, desaturated blues and accents of orange and electric blue. To accentuate the fashionable and girly personality of this character, assign the bright accents to the subject's accessories and use the darker hues for her hair and clothing.

WORK WITH THE BACKGROUND ELEMENTS

What began as a few circular shapes can form the inspiration for new decorative elements in the background. I feel the circles are doing little for the composition and change them into flowing forms that lead the eye across the canvas. I also change the canvas size to give these elements more space. They add a playful and colourful aspect to the piece.

12 TWEAK FACIAL FEATURES

As I add more detail with the paintbrush, I may feel the need to make structural changes to the facial features. Here, I think the mouth is no longer properly aligned to the rest of her face. Change these things as soon as you notice them – it will be harder to do it later on. You can use Filter>Liquify, or just make a selection and transform it. Paint over any misaligned edges or other inconsistencies after you're done. Try not to use these methods excessively because it will show.

PRO SECRETS

USE A HIGH RESOLUTION
Painting at high resolution is crucial to being a professional digital artist. First of all, it increases the possibility for detail enormously. You can work roughly when zoomed in and still maintain a detailed and smooth look once you pan out. Also, having high-resolution versions of your artwork is absolutely essential when creating prints, so the bigger the better.

13 PAINT THE HAIR

Something to keep in mind when adding more detail to the hair is to draw it in chunks rather than individual strands. This is what it does in real life, and remembering that helps you create more mass, volume and expression. Try to work out how the different sections overlap, vary in length and move in different directions. You'll add more detail later, so focus on the basic form for now.

14 GET READY FOR PAINTING

At a certain point, you should decide that the piece is ready for refined painting and details. The canvas and composition should be set, so if you feel you must make changes to these things, do. In my case, I finally settle on a warm colour palette with lots of browns and desaturated greens, as well as bright orange, blue and red accents.

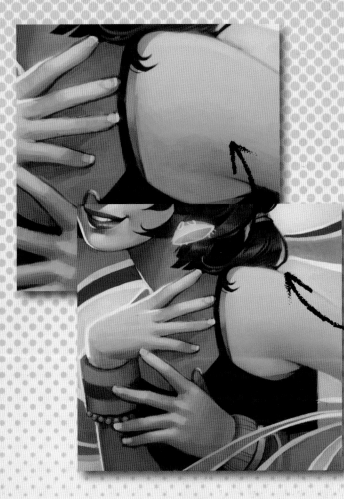

SHORTCUTS
ALTER YOUR VIEW
Ctrl+R (PC) Cmd+R (Mac)
This tool is relatively new to Photoshop. It enables you to tilt your canvas to different angles while you paint

15 SMOOTH THE SKIN

Until now, we've been using chunky and rough brush strokes. Although this effect is desirable and important for the final work, we can strategically smooth out certain aspects of the image, such as the girl's skin, to enhance her femininity and youth. Change to a smooth, large brush with a low flow (between one and 10 per cent), and use the Eyedropper tool to pick shades. Paint gradually over the textured brushwork with smoother colouring. I prefer not to use the Smudge tool because it rarely creates a painted effect.

16 ADD CONTRAST AND SHINE

Your colour palette is already set, so you can give the work more contrast and shine by painting in some highlights and dark areas. Adding some deep, dark lines to the pupils and eyelashes or tips of the hair can make these shapes stand out. Putting highlights on the skin, jellyfish and decorative forms can also make them shine. Use the Eyedropper to pick the base colour, then manually choose a lighter or darker shade. As opposed to the rough painting phase, zoom in a lot and work in a detailed fashion.

PRO SECRETS

UNSHARP MASK

Your original artwork exists at a really high resolution, so you'll eventually have to create a small version for posting on the web. When shrinking the piece down to a more compact size, you might notice that some of the detail from the large work becomes less sharp and defined. Applying the Unsharp Mask filter can sharpen the image and bring back some of the detail. Keep the radius small to avoid an overly sharpened look.

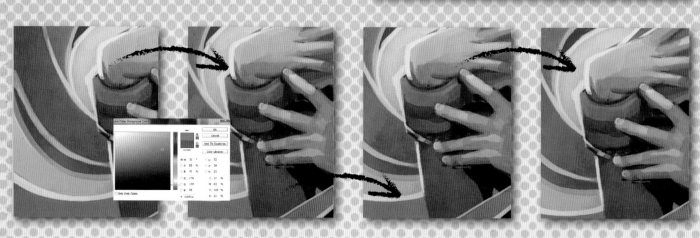

17 WORK ON FINE DETAILS IN THE HAIR

Because the different chunks of hair have already been painted in, you can add some strands and shine to the hair, as well as smoothing out the chunks. It pays to have detailed and realistic hair in your final piece, so this part of the process deserves some extra time and effort. Zoom in and add a bright shine to each individual chunk. Draw strands that pass over the different chunks for added detail. Turning the canvas using the Rotate View tool can help you draw the brush strokes in the same direction as the hair.

18 ADD EMPHASIS TO THE JELLYFISH

Throughout the painting process, I've been gradually adding more detail to the jellyfish. Because they're quite central to the composition, I'll now give them some special attention. After adding details, you can make them glow. Select the jellyfish using the Magic Wand or Lasso and, on a new layer, fill the selection with a bright blue colour. Blur the layer using Filter>Blur>Gaussian Blur. Then change the Layer mode to Hard Light and adjust the opacity to brighten colour and give the creatures a vivid glow.

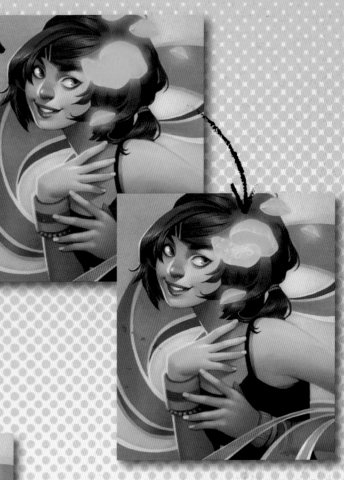

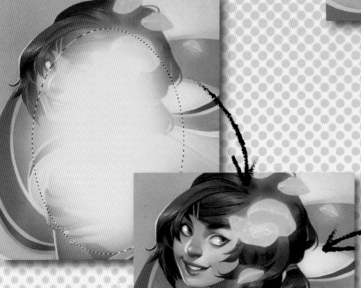

19 FINISHING TOUCHES

At some point, when enough details have been added and you feel good about the colours, you're done painting. However, some finishing touches can be applied to bring the piece together. On separate layers, you can add gradients or soft highlights to the picture. Change the Layer mode and opacity to make these layers blend in to the final picture. In this case, I've placed an oval shape with blurred edges on a separate layer and set it to Soft Light at 25 per cent opacity, creating a gentle highlight in the centre of the image.

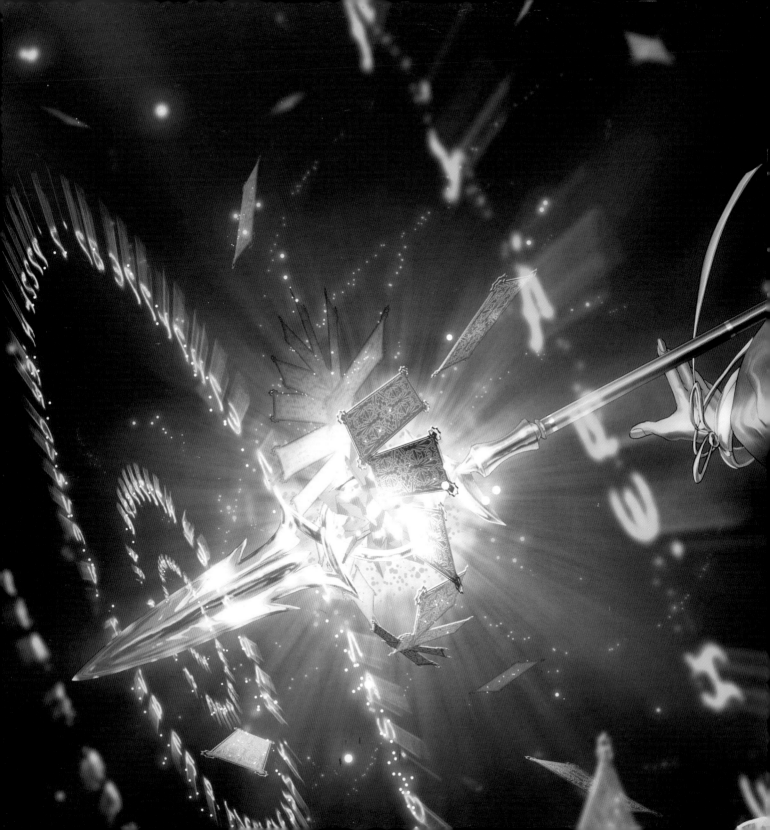

CHARACTER CREATION

ARTIST **PROFILE**
CHESTER OCAMPO

COUNTRY: Philippines
WEB: www.chesterocampo.net

Chester is a freelance illustrator. He loves Haruki Murakami novels and conspiracy theories, and is on a quest to find the best salmon sashimi in Manila.

PHOTOSHOP
PAINT A DYNAMIC MANGA CHARACTER

Creating a cover image is about so much more than just the character placement, explains Chester Ocampo

I was asked to do create a cover image for the *ImagineFX* magazine, and it had to be either an action-oriented or a wholesome character in a manga style. As you can see, I decided to choose the more dynamic option. I was originally asked to paint a double-sized image with the aim of it forming a wraparound cover for the magazine, and although the extra area wasn't needed in the end, I decided to stick to the original brief.

A front cover image needs enough negative space to take into account the masthead (the *ImagineFX* logo) and all of the coverlines. There are also the colours of these cover elements to consider. Because it's an action shot on the front of a manga issue, colourful cover elements are par for the course. The trick is not to let the illustration get lost in the background when placed against these elements. Bearing all this in mind, I set out to create the illustration you see here.

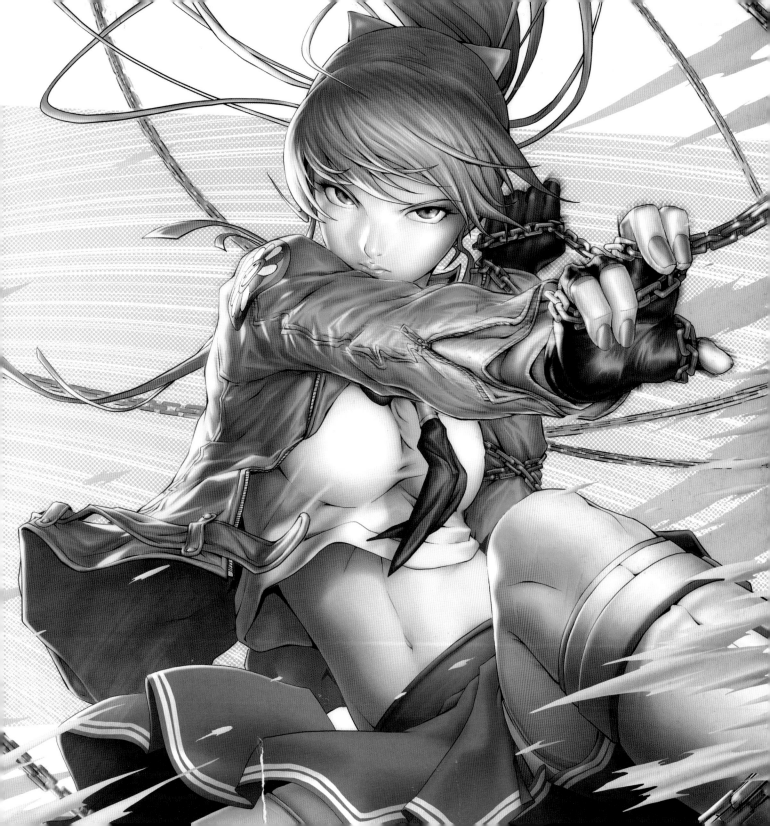

INDICATORS OF MOTION

In a manga action shot, motion must be conveyed convincingly for visual impact and energy, and several indicators of motion are seen here. There are high-speed objects such as the chain-whip; wind-affected objects such as the ribbon and the girl's ponytail; objects reacting to motion – notice the jacket's edges, which are fluttering; the particle effects of the dust that's been disturbed by the girl; and the speed lines in the background. All these elements are painted to suggest that they're moving at different speeds.

COMPOSITIONAL BALANCE

Composition is a great challenge when it comes to wraparound illustrations. For this image, I used a Yin-Yang balance, where the main point of interest on one side has an equivalent point of interest on the opposite side. And where one side is sparsely detailed, the other side is dense, to create a more interesting visual flow.

STEP-BY-STEP:
HOW I CREATE...A MANGA COVER

 ### GENERATING THUMBNAILS

Focusing on composition, I sketch a thumbnail of the wraparound cover. The placement of the character is set to be on the right side of the image, because this is the front cover. The thumbnail is drawn at low resolution for speed; the high-resolution version will come later as the illustration develops.

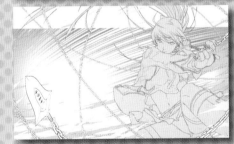

 ### ROUGH SKETCH

I refine the sketch from the approved thumbnail. Details such as the blades of the chain-whip, the path of the chains and the placement of the character are finalised. The character is moved further to the right so that her head lies on the vertical centre of the front cover for better eye flow, in anticipation of the cover elements.

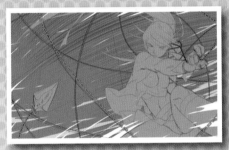

 ### LINE ART AND COLOUR FLATS

Scaling up the image to high resolution, I then digitally ink the lines. I check the thinness and thickness of each line, as well as how lines converge on overlapping objects. Colour flats are then applied on the image. I note their relationship with each other, and their relationship with the cover elements.

A SENSE OF DEPTH

Although the final image will be in colour, it helps to convey depth through the line art. Varying line weights create interesting forms and provide hints on an object's depth. In addition, when objects that are spatially far apart overlap in your view, a gap between converging lines creates depth.

CHECK THE LIGHTING

To achieve consistent lighting, I create shadow layers set on Multiply and highlight layers set on Linear Dodge, placed under the line art layer but above the object layers. The Shadows and Highlights may look rough at the moment, but more detail can be applied once the object layers and lighting layers are merged together.

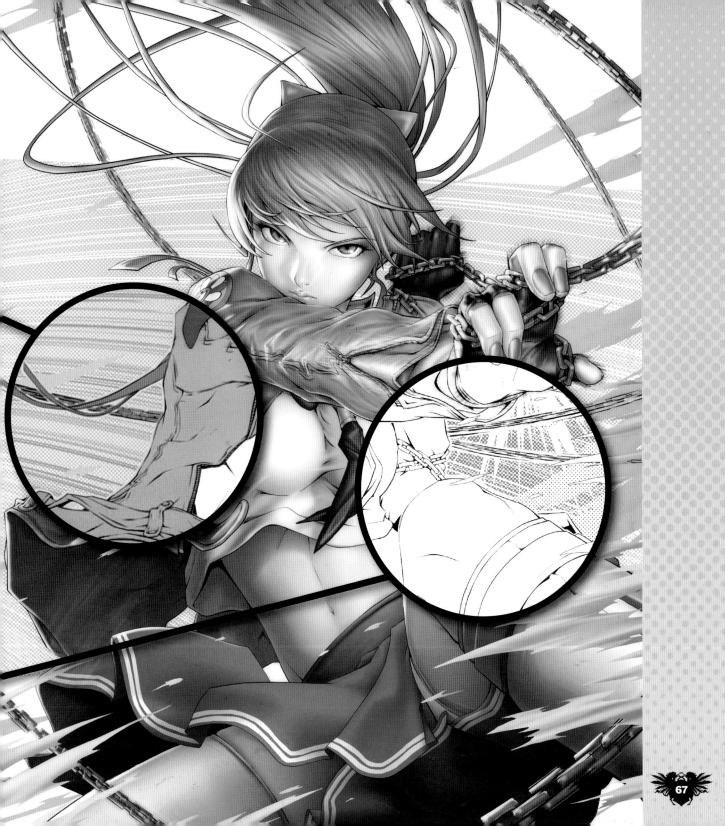

ARTIST Q&A

Q How do I give my manga characters a fun and lively, animated look?

STEP-BY-STEP: GIVING YOUR MANGA CHARACTERS A FUN, DYNAMIC LOOK

1 The sketch on the right is some of the gesture work that I go through when creating a dynamic manga character. As I draw these poses, I try to keep the line of action (red), and the angle of the hips and shoulders in mind (blue), in order to maintain a nice flow.

2 Once I decide on a pose, I draw out the final line art exactly as I want it. Again, I want to maintain a dynamic flow throughout the character. The red and blue lines mark the spine, shoulders and hips, while the green colour marks the lines of action for the limbs.

3 When I finish the drawing, I apply colour. In this case, I push the fun look of the character with some vibrant tones. I also like to look back at animation-style, cel-colour work, but instead of keeping the shapes very sharp, I apply a slightly more refined, painterly feel.

A MICHAEL CHOMICKI REPLIES

The first thing you need to do is to get confident with your line and colour. That comes through practice. Second, start your drawings by generating pose ideas through thumbnail-size figure gestures, always remembering to establish a line of action to give your character a sense of motion. Keep your line loose and flowing at all times. Third, make use of suggested lines in your work. You don't need to draw every single detail on your character. For example, when drawing the nose, you only need to develop the tip and possibly the top end that touches the brow, avoiding anything in-between. Being deliberate and strategic with your line placement and flow will keep your artwork from looking stiff and stale. Finally, when it comes to adding colour, keep 'light versus shadow' in mind. Don't be afraid to get colourful, as this can add to the liveliness of your piece of art. I always try to block in my base tones first – in this case, the lights – and then I go back in and block in the shadow shapes with a darker tone. I try to keep just as much flow in my brush strokes as I do in my linework, which in turn generates a feeling of unity throughout the artwork.

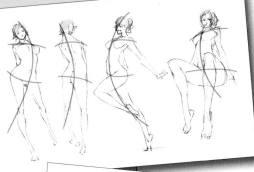

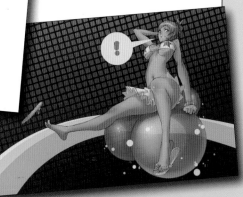

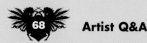

LEFT: In order to keep things lively, always remember to maintain the flow of your lines throughout the entire drawing. Simple props, such as the flying sandal, can really intensify the lively mood.

BELOW: Letting the decisive paint strokes complement the tight, flowing linework will give your artwork a complete, dynamic feel.

ARTIST **PROFILE**
MICHAEL CHOMICKI

COUNTRY: Canada
WEB: www.studioqube.com

Michael got serious about drawing at the end of his high school career, where he became inspired by Japanese animation and European graphic design. He graduated in illustration and computer animation, before beginning work in the videogame industry. He's since co-founded Studio Qube with his brother Cyprian.

PHOTOSHOP
THE GREATEST WAVERACER

Michael Chomicki shows you how to paint and colour rubbery fabrics in your character art

In this workshop, I'm going to show you how to create a manga-esque character illustration. I'll mainly focus on specific rendering techniques that, while painterly, enable me to preserve a clean, line art feel.

Throughout the workshop, I'll also study the differentiation between material types, as well as the relationships between warm and cool colour tones. I'll look at how to successfully make use of shadows, lighting and reflected light, in order to achieve a three-dimensional form from a flat line drawing. You should keep the decisive use of dark versus light in mind throughout the workshop, in order to achieve a shapely, yet comfortable look to the artwork. Although I'll be working on a flat, white background, I'll keep a virtual atmosphere in mind,

and really push bounced lighting. I am going to achieve this mainly by sharing colours between materials and objects.

Of no lesser importance will be my focus on maintaining a very Japanese art-inspired look and feel to the character art. As a result, I'm going to be very deliberate in how I shape such areas as the eyes and hair – always distinct points in manga illustration.

I'm going to keep Japanese animation in mind, specifically the way that shadows (or 'cuts') are shaped. Cuts are used in animation all over the world, but the Japanese have a very specific way of shaping them. Since I'm taking a painterly approach in this workshop, my cuts will be a lot more painterly than those found in most classical-style animation.

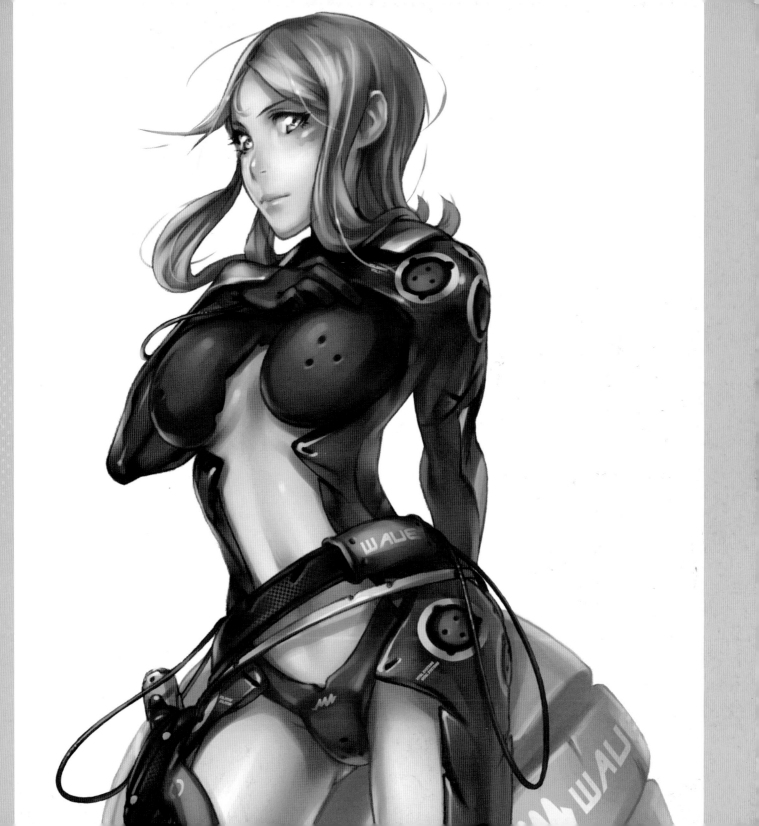

 SCANNING THE LINE ART

I start by scanning my line art in at a high resolution, in this case 600dpi. When it's scanned, I reduce the image to somewhere between 300 and 400dpi, depending on the size and purpose of the artwork. I clean up the scanned line work, and remove the white background space after using Select>Colour Range to highlight it. This will later help me in painting over my line art. Next, I colourise the line to a desired tone, using Image>Adjustments>Hue/Saturation. I continue by importing some solid graphics and logos from Illustrator, and place them in the artwork (beneath the line art layers), mainly using Edit>Free Transform and Edit>Transform>Warp. I set the line art layer's blending mode to Multiply: this will enable me to maintain the line, while I place all the colour beneath it. I conclude by organising and naming all my layers as something sensible; whatever I see fit.

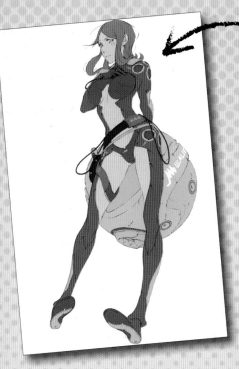

 ORGANISE YOUR LAYERS

Once I have all the basics set, I begin creating colour separations for the various sections of the artwork. For example, I place the skin tones in their own layer, the red of the bodysuit in its own layer and so on. I'm not too concerned about achieving colours that are absolutely spot-on at this stage, as I find that I'll often go back and readjust tonalities later. Most of my colour separations are within the mid-tone range. I also make sure that I name the colour layers accordingly, for easy organisation. Working with multiple layers enables me to alter specific sections of the artwork at a later stage without disturbing the rest of the piece.

SHORTCUTS
**SWITCH FOREGROUND/
BACKGROUND COLOURS**
X (PC and Mac)
A shortcut to switching between
selected foreground and
background colour

ADD SOME VOLUME

I start giving the image some volume, mainly through the use of shadow and reflected lighting. Having assigned all my colour separations to separate layers, I've made my workflow for the rest of the painting process much simpler and cleaner. I select a colour layer, and while holding Cmd on a Mac, or Ctrl on a PC, I click on the thumbnail within that layer. The Selection Marquee is in my way, so I untick View>Show>Selection Edges. As I begin to paint, I use a softer brush for roughing sections in, and a harder brush for tightening things up.

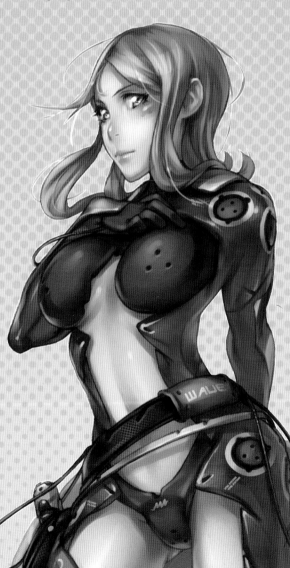

COMPLEMENTARY COLOURS

While picking and choosing my colour tones, I'm always mindful to push my lighter tones in a relatively warm direction, and my darker tones and reflected lighting in a cooler direction. This stems directly from some basic art principles: warm lights should be complemented by cool shadows, while cool lights should be complemented by warm shadows. The idea is to push for opposites in tonalities, in order to achieve a significant level of contrast, and therefore volume.

DEFINING SHADOW AREAS

I want to give certain shadowy areas a defined look. I try to stay away from working a single area too much. Although it's often very tempting to just go in and finish off a section, it's always best to work the entire painting at once. For reflected lighting, I usually tend to choose tonalities of greys.

6 MATERIAL GIRL

Once I feel that I've completed blocking in the shadow areas, I start adding the lights, as well as some detailing. At this level I also want to concern myself with the material types that I'm working with, and their reflective properties. Areas such as the character's skin will never match the high specular values of the motor-cyclist's plastic bodysuit. Since I'm aiming to give the red a significant amount of gloss, I have to focus on high contrast between its values. I achieve this by placing the lights right alongside the darks. To top off that plasticky look, I use a sharp brush with a pressure-sensitive tip to add some precise areas of bright specularity.

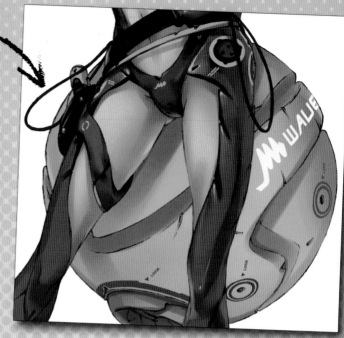

PRO SECRETS

LAYERS ARE YOUR FRIEND

Make sure you remember that layers are your friend, and have countless uses. One of the many ways that I apply the layer system is in combination with the Eraser Tool. I create a clean layer and, with my brush, roughly block in an area of colour. I then take the eraser, with the same settings as my brush, and erase into the roughed-in colour, without having to worry about altering the information below it. This is just another way of shaping your painting.

7 LOVELY RUBBERY

For the rubbery areas of the suit, the specular value is much lower than that of shiny plastic, which means the hot spots tend to be gradual. I no longer require that high gloss.

COLOURISING

As I continue detailing the artwork, I make another layer over the top of the line art layer. It's going to be in this layer that I'll paint over and colourise my line. Depending on what I feel is appropriate for the situation, I'll either freehand some colour over the line art, or alternatively, I may select all the line in the same way that I do with the colour separations, and then paint into the selection. This selection procedure will only work if the white in the background was removed from the line art layer in the first step. For sections where I want to be rid of line art completely, I use a layer mask on that layer, which can be activated by clicking the third icon from the left in the Layers palette. Following this up by painting white into the layer mask, I'm then able to easily hide sections of the line at my convenience, without actually removing it permanently.

MANGA FEATURES

When adding colour to the face, I have to keep in mind its manga/animé origin. Everything here comes down to a soft look and selective simplification. At this stage, I'm mainly concerned with solidifying a comfortable sense of volume. I want to avoid a flat look, although you'll find that, as a result of its simplified nature, a manga/animé face style will tend to look flatter when compared to other contemporary styles.

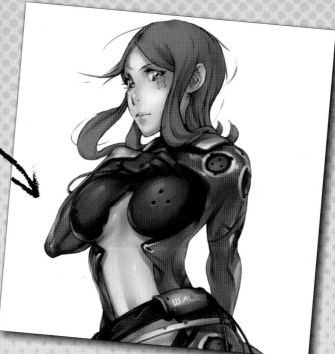

 LOOK INTO MY EYES

Since the viewer's eye will always be attracted to the character's face first, I have to make sure to refine it appropriately. This is especially important to me since I'm trying to achieve that Japanese look. I paint over the line art, throw in some gloss on the nose, lips and cheeks, and pay a lot of attention to the eyes, which, along with the hair, are of utmost importance.

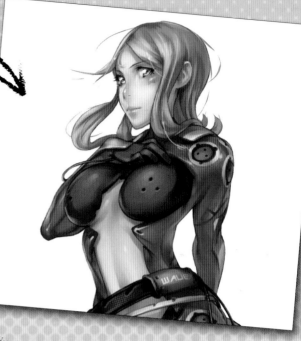

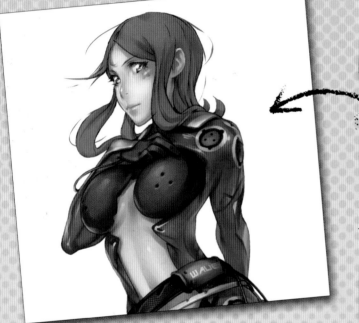

⑪ HAIR CARE

When approaching the hair, I don't want to be overwhelmed by a strand-to-strand approach. I do add some random hair strands with a sharp, pressure-sensitive brush, but fake the majority of the hair with some solid areas of colour, always making sure to maintain the Japanese-style feel. I finish up the hair by adding some animé gloss to it.

PRO SECRETS

CONVINCING LOGOS

One thing to keep in mind when importing graphics, such as logos, emblems and designs, into your art, is that they have to look convincing. One way of achieving this is through the Free Transform and Warp Tools, in order to distort the desired graphic over the topology in question. Use the Free Transform Tool to rough in the placement and perspective, and then the Warp Tool's mesh transformer to get into those finer, detail areas. Both tools can be found in the Edit menu.

 # FINISHING TOUCHES

I finish up the artwork by adding some final colours to the hover ball. Although I want the tones to remain colourful, I also want to make sure that they don't compete with the colours on the character, but rather that they recede into the background. In order to wrap it all up, I make any final adjustments to the areas of the artwork that I'm not quite satisfied with.

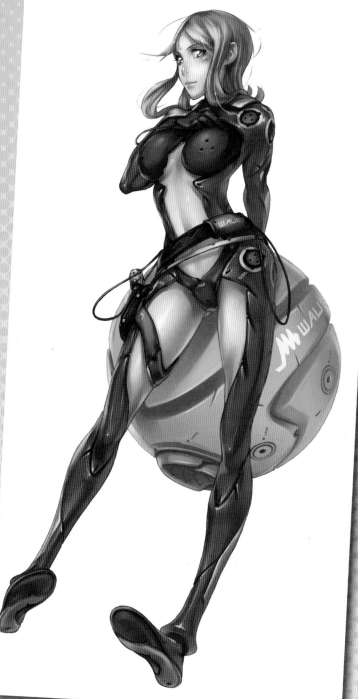

SHORTCUTS
ADJUST BRUSH HARDNESS
Shift+[or] (PC and Mac)
Select a brush and press Shift+[
to decrease brush hardness,
or Shift+] to increase it.

ARTIST Q&A

Q
How can I render semi-transparent materials such as latex convincingly?

A | CHESTER OCAMPO REPLIES

Latex presents several challenges. It is flexible, conforming to the shape of the object it wraps over. There are also different finishes, from glossy to matt, but it is always smooth. Latex can be fully opaque or semi-transparent, showing the colours of the object underneath. I've chosen to render a type that is flexible, glossy, and semi-transparent. It may seem challenging to paint all these effects on a single object, but the pay-off is definitely worth it. Layers help a great deal here, so Photoshop is my program of choice. Latex has strong highlights because of the reflectiveness of the material. Creases and edges will catch lots of light. As the material is semi-transparent, feel free to erase some of the base colour of the latex using a Soft Round brush.

STEP-BY-STEP: PAINTING LATEX AND MAKING IT LOOK REAL...

1 Sketch out your design to start. Even at this stage, you should be figuring out which type of materials you'll be painting on to which object. Try to prevent separate objects made from the same material from overlapping in your composition, so that each object is easy for the viewer to distinguish.

2 I recommend that you paint the latex on a separate layer. First, block out the parts that you intend to paint as latex. Use a Soft Round brush with its Mode set to Linear Dodge to render the latex material's highlights. Vary the brush opacity to suit the intensity of the highlight.

3 Underneath this, add a layer filled with white, on a low Opacity and with a Soft Light blending mode. Some areas of the latex clinging tightly to the skin need to be erased using a Soft Round Airbrush, again with varying brush opacities, depending here on the latex's proximity to the skin.

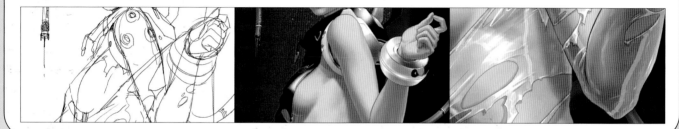

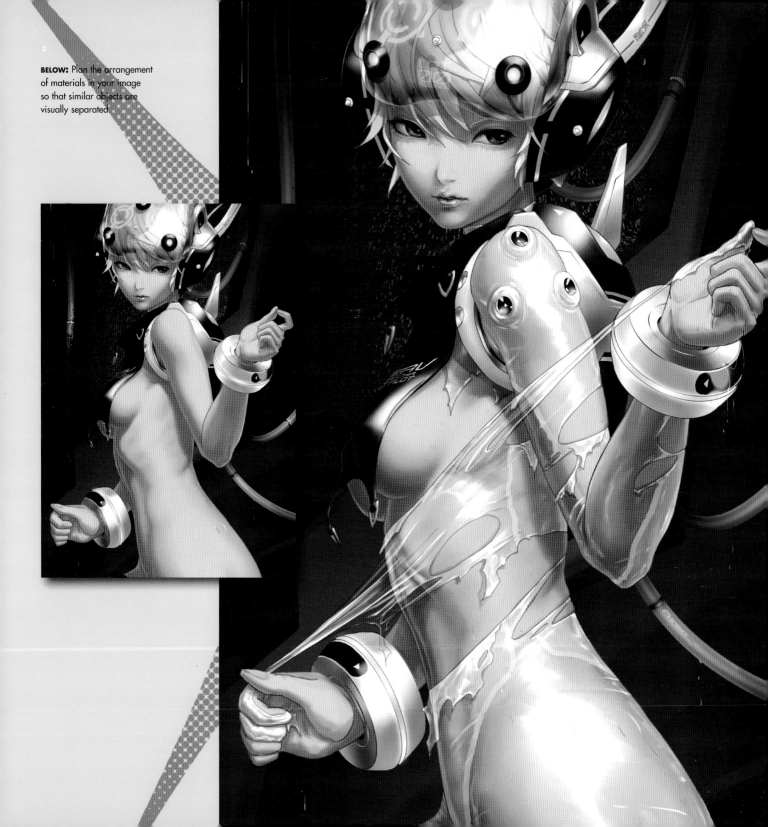

BELOW: Plan the arrangement of materials in your image so that similar objects are visually separated.

ARTIST **PROFILE**
CHESTER OCAMPO

COUNTRY: Philippines
WEB: www.chesterocampo.net

Chester is a freelance digital illustrator who loves Haruki Murakami novels, videogames, and conspiracy theories, and is currently on a quest for the best salmon sashimi in Manila.

PHOTOSHOP

THE SPEAR AND THE SPELL

Chester Ocampo shows you how to create a manga-inspired, special effects-laden character image

Female fantasy characters dressed up in outlandish costumes in an action-orientated image have been a constant source of inspiration for me. For this workshop I've decided to draw just that, and hopefully add to your knowledge of presenting a character that packs a visual punch. Be forewarned that my methods involve several layers and versions of the same image, and may present challenges for those with limited hardware power (like my stalwart, rickety old workstation). I won't be covering concept generation here, as you probably already have favourite character types in mind. That said, the idea for this image is a straightforward one: a female battle mage casting a spell in preparation for an impending conflict. This idea can be executed in several ways, by contrasting the battle mage's arcane spells with modern-day clothing, or a futuristic battle mage casting spells that look like digital interfaces. I've decided to go with a manga/videogame fantasy approach, with the battle mage sporting a spear that serves as both magic-channelling device and weapon, and exotic, non culture-specific fantasy clothing.

A few tips worth mentioning before we start: when working with several layers, it's best to name, group, and even colour-code your layers for quick referencing.

Save different versions of the image, and save often. Merge any layers that can be merged to reduce the file size and avoid having your computer slow down on you. Also, in case you mess up your current file, you can always go back to the previous versions and take the parts you need. Okay, on with the workshop!

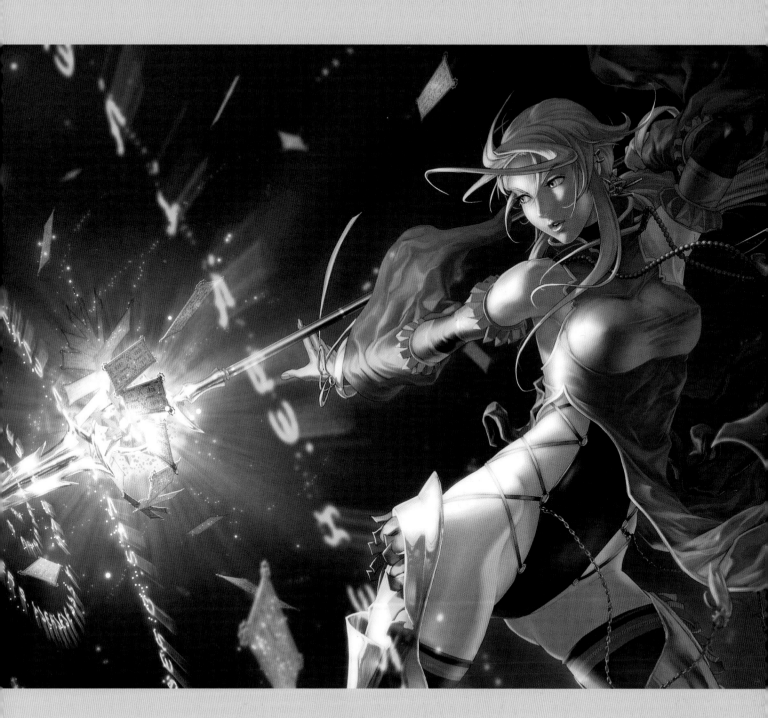

START SMALL, START STRONG

Image dimensions determine composition, so I sketch out ideas in the given sizes and see which size fits the needs of the artwork. For this workshop, the sizes to choose from are either single-page portrait or double-page landscape/portrait. I draw three thumbnails on scaled-down (25 per cent) versions of the actual image dimensions. There's no need for fine details: the main concern is composition at this early stage. I make sure that the composition and the subject's figure have a nice, smooth flow with the use of curved lines, contrasting shapes and varied sizes of elements.

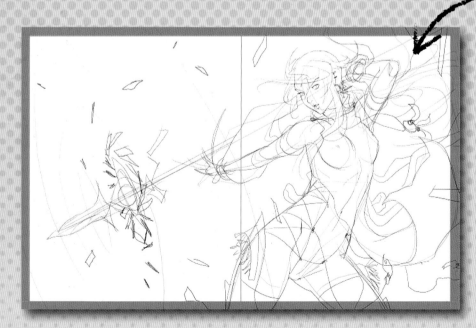

ROUGH IT OUT

Using a rectangular marquee, I copy the chosen thumbnail, paste it on to a new file with the actual image dimensions and working resolution, and scale it up to the edges of the image. I reduce its Opacity to 30 per cent, create a new layer, then refine it once the rough sketch is finished. I put a 10mm allowance on all sides to make sure that none of the important parts of the image get cropped out during printing. It's easier to crop an image than to add extensions onto it.

 ## FINE LINES

I reduce the Opacity of the sketch layer to 30 per cent. I create new layers for ink lines, inking certain areas such as the face in a separate layer so that it won't get messed up when the areas surrounding it get inked. I use the regular Hard Round brush, with Size Jitter set to Pen Pressure for varying line weights, and the Eraser Tool to knock out overlapping or unwanted lines. I turn off the visibility of the rough sketch layer once inking is finished. I refine the line art by zooming in and erasing or redrawing some lines, then merge all the ink lines under one layer of line art.

SHORTCUTS
MERGE LAYERS
Ctrl+E (PC)
Cmd+E (Mac)
Merges selected layers together,
or an entire group of layers
into a single layer.

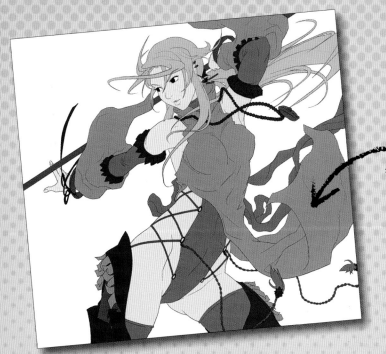

DIVIDE AND COLOUR FLAT

Underneath the line art layer, I create a colour flat layer that covers all the elements conveyed by the line art. This omnibus colour flat layer serves as a fail-safe in case some elements are not properly given flat colours. I use a combination of the Wand and Lasso Tools to select elements that are not next to each other, and fill each with a flat colour. Each layer of colour flats should have a different hue for easy distinction. I group the line art and colour flats together by selecting the layers and pressing Ctrl+G.

⑤ HOUSE OF FLOATING TILES

Elements not included in the inking process, but that play a significant part in the composition, are fleshed out at this point. In this image, the battle mage has several tiles floating around her spear and flying all over the place. All tiles are of the same design, so it pays to create a master copy. From this, I make duplicates and Free Transform (Ctrl+T) each tile to its proper perspective, referencing the layout from the rough sketch. I position the tiles on the foreground and background, above and below the character group respectively, and keep the tiles in separate groups.

⑥ CAST SOME MAGIC RUNES

The magic runes emanating from the mage's spear are another important element not included in the inking process. I make a new file and create a spiral vector path with the Pen Tool, selecting Paths in the top toolbar before I start drawing the shape. I select the Horizontal Type Tool, double-click on the spiral to create a text cursor, and type along the path using an arcane font. Now I Ctrl-click on the text layer in the Layers palette to select the text outlines. In the Paths palette, I click Make Work Path from Selection: this converts the type to a shape, so I can apply Free Transform on the magic runes later. I make two rasterised copies of the magic runes, applying Filter>Blur>Gaussian Blur on one and Filter>Blur>Radial Blur on the other. I group the rune layers and drag the group to the main image. I Free Transform the runes based on the sketch layout. I create the feathers on separate layers, using a regular Soft Round brush.

 84　**Character Creation**

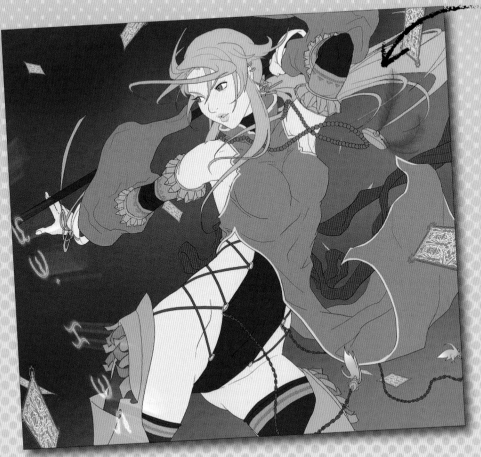

⑦ PICKING LOCAL COLOUR

With the composition locked down, I go back to the colour flats of the subject and start choosing local colours for her costume and weapon using the Lasso/Magic Wand-and-fill method, or painting over with a Hard Round brush. Using a Soft Round airbrush, I paint the background colours. These background colours may be dark and muted, but the hues shift from cool to warm, hinting at a sense of movement. The colours harboured in the background will play a huge part in lighting up the character and other objects later on, so I'm careful to choose them well.

⑧ PREPARE FOR LIGHTING

I save a copy of the image, then flatten the line art and flat colours group into a single layer, leaving the group of floating tiles in their respective single layers. I duplicate the background colours layer, bring it to the top of the layer stack, and set the blending mode to Multiply. The entire image has darkened, making it ripe for rendering lighting effects. There's a faint light coming from above (let's call it skylight) and a warm light (firelight) from the bottom right. The battle mage's spear has its own lighting effect emanating from the crystal mounted at the tip. It's good to vary the intensity of each light source for a more interesting result. I assign the faint purple skylight as the weakest, the warm orange firelight as a moderate, and the magical blueish light as the strongest.

PRO SECRETS

DETERMINING LIGHT SOURCES

When applying multiple light sources on an image, it is highly recommended to work one light source at a time to maintain the consistency of each lighting effect, and to avoid confusing one with the other. Work from the weakest light source to the strongest. If the strongest lighting is rendered ahead of the other lights, there's a danger of neglecting the other light sources altogether, making the forms look flatter than they would have if proper multiple lighting had been executed.

SKYLIGHT

I copy the background tiles, subject and foreground tiles layers into one group: I bring this to the top of the layer stack, lock each layer's transparent pixels and fill each layer with black, then set the group blending mode to Linear Dodge. I make two more copies of this group, for a total of three groups set to Linear Dodge: the top group is for rendering light from the magic light source; the next group is for firelight; and the bottom of the three is for skylight. Keeping the lighting layers in different groups is handy for adjusting the intensity of each light source later on. I render the skylight first, which is a faint blueish-purple light coming directly from above. I pick the colour from the top part of the background colours layer (the one with the Normal blending mode, not Multiply). I render the lighting on each layer inside the skylight group, using a semi-Soft Round brush with noise, as it gives a hint of faint brush strokes and a bit of texture at the same time.

FIRELIGHT

Next up is the firelight lighting group. As with the skylight, I pick the warm orange colour from the bottomright corner of the original background colours layer, and proceed to render the lighting on each layer of the firelight.

⑪ MAGIC LIGHT

Lastly, I render the magic light by determining its source, the crystal at the tip of the spear, as the point from where the pale blue light radiates. The magic light is quite close to the subject, and it will only hit areas directly exposed to it. After determining the intensity of the magic light as it affects the subject, its effect on the background can now be created. Using the Lasso Tool, I create a star-burst shape, with its focal point the magic crystal near the tip of the spear. I feather the selection to 50 pixels and, using the Radial Gradient Tool and a pale blue colour, create a gradient from the focal point outwards. The basic lighting render for the entire image is complete.

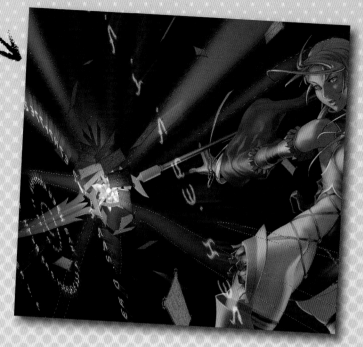

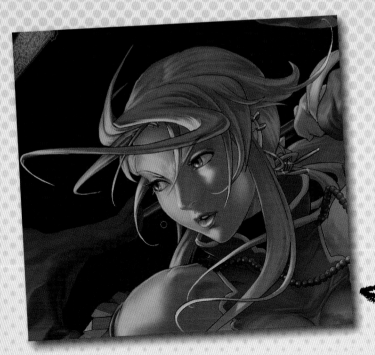

⑫ UP-CLOSE RENDERING

I combine the skylight, firelight, and magic light layers with each of their corresponding flat colour layers. (Skylight subject, firelight subject, magic light subject, and flat colour subject layers should be all merged together.) I set each lighting layer's blending mode to Linear Dodge. Once the lighting layers have been combined with their corresponding flat layers, the image should be ready for fine rendering. I zoom in on detail-intensive areas such as the weapon, face, and body, and blend the colours using a smaller size brush. I check how the elements interact in terms of lighting and apply the necessary bounce light by picking the colour of the reflective element and painting it lightly on the reflecting element. I paint over the line art, picking the surrounding colours.

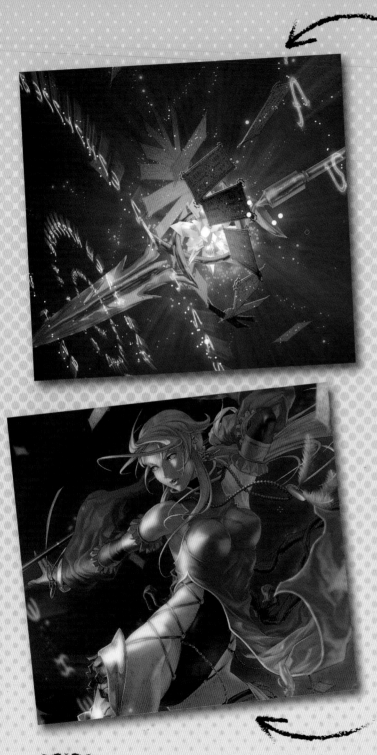

MAGIC PARTICLES

Using a regular Hard Round brush, but with tweaked scattering and spacing settings, I create the particles of magic on layers underneath and above the subject layer. I create a pale blue outer glow for the special effects layers using Layer Effects. I make another special effects layer that follows the path of the runes, using the Scattered Dots brush. I apply an outer glow layer effect on this as well. I make another layer just above the background layer and doodle in concentric circles with the scattered dots. I use Radial Blur to create a burst effect, lock the transparent pixels, and use radial gradients to fill it with colour.

PRO SECRETS

LOCK UP THOSE PIXELS

A layer's transparent pixels can be locked in such a way that brush strokes will be limited to a layer's contents and not go past them. Alternatively, using a selection that has dotted lines may be a bit distracting while painting. But there is a way to work around this. Ctrl+H will hide the dotted lines but still keep the selection. Locking a layer's transparent pixels is particularly useful in keeping the edges of the image elements clean and sharp.

DEPTH AND FOCUS

Since the layers are kept separate throughout the entire process, a depth of field effect can be applied using varied levels of Gaussian Blur. The battle mage and her weapon are the focus, while all elements in the foreground and background are blurred relative to their distance from the focus. Objects nearest to and furthest from the viewer are blurred the most, with other objects blurred less as they approach the focus. Using a feathered Lasso Tool, I select any specific areas that require blurring. The magic runes, for example, stretch out from foreground to background, so only the central area should be left free of blurring.

⒖ THE FINAL TOUCH-UPS

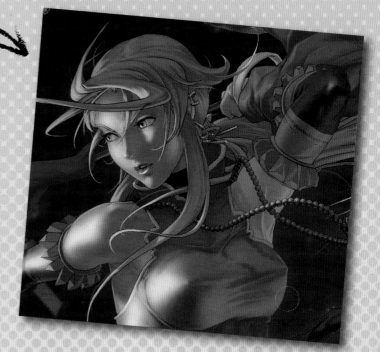

Before continuing, I save the current version of the image as a copy and flatten everything. Now I can zoom in and touch up the parts that need further definition or correction, safe in the knowledge that I have a back-up if things go wrong.

⒗ COLOUR TREATMENT

This step can be conducted as early as the lighting stage, but it's usually easier to just do this during the last stages, so I don't get distracted by too many options too soon during the work process. Cool colours usually recede when placed next to warm colours. With this image's focal point being dominantly blue, I increase the saturation of the blue and slightly desaturate the warm areas, but do so carefully to retain some of the colours established during the painting stage. I create a new layer with blending mode on Overlay, filling that layer with a low-saturation warm colour, then apply a pale blue radial gradient from the magic crystal outward to the far ends of the image. I use adjustment layers to tweak brightness and contrast and use some selective colour (blue). Lastly, I create a new layer, fill it with black, apply a Noise filter on it, set blending mode to Overlay, and turn Opacity to 10 per cent. This will create a subtle grain texture to the image, so that it doesn't look too pristine. And there you have it: the finished image.

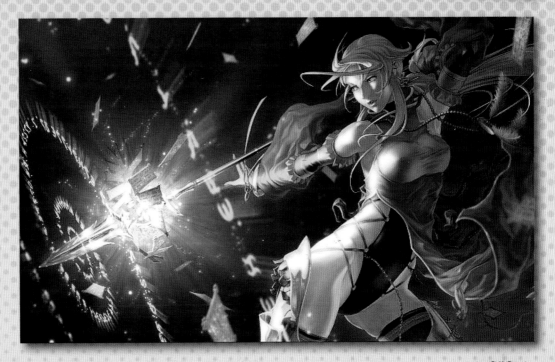

ARTIST Q&A

Q | How can I make two big mechs colliding feel more powerful?

BELOW: Render highlights and shadows based on the light sources. For finishing touches, use adjustment layers on top of the entire image to tweak the colour balance and contrast.

A | CHESTER OCAMPO REPLIES

It's always fun to see two objects collide at high speed, and to paint the point of impact. I'm going to paint robots colliding, in the middle of a battle. They're always fun to draw because you can make them do just about anything and not worry about whether or not it's based on hard science. In my opinion, they rank as one of the most fantastic character types you can draw from in science-fiction and fantasy, along with wizards and aliens. The first thing to do is to conceptualise how you want two robots going head to head to look. Make a list of interesting things that only robots can do or interesting attributes that only robots possess. Some cool things that come to mind are energy projections, machine parts, glowing bits, and, best of all, guilt-free violence. With robots, you can have them fighting as viciously as you want and still manage to appeal to the squeamish. Their battle could reach crazy levels of violence without showing blood and gore. After you've made the list, choose which of those interesting elements you want to highlight. Giving them all equal emphasis makes everything compete for attention and will leave the entire image looking flat as a whole. So it's best to prioritise just a single element, and show smatterings of the rest. Here's one way to compose this scene, using Photoshop.

STEP-BY-STEP: HOW TO PAINT THE POINT OF IMPACT...

1 Begin by sketching. Lay out all the elements you want to see in the final image, and make sure the interesting stuff is included in the sketch. Choose one element, like energy projection, and emphasise it over other elements. This gives the image a clearer focal point.

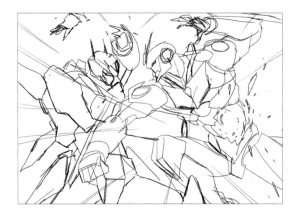

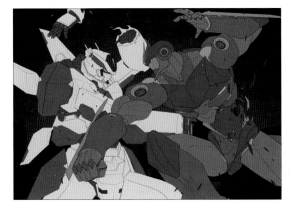

2 Once you've finished the line art, add flat colours and a basic background. With flat colours, create several decals in different colours as accents to large flat areas of the robots' armour plating. We're starting to feel like these metallic monsters are pounding on each other

3 Now you can add special effects, like energy blasts, sparks, glows and light streaks on separate layers. Looking at it now, the energy blast is the strongest light source in the entire image, and will largely determine the highlights and shadows as you get painting.

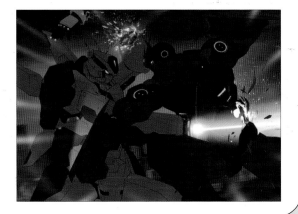

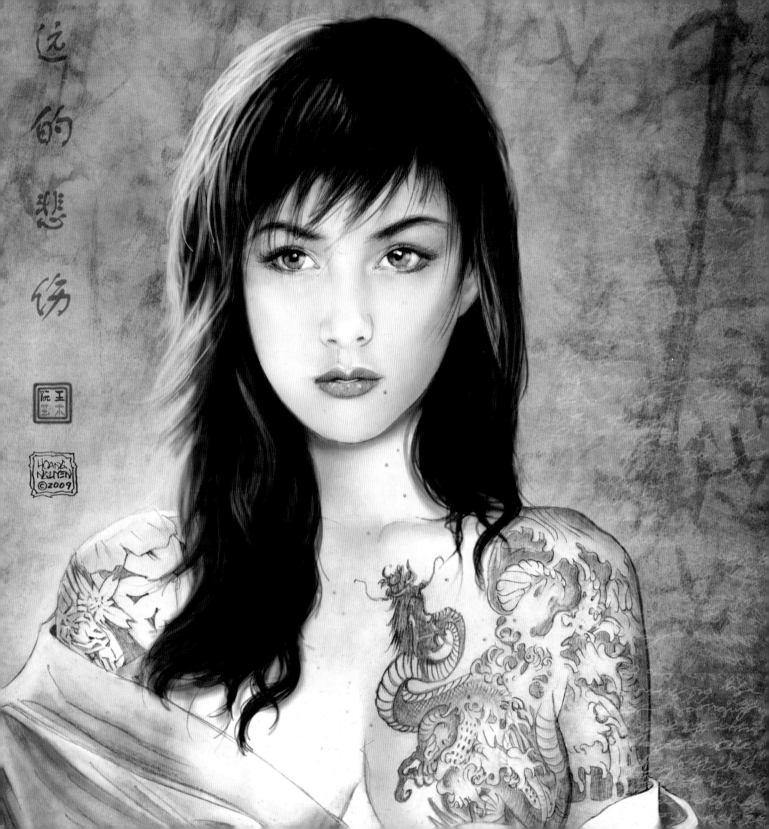

MANGA
STYLE

ARTIST **PROFILE**
HOANG NGUYEN

COUNTRY: USA
WEB: www.liquidbrush.com

Hoang works in the game industry, contributing to well-known titles like The Elder Scrolls, Dead to Rights, Tiger Woods and The Godfather. Currently he's at Namco Bandai as the senior art director.

PHOTOSHOP
THE PAINTED PRINCESS

Create a unique style using proven techniques in Photoshop, as Hoang Nguyen demonstrates his angle on the floating world...

Most artists will search a lifetime for their own style and identity. Some have a unique look that sets them apart earlier on; others might take a while. But what is important is that the artist's artistic vision stays uncompromised and true to their drive. I'm a firm believer in growing and learning as an artist, and even an amateur can teach a professional a thing or two. In this workshop, I'll explain how to draw and direct viewers into your own world. I'll focus on using simple composition and design to capture that fleeting moment. This is my take on Japanese ukiyo-e, a print-making and painting technique that goes back centuries and was made famous by artists like Hokusai and Hiroshige.

I like to start by focusing on creating a simplified background, so that it doesn't overwhelm the main theme, but helps to keep the focal point and lift it off the page. Then I'll explore how to create a colour scheme to complement the subject. Lastly, I'll define the light source to help tie up all the elements.

It's a portrait – but not in a traditional sense. I like to set up my composition with themes that I like to paint. And since the theme of this workshop is the ukiyo-e style, it's right up my alley. I'm a big fan of old Japanese art, especially Hokusai, so I'm going to be bringing together something old and new.

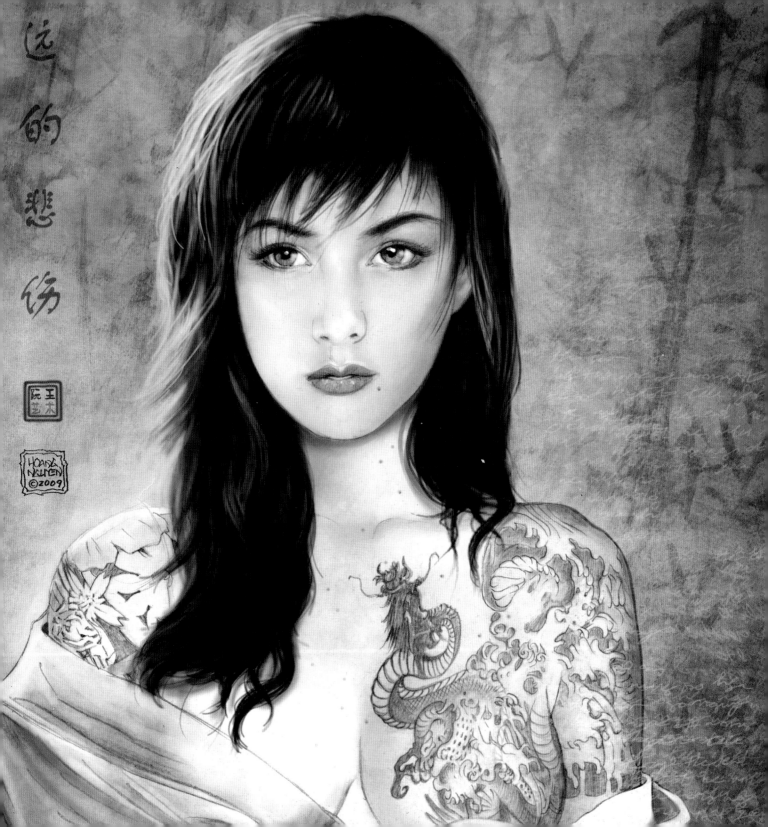

COMPOSITION

As the subject matter is the ukiyo-e style, I'm going to try and mimic those Japanese paintings, but with a modern twist to make it a bit more interesting. Ukiyo-e was a kind of woodblock painting depicting the 'floating world' – a world of luxury and privilege, unattainable to the common man. I like to keep my composition simple and not centre on the image, so I focus most of my attention on the face and direct the viewer's attention to the main focal point. My other point of interest is her tattoo, so I spend time on that too. Now that I've established that, my attention will be on the subject, and everything else is just background.

FINAL COMPOSITE

TEXTURE LAYER

BROWN LAYER

PENCIL LAYER

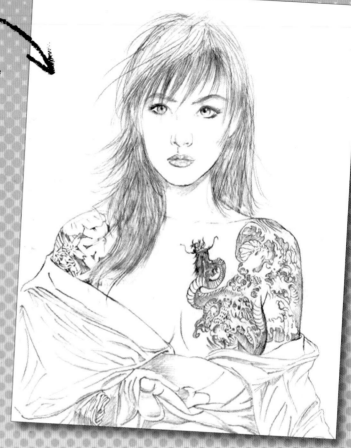

② MAKING A BACKGROUND

I'm fond of bamboo forests. There is a calmness that has always drawn me to them, and I'd like to capture that in this workshop. I start with just a pencil and paper, using a vellum Bristol board (because of the smoothness). I focus on blocking in the bamboo, always trying to keep it simple. Once I'm happy with the result, I scan it in at 300dpi greyscale. I'll convert it to RGB mode when I start painting. It's currently a bit busy, but once all the layers are composited, I'll simplify it even more. Now I start out with some colour testing. I'm more concerned with big shapes and colour rather than worrying about details. In this image I'm going for a cooler colour palette, and trying to keep it almost monochromatic. This was made using textures and clone tools. I add some noise using Despeckle (it's under Filter>Noise>Despeckle). This gives the image that old textured look. It sometimes creates a moiré pattern, so you might want to be careful of that.

PENCIL LAYER

TEXTURE LAYER

THE FINISHED BACKGROUND

Now that I've got all the necessary layers done, I start experimenting. The pencil layer is at 40 per cent Opacity, with the blending mode set as Linear Burn. The brown layer is set at 75 per cent Opacity, using Overlay as the blending mode. The blue texture layer is at 100 per cent Opacity, again using Overlay. To composite the finished background, each layer is applied in chronological order to achieve the final look. Texture gives the image more depth and it helps to weather the look a bit.

FACE DETAILS

Now that I have the background in place, I'm going to focus on her face. I start out with simple black and white hues and apply shapes. I usually like to paint in layers, so that I can just delete it if I'm not happy with how it turns out. I play with the hair, experimenting with various brush sizes and opacity. I also block in the face and define some shapes and forms. At this stage, I keep everything pretty flat and simple. I think about where the light source is coming from, and start to give the form some light and shadow.

PRO SECRETS

MIRRORING YOUR IMAGE
Flipping or rotating your image can help to fix problematic anatomy. I often flip the image during the painting process, as this helps me address problems with my anatomy and many other aspects of my image creation process.

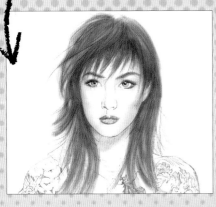

EYES, FACE AND SKIN

I want to put more emphasis on the eyes and face to draw the viewer in. The eyes hold so much emotion that you can tell if someone is happy or sad just by looking at them. I start by applying skin colour over the B&W layer, and add detail around the iris and her eyelashes. Using just the regular brush and setting my brush size between 4 to 10 pixels, I detail in her face. I also play around with values and shadows to define form around her facial features.

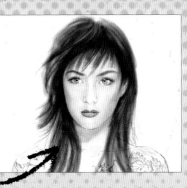

 ## THE HAIR AND LIGHT

I put more details into the hair and start to focus a bit more attention on how the light bounces off her. At this point, I'm pretty happy with her face, so I move on for now. I'll add more details, like light and shadows, once I'm near the end.

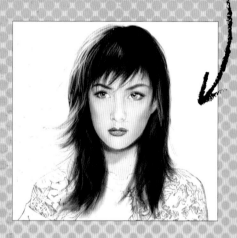

 ## KIMONO DETAILS

I start out with the pencil line work. Notice that I have the bamboo layer showing through: this is to help me with positioning the background art. Now I have started to paint in the form and shape using only greyscale. This helps me to determine how I want the composition to turn out.

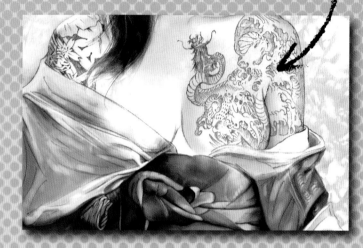

 ## ADDING COLOURS

I'm going with a more desaturated colour palette, so I do some testing with the blue tint. I'm thinking of having her body blend into the background, with the primary focus on her face. Here I'm testing various elements, combining the blue layer and the warm layer to achieve the look I'm after. I like how it's turning out at this stage and will move on to the tattoos. I'll be adding more details to the kimono in the final stages.

TATTOO DETAILS

Here I create a serpent-like dragon bursting from the ocean. My idea is to show the dragon breaking free of its shackles. The ocean represents the tides pushing it back, and the dragon represents freedom. I then isolate the shoulder to focus on the tattoo, and turn off everything else. Using Multiply, I apply a faint blue tint, carefully going around the serpent. Next I add some more details and colour around her shoulder. I paint some warm colour to help the tattoo settle on to the skin.

SHORTCUTS
MERGE LAYERS
Ctrl/Cmd+E
Helps reduce the number of layers in your file. Quite handy for keeping your file size manageable.

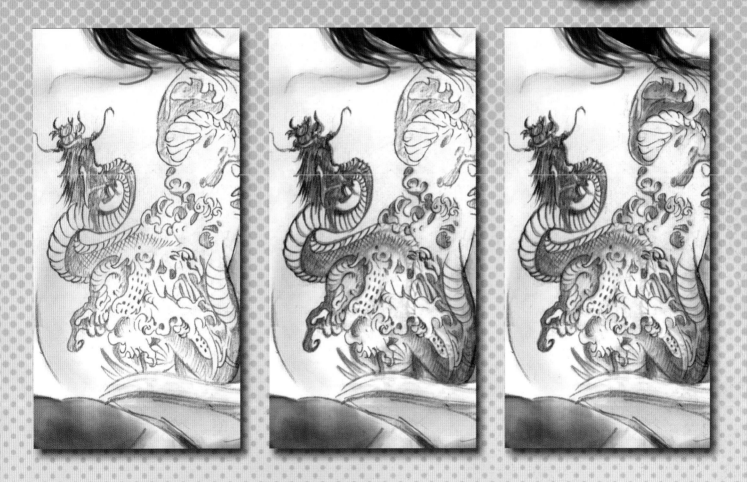

10 BLUE WORK

I start experimenting with a blue hue, overlaying it on top of the tattoo. I test the skin colour to see how the tattoo works with the other elements. Notice that her shoulder is blending into the background, which is what I was planning. I make some minor touch-ups and move onto the next stage.

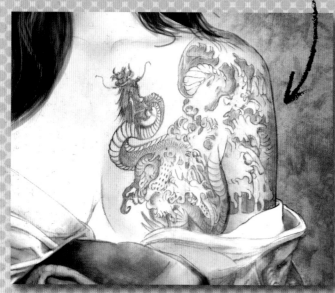

11 COMBINING ELEMENTS

At this stage, I'm ready to combine various elements and start to finalise the painting. I drop the background in and mask around the figure. I then paint in the light source and try to soften her look a bit. I'm getting close to finalising the painting – I just need to combine the foreground and background.

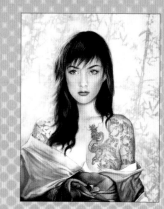

12 WORKING THE SKIN

I build up layers of skin tone and add a variety of hues – mostly purples and blues – beneath the skin layer. This process is very important in building up realistic skin shades, since it will give more depth and form. As light bounces off the skin surfaces, certain elements will be lighter than others. Areas under the eyes, around her eyelids, and the breast region are very thin and will reflect light and shadow more. Using a much warmer palette, I experiment with a few different colour schemes. I actually like this look, but feel that the impact is not strong enough. Because I want all the attention to go toward her face, the warm colour choice might not work.

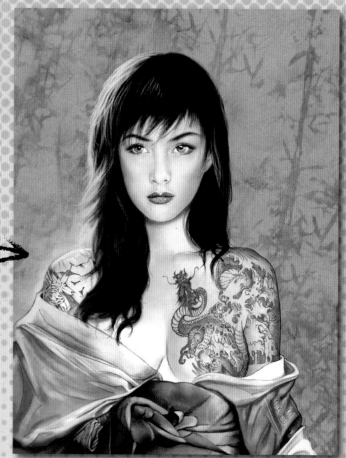

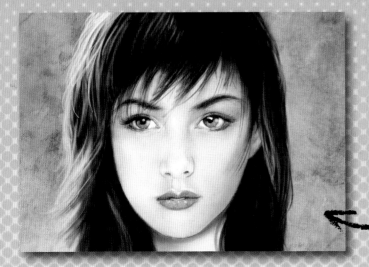

 FINAL DETAILS

I go back to the cooler scheme: it seems best for the image, since it'll help to make her face stand out. I start to focus more on her face, adding highlights and mascara. The background and foreground blend rather nicely. At this stage, I'm very close to finishing the painting. I just need to go in and add the final details. On a different Multiply layer, I apply more make-up around her eyes. Using a muted olive green, I apply a thin layer over and around her eyelids. I'm also softening around her eyes so that it's less intense, and add highlights to reflect the light source coming from the left.

PRO SECRETS

HELP WITH ANATOMY
If you want to get to grips with your anatomy skills, but don't have access to a life model, this website is really helpful: www.human-anatomy-for-artist.com. There is a lot of human nudity in it, so be careful where you view the site.

 FINISHING IT ALL OFF

I paint in some birth marks and moles to give her more realistic skin. These flaws help to define who we are, and are quite attractive. I also add some handwritten text to marry the images together. The background blends nicely with the characters, making it look somewhat worn down. Lastly, I add a Kanji layer and make my final pass, and it's all finished.

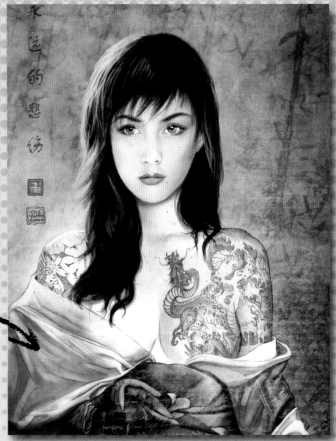

ARTIST **PROFILE**
JOANNA ZHOU

COUNTRY: UK
CLIENTS: Animexx eV, Raptor Publishing
WEB: www.chocolatepixels.com

Joanna is a freelance illustrator and graphic designer. She has 10 years' experience drawing manga with professional exposure in the UK, USA, Austria and Germany. She is also a member of the well-known UK manga group Sweatdrop Studios.

PAINTER

SHE DREAMS OF LILAC

Joanna Zhou shows you how to create an atmospheric manga painting without relying on outlines

One of the greatest challenges of painting is being able to produce realistic contours using only colour and shade. Manga style is poorly suited to this style of painting, since details are always rendered as inked outlines first.

We tend to think of colouring in a manga drawing rather than painting one. This tutorial introduces an unusual manga technique which involves painting directly on top of the sketch. It's a great way to experiment with lighting, colour combinations and atmosphere, and I thoroughly recommend that you try it. Working without outlines also encourages you to loosen up your style, and trains you to exercise control over the fluidity of a painted surface.

This is an ideal crossover technique for manga artists wishing to venture into realistic fantasy painting, or vice versa. Bear in mind that manga characters are stylistically quite different from real humans, so standard painting conventions need to be treated with discretion. The distorted facial features mean that the T-zone across the eyes and down the nose and mouth need to be treated with particular attention. A manga face is quite flat so you can't make features meld with the bone structure as you would on a real face.

The key is to keep shading nice and subtle, and carefully layer on shadow until you have your desired result. Of course, this image is still quite comic-like, but you are free to tweak your own style between manga and realism to create something truly unique to you.

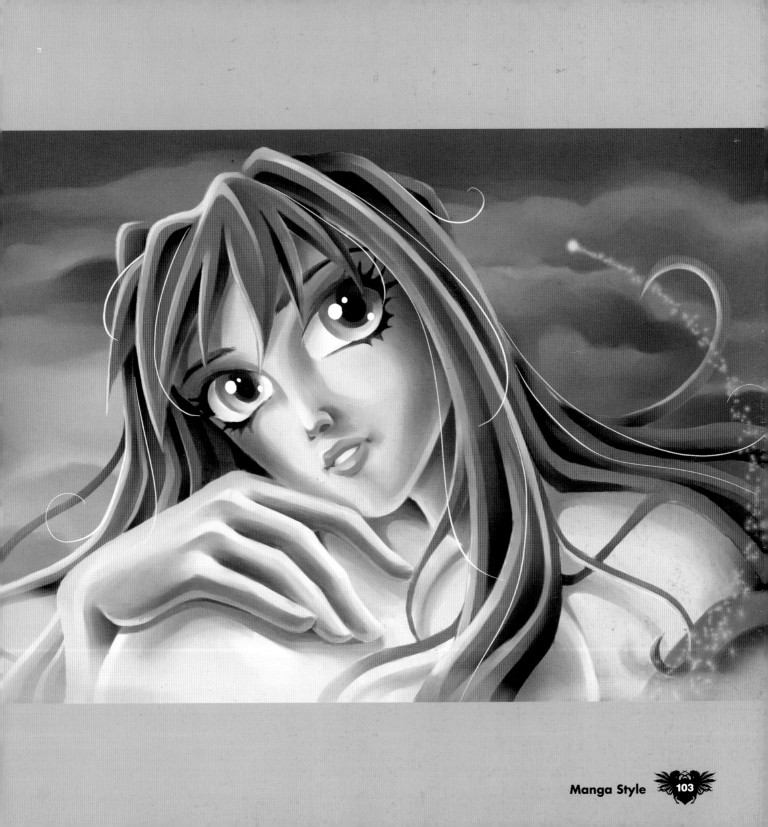

STOP THE WHITE WASH

With a painterly technique in mind, I pay close attention to the interplay of light and shade when sketching. I try to visualise the final image without any outlines, and block in appropriate areas of shade. I scan the sketch and set it to a Multiply layer.

A good trick when attempting a dramatic or experimental piece is to fill the background in with a different colour. Working off a white background will almost always force you into a rut of using predictable shades. I test a few skin tones against the pale blue, and settle for complementary lilacs and dusty pinks. I don't think I would ever have picked these tones if I had been working off white.

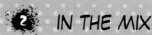

IN THE MIX

Using the sketch as a guide, I begin blocking out areas of colour in my picture with the Smeary Round Oil brush. As usual, I keep distinct areas on different layers for easy editing. For this technique, it's very important to make use of the Mixer. This is a palette where you paint tiny swatches of all the colours you've used in case you want them again. (pick a colour up with the Eyedropper Tool). The Mixer is also useful in controlling the overall colour scheme of your image: you can see at a glance how many shades are going on, and whether or not they complement each other.

PRO SECRETS

CREATING DYNAMISM AND DEPTH
Many tricks can be used to give very tranquil compositions a touch of movement, such as having flying strands of hair around an otherwise still character. Dynamism is closely linked with depth: if you can show something moving through (or rather, suspended in) three-dimensional space, it instantly generates a feeling of tension in your image. The drop shadows underneath the hair strands, the mist in the foreground and the sparkle flying into the background all contribute towards this effect.

3 REDUCE OPACITY

My basic colouring style here is to block in shades with the Oil brush then smooth it with the Blender Tool. The key objective is to wean myself off the reference sketch, so I constantly reduce Opacity as the shading builds up. Eventually, I turn off the sketch altogether and continue to work only with the colours on my painting layer. The Blender Tool is amazing for subtle gradation, but should be used with care: it can muddy up your shades if applied too liberally.

4 SHARP CONTRASTS

As more details begin to emerge, I face the challenge of creating crisp edges without using outlines. The best way to simulate depth is to have a sharp contrast of dark (object behind) and light (object in front). You could even go a step further and really "lift" up an object by edging it with a colour that contrasts in hue and tone (such as the yellow hair highlight shown here). Try to build up all areas of the painting at an equal pace, with an equal level of complexity. This ensures that your final piece will be coherent, and that all the colours and shapes work well with each other.

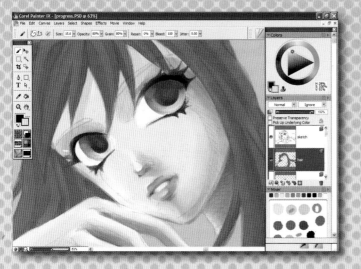

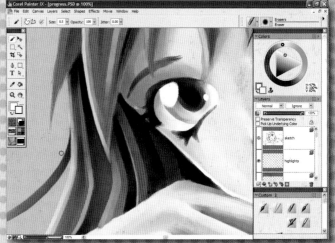

SHORTCUTS

CHANGE SIZES

Ctrl+[or]

Cmd+[OR]

Changing paintbrush, blender or eraser sizes is useful for rendering tapered shapes and crevices.

HEAD DETAILS

I make a new Multiply layer and use the Digital Airbrush to paint on cheek blush. The Multiply setting means that any shading I've done below will show through and the tint appears realistic. For the hair, I use the Opaque Smooth Gouache brush to flick out pale, wispy strands. This has the effect of creating more depth in the picture. I decide to refrain from using solid black: it would create much deeper shadows than I want for the colour scheme of this image.

STRANDS OF HAIR

The Blender Tool is useful for defining strands of hair: set at the right width, it creates a sharp edge with the adjacent colour. For the flyaway strands I colour over them thickly, turn on the sketch, and use the eraser to remove any excess.

Finally, I paint in a dark cloudy sky to give the scene a little more drama and add a sparkle trail with the Fairy Dust F-X brush. Symbol brushes should be used sparingly, though: they can quickly overwhelm a picture.

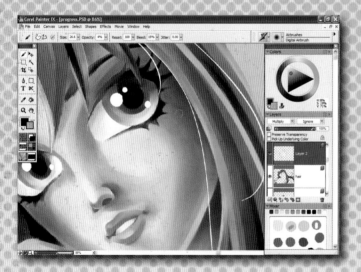

ARTIST Q&A

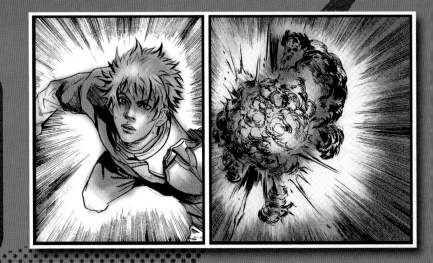

Q When I try to draw manga, I find it hard to flow the story from panel to panel. How can I improve?

A | MICHAEL CHANG TING YU REPLIES

When you're trying to show a story, sometimes it's hard to choose what to draw. In fact, drawing manga is similar to shooting a movie or making an animation: you have to choose the right thing to draw in order to show the continuance of the story. In manga, it's even harder because you need to pick only a few frames out of the whole scene to convey the story. But the way to connect them is pretty similar. For example, if you have a person who's looking at something in the panel, try to think about what the reader would expect to see in the next panel. I'd assume that the readers are curious about what the person is looking at. So in the next panel, I draw the object or view of what they are looking at, but not the person with the object or the view. Then, in the next panel, maybe you want to show something specific, such as the size or distance of the object. In story writing, I often follow the writing structure 'start, support, transition, closing'. This is the way of keeping the flow of the story going

smoothly. I use this writing structure as reference to draw manga. For example, you might start with a person who is looking at something. In the next panel, you show the reader what that person is looking at. Then maybe in the next panel you can show more supporting detail, such as the size of the object. Then for closing, you show the reaction of the person after they saw the object. It's not a real 'closing' if it's in the middle of the story: it's just a stopping point for readers to go on or simply just a transition. Now you've built up the atmosphere that attracts the readers to go on to the next page. Sometimes you want to show impact in the story. Then you choose to have a big panel. But what should you do before that? I usually make the panel before the big one smaller, and draw something minor in it. For example, say I want to show a huge group of bees in a big panel. The panel before this would be just some small dots coming from far away. When readers get to the big panel, the huge group of bees will really stand out.

ABOVE: With manga, you have to tell an entire story in just a few frames, so it's important to think carefully about all of your panels.

ARTIST **PROFILE**
AILEEN STRAUCH

COUNTRY: UK
WEB: www.kiwichameleon.com

Aileen is a freelance illustrator and comic artist who focuses mainly on manga art. She ventures into digital art, but plans to stay true to her roots as well.

MARKER PENS

MISTRESS OF THE ELEMENTS

Aileen Strauch shows how you can work with marker pens to create an action-packed manga image in iridescent and vivid colours

You can create slick and clean looking illustrations of all sorts when you know your way around marker pens. It might take some time to get used to a few of their habits, but the results can look quite impressive for a tool branded as traditional media.

This tutorial will solely focus on colouring a manga-style image with marker pens. I will show how they can be used while going through each stage of the image, from first sketch to the last stroke of colour. One thing I cannot stress enough is the fact that there is no Undo button for any mistakes: once the colour is on the paper, it stays where it is with little or no chance of correction. This might sound a bit harsh, yet with some planning you can prevent most major disasters, like bad colour combinations, from happening.

Most of the time I get inspiration for my artwork from unexpected sources, but browsing for something specific can yield its surprises too. When I am fixed on a specific idea, I usually start to sketch a variety of poses and related things until I am looking at the right version. It also helps to think of a background story or what kind of personality a character has. I often like to include little things which define a character's traits, and it makes the time working on an image much more exciting. It can even spawn its own little comic idea.

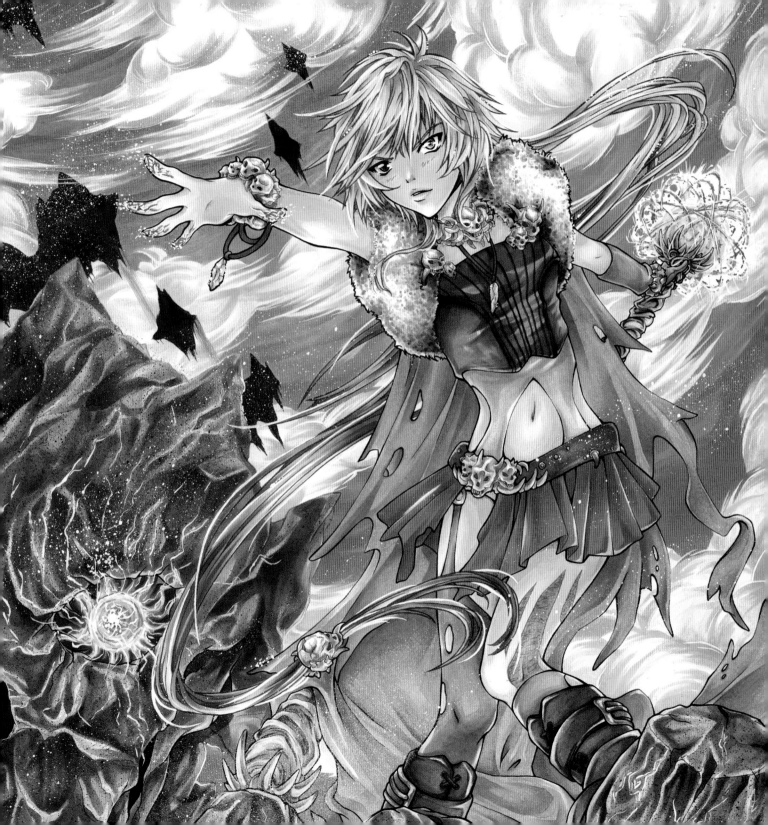

 SHADOW AND LIGHT

Before I start to draw the outlines on to marker paper, I make a quick copy of the rough sketch to get an idea about the light sources in the image. I tend to use garish colours for this step, but it helps as a quick reference later on when adding shadows and coloured reflections. Any planning done now will save you lots of time and redraws later. There's no Undo button here – how exciting!

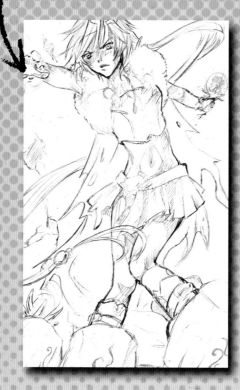

 COLOUR SKETCH

A second and equally useful preparation is a colour sketch that contains the main colours for the picture. Picking colours for minor details is not important at this point, but it gives a good idea of whether the main colours work together. Sometimes I have a certain colour scheme in my head, but it doesn't work as well on paper. I try different combinations until I am satisfied.

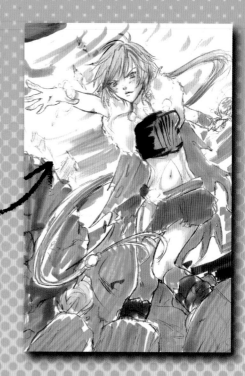

 LINES

For the outlines, I use a mechanical pencil not thicker than 0.5 mm, and 0.35mm for smaller details. It's easy to draw clean and smooth lines with them. I then trace them with different coloured fine-liners that are marker proof. This is crucial: some types of fine-liners can bleed when they come in contact with markers and will result in weird smudges.

As a precaution I only trace a line once with the fine-liner, leaving out any dynamics of the outlines, because of a marker's ability to pick up dark colours.

After finishing the coloured outlines, I carefully remove the pencil lines with a smooth eraser. It won't be possible any more once the colour is on it.

 LIGHT RELECTIONS

The first step of the colouring process is the blue light reflections that are cast by her magic. It also adds a nice touch of contrast to the overall sunset colour scheme. In general, the colours of marker pens are transparent and mix when another colour is added on top, which is why I add the blue with the fine nib first.

SKIN

Since it's advisable to work from light to dark, and because the skin is the brightest colour visible in the image, I apply it to the paper next. Here the brush nib comes in really handy, and enables me to create slight gradients from the skin colour to the white of the paper.

 DARKEN THE SKIN

It's easy to build up the colour with markers on a few layers. With two shades slightly darker than the base skin colour, I add depth and some defined shadows, taking into account the reference I created earlier. With the brush nib, I add the darker colour which blends into the base of the skin colour.

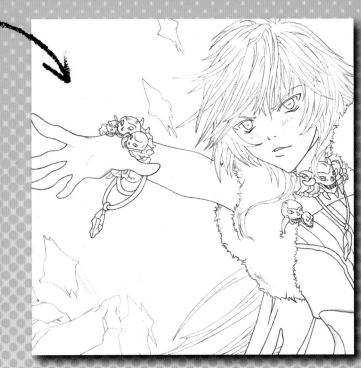

SHADOWS AND CONTRAST

Finally, I put an even darker skin tone on top, which gives the defined shadows more shape. I like to apply a contrasting colour: one of my favourites is a greyish lilac. I add it to some of the darkest parts of existing shadows. Skin tones in general work well with cold colours as shadows.

PRO SECRETS

CONTRASTS AND COMBINATIONS

Contrasts make an image much more interesting. Some colour choices might seem strange at first, yet they can add a particular edge. I find greyish lilac or greyish violet very useful. It provides a subtle cold contrast to the warm skin colour and it leaves a hint of colour, rather than a simple grey spot. Light blue shades are a good alternative, but they can easily turn into greens when you put them on to skin colour.

HAIR: THE FIRST STEP

I have a tendency towards multi-coloured hair, and I decide to give her partially blonde and violet hair. When using the brush nib, I can easily create highlights that look organic and not cut off. To make the transition from the blonde to the violet part more smooth and natural, I shape strands of violet hair that dissolve into the yellowish colour.

STRANDS OF HAIR

With the second coat, more of the strands are defined more clearly. Similar to in the previous steps, I opt to use a darker shade for each coloured part.

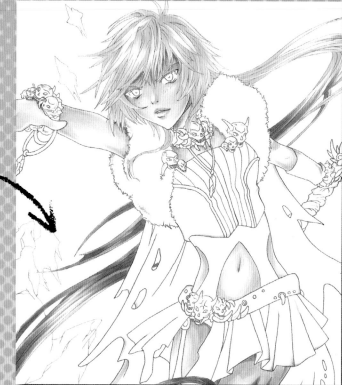

FINAL HAIR STEPS

The hair finally gets its darkest strands and a few shadows applied. I draw the dark strands with the brush nib. I add my favourite greyish lilac occasionally to the blonde parts to give it more contrast. I also apply a scarce bit of a dark greyish lilac on both hair colours, simulating more depth.

11 PATTERNS

Patterns without outlines can look as interesting as those with, but because there are already a lot of details on her corset and the image, I decide not to use any bordering lines for the small pattern. I recommend drawing the pattern on a separate sheet, even though it is fairly simple. Because marker paper is very thin, I put it underneath the image so that the pattern shows through. I use the colours according to the shapes but I am careful that the colours do not overlap.

12 MORE COLOURS

Now I add the flat colours of her clothes. It is the first time I discard the brush nib and use the thin nib instead. When I colour a large area like the cape, I have to work rather quickly in order to prevent an overlapping of the same colour or visible strokes. This happens when wet colour layers over an already dried part: it can spoil the effect of an evenly coloured area. Small circular strokes with the thin nib are very effective at preventing this.

13 FOLDS AND FUR

Defining folds on the clothes is an act of spontaneity, since I don't plan every single fold of the fabric in advance. It looks unnatural if they're all shown as part of the overall outlines. I put several layers on top of each other to model a decent amount of fold in her cape, indicating a thinner fabric. The skirt contains a second layer of the base colour and brown colours on top. I add more attraction to the white part of her undergarment with the light turquoise that I used on her skin in step 7. Lastly, the fur gets a different treatment. I enhance the look of the fur by using single dots. I place them according to the shadows in a variety of colours, some of which pick up elements of the cape's colour.

DETAILS

Now that most parts of the character have received colour treatment, I start to focus on the details. It takes up some time, but can enhance the picture's atmosphere immensely. The wand is supposed to be made of some kind of metal, so I apply bold lines with a dark greyish lilac after the soft gradients of shadows. Her boots get a treatment of a top coat using a neatly applied light blue, while I colour the skulls more roughly.

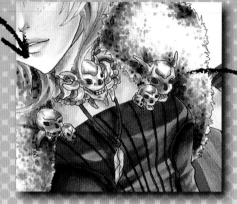

DOING MAGIC

Finally I can add the visible parts of the magic as blue sparks: the essence of the evoked spirit. I simply add blue in irregular lines and bubbles with the help of different blue shades. I start with the lightest tone, then apply more tone but less colour with each darker shade.

EYES

In contrast to the colour sketch, I change one of her two eye colours. I replace the green with red because I want a pop-up effect together with the blue eye. Even though the sclera is white, it needs some soft and defined shadows to work together with the shading of the rest of the face. Afterwards, I create the darker parts of the iris with the same colour as the base colour.

17 THE STONE BODY

With the base colour, I leave the space for the blue spirit particles intact. Following this step I add an orange colour to a few parts of the body in order to reflect the colour of the sky. Turquoise suits the faint reflection of the blue from the light particles. Afterwards I create different cracks and partial shadows with various cold grey tones to emphasise the rock-like feel. A bit of light yellow on the head of the giant functions as a visually more pleasing transition between the stone and sky. Once I finish these steps, I apply bold shadows with a dark cold grey on top of the other layers.

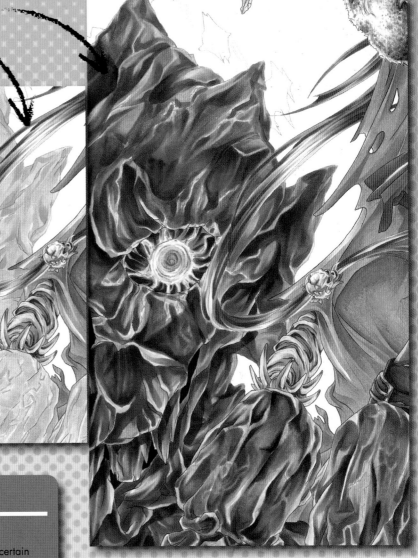

PRO SECRETS

ADJUSTING YOUR SCANNER

Many people complain about their scanners leaving out certain colours completely, or displaying a lot of them incorrectly. Make sure you adjust options like Brightness and Shadows before you use your scanning software. Have a look at the preview to get a rough idea of the hues. I always scan my images slightly darker: the scanner catches brighter colours this way. Afterwards I adjust the image colour by colour, having the original as a reference.

18 CLOUDS IN THE SKY

Before I started with the colouring process, I intended to use a stylised cloudy sunset, which I will add now. First I'm going to colour the sky, while I leave the clouds blank for the moment. Sketched clouds on a separate piece of paper underneath the picture provide a good guide for where to place the colour for the sky. Dark colours are trickier to blend because more shades are needed, but the colours themselves can be used as blenders. This is exactly what I am doing with the gradient from orange to violet.

While the orange is still wet, I carefully apply the lilac to blend the colour with strokes in only one direction – no wild or irregular movements. Marker colour tends to dry very quickly, so I work on one part at a time. After I finish the different tones of the sky, I turn my attention to the clouds. I wet the area with a blender and create a smooth flow from beige to the paper's white. A blender is a marker without any colour: it makes blending techniques like the wet-in-wet method a lot easier. I don't let the beige dry, and I apply some yellows and faint violets onto the clouds to add more movement and character.

Last but not least, I add colour to the flying rock islands with slight shadows.

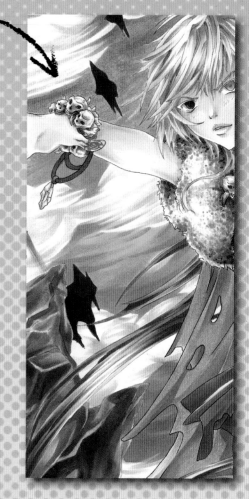

19 BLACK AND WHITE

The only things left are the finishing additions of dynamic outlines, white highlights and colour splatters. I use the fine liners to give the outlines varied thicknesses; a white gel pen helps with highlights. Additionally, I create white and black spatters with a small metallic screen and a Bristol brush.

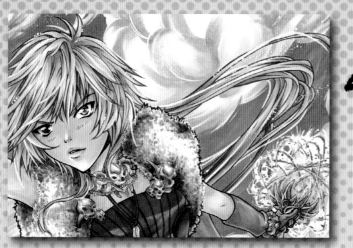

20 FINISHING TOUCH

A scanned picture without adjusted colours can quickly look flat and lacking in colour. Always take time to properly scan the image and set the colours right by readjusting the scanner's preset settings as a first step. Colours can then be individually changed in software such as Photoshop.

ARTIST Q A

Q How do you use black and white effectively and make it look finished?

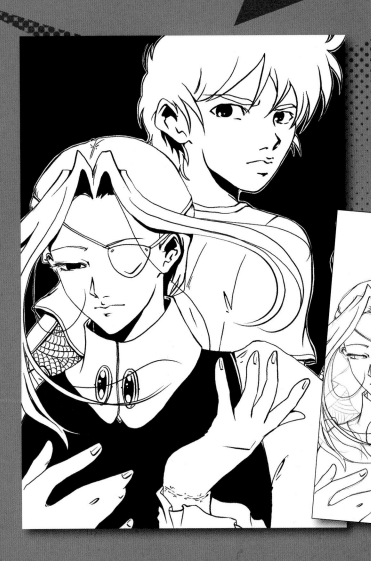

A EMMA VIECELI REPLIES

The inking stage holds huge importance in black and white manga images. The finish of your inks will dictate the finish of the image, so do take time over width variation and making ends nice and sharp. Even if lines aren't going to be obviously visible by the end of the image, they'll act as a framework for your fills. Because of that, it's good to start any manga image by completing the line art fully. Start with the largest area of solid black, which will guide you through the rest of the image. This step is especially important if black is to be your surrounding base colour. Sometimes, an effective tip is to leave a white 'halo' between your lines and the solid fill. The trick, then, is simply to fill in further areas of the image with two things in mind. First is balance: try to avoid all of your blacks being bunched up in one place and vice versa. Make sure that black and white are nicely balanced. Second is proximity: should you need to put two areas of black next to each other, add a white divider. (Ideally, however, no two black fills should sit directly next to each other in the image.)

FAR LEFT: When you only have two tones to play with, it can be hard to plan exactly what will work, so have fun experimenting.

LEFT: It's good practice to start with fully finished line art.

ARTIST **PROFILE**
SINAD JARUARTJANAPAT

COUNTRY: Thailand
WEB: www.sinad.cgsociety.org

Sinad is a 30-year-old illustrator from Bangkok who paints both male and female manga art in Photoshop.

PHOTOSHOP
FLIGHT OF THE WARRIORS

Sinad Jaruartjanapat explains the techniques used to develop Japanese style characters, from line art right through to colouring and shading

Most people are aware of the differences between typical manga illustrations and western art styles. You probably know what makes each style look good, too – but have you ever wondered why manga artwork often appears simple, but still manages to convey lots of detail? To understand this style, we need to get right back to basics.

We'll start by looking at layout and composition, and how they're connected to the story you want to tell. As you'll see, line art isn't just used as a guide for painting in manga illustrations – it's an essential part of the finished image.

Use of colour is also important. It may look simple, but as you'll see, appearances can be deceiving – it's not just about what you can see with your eyes! In this tutorial you'll also learn the importance of colour theory, and find out about different ways of using colour that are exclusive to the Japanese manga style.

This is how I go about drawing and painting manga artwork, from the initial sketch to the line art, to the colouring. I'll give you an insight into the techniques I think are most important for creating Japanese-style illustrations.

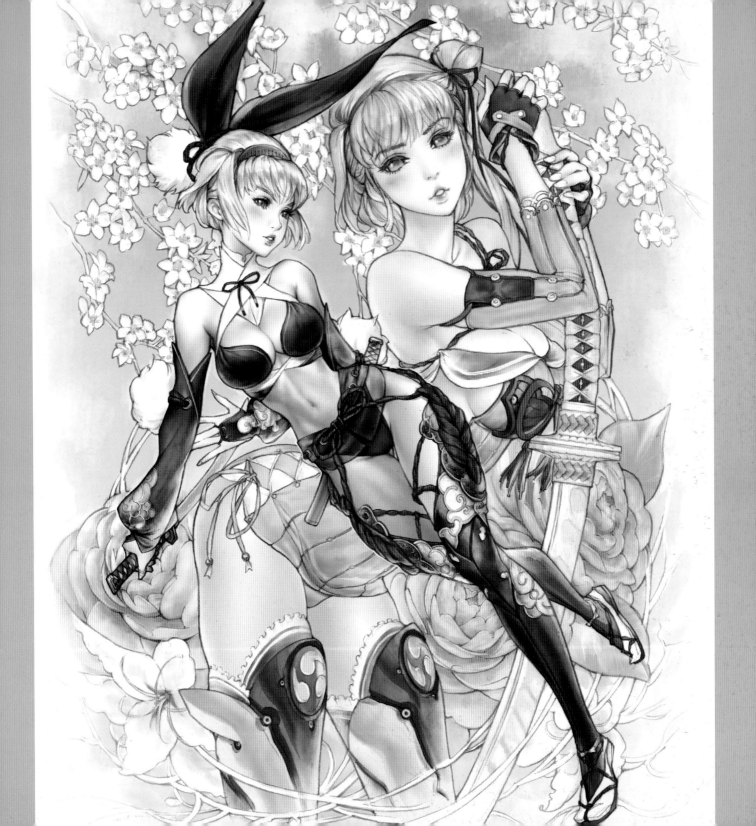

1 CREATE A COMPOSITION

I need to get a basic idea of what I'm going to draw and what it'll look like. Once I've got that idea, I make a quick sketch to help me decide on a composition. I usually do several sketches and choose the one I think looks most interesting and attractive, and that will suit the image I have in mind. I usually leave the sketches for a while before deciding, which helps me see which parts of the composition I need to improve.

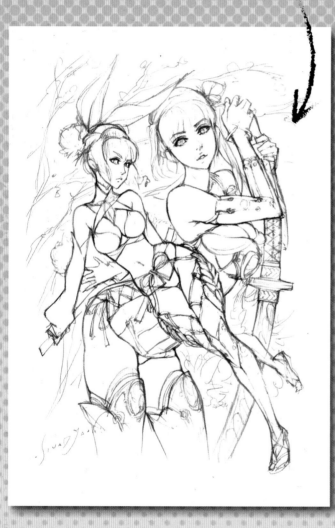

2 DRAW THE OUTLINE

The outline is the most important part of any manga illustration. You can use an almost infinite number of tools to make your line art come to life and express emotion, but whichever tool you choose, you need experience of using it. Pencils, G-pens (a specially shaped nib held in a wooden shaft) and Chinese brushes are some of the most popular choices. I feel most comfortable with pencil because you can erase any mistakes.

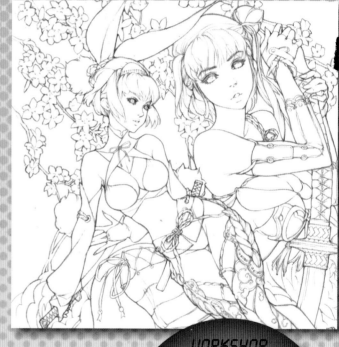

WORKSHOP BRUSHES
PHOTOSHOP

Custom brush: All In One Brush
I find that this brush, modified from Photoshop's default set, works well when I'm painting my Japanese style illustrations.

3 PREPARE TO ADD COLOUR

Before I start colouring, I usually make a selection for each character (Select>Save Selection) and save it so I can make adjustments later on. These selections make it easier to work on an image, and are particularly helpful for painting manga illustrations, because this style needs clearly defined areas of colour. While selections are useful, don't use too many or it won't look natural. For this image, I've only created selections for the two main characters' outlines and skin. I colour the other areas by hand.

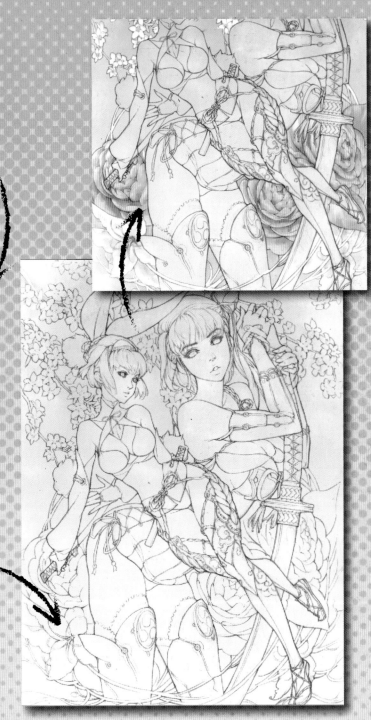

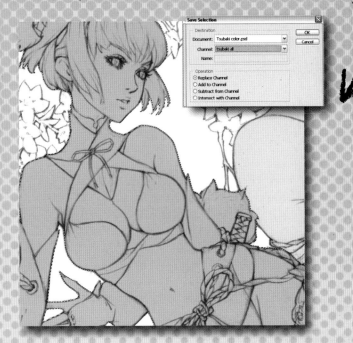

4 USE DIFFERENT HUES TO CREATE SHADE

I use colour to control the overall feeling of an image. I like to blend colours with either the nearest or the opposite hue on the colour wheel to create a feeling of depth. I think this is a better technique than using bright and dark tones of the same colour to create shadows. This colour-blending technique is very popular in Japanese illustration.

 ## CHOOSE YOUR CHARACTER COLOURS

I've added colour fills to my characters to make them jump out of the background as if they were part of a collage. Colour fills help create harmony in the image and provide depth for characters and objects. I erase some colour from the character so the colour fill appears. The amount I need to erase depends on how much I want the character to blend with the background. I might use this technique to blend a character into the background or to make another stand out.

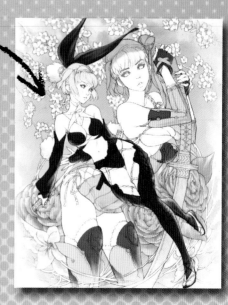

6 HAIR IS LIFE

When I'm colouring hair, I always try to create an impression of volume. I don't draw individual strands – I just try to give the impression that the hair is waving in a certain direction. This is a key part of the manga style. Have a look at any Japanese manga comic or cartoon for examples of this.

PRO SECRETS

LET NATURE BE YOUR GUIDE
Using references from real life or photographs is essential, even if you enjoy drawing like your favourite artists by learning their technique. These will form the base of your illustration and help you solve any problems you encounter with logic. Even if you change your style, what you've learned will stop you getting lost.

7 GET RID OF THE UNNECESSARY DETAIL

Trying to paint realistic detail in this style is forbidden – seriously! The main parts of this character's face are her eyes and cute mouth, so I only paint the area between the eyes and eyebrows, and the T-zone. This is enough to draw attention to the eyes and mouth and show that this is a person's face. Don't add more detail than you need to, because doing so will spoil the image.

8 PAINTING SKIN

While I'm painting the character's skin, I make sure I check some reference pictures. There are two parts to this step, the first of which involves creating a sense of volume. Once I'm satisfied with the shape and lighting, it's time to move on to the second part…

SHORTCUTS
EDIT SATURATION
Cmd+U (Mac)
Ctrl+U (PC)
Use this to adjust colours if you need a different hue in a selection, but want to keep the brightest and darkest areas.

ADJUST THE SHADING

At this point, I look at the image as a whole and decide if I need to adjust any shading. I often add a little more colour to areas that need it to create a sense of depth. Another technique I like is adding a little of the background colour to parts of the skin that are in shadow. This should come from the opposite direction to the main light source. I apply these techniques on separate layers so I can adjust them later.

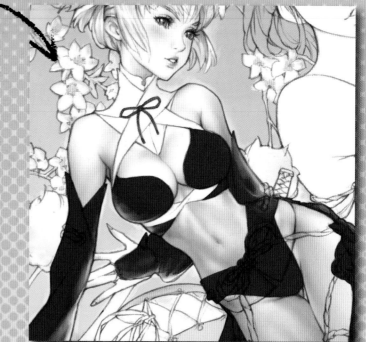

10 LET THE LINE ART SHINE

I focus on refining the shadows and making sure they're large enough to create an impression of volume. I don't worry too much about the smaller details, such as the girls' accessories – the line art will give these depth. In my opinion, too much shading in a tiny space can make the image look heavy.

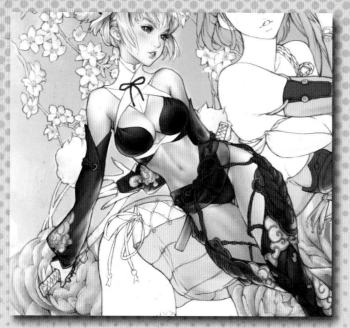

PRO SECRETS

KEEP IT SIMPLE
Adding too many details and light sources to images can suffocate them. How do you know when to stop? Ask yourself what you're trying to say in your work. What do you want the viewer to see first? This will tell you what to focus on. Once you've found your focal point, you can add the details to strengthen it. Eventually, you'll know when to stop.

NO COMPETITION

Now it's time to paint the second girl. I use slightly brighter colours to make her blend into the background, because I don't want her to compete with the foreground character. Anyone looking at the picture should see the front girl first.

CREATE DEPTH

Now I've got all the detail I need, it's time to create depth by erasing some colour from the main character. This is the same technique I used to add a little background colour to the shaded areas.

SHORTCUTS
ADJUST CURVES
Cmd+M (Mac)
Ctrl+M (PC)
Change the selected colour's tone – make it less red but more blue, for example.

FINAL ADJUSTMENTS

It's hard to decide what I need to adjust in the final step to make the image look exactly the way I want. I've been working on the painting for a while, which can make me too familiar with it, so I try to get it out of my sight. When I return to it later, I can see what needs adjusting. This is the same technique I used with the initial sketch.

ARTIST Q&A

Q | Is there a foolproof technique to creating a cute chibi character?

A | JOANNA KHOU REPLIES

When drawing chibis, I always make sure the body stays between one and three head heights tall. Guidelines are indispensable, since it's easy to subconsciously drift away from such compressed proportions. I feel that the purpose of the chibi style is to create an emotional connection with the viewer, so I tend to put most effort into attaining the right facial expression and body language. unemotive details such as wrists, ankles and feet often get streamlined in the process. If something doesn't look as cute as it could be, I'll try moving the eyes further apart or the mouth higher up, shortening the eyebrows or erasing the nose. I also love incorporating cute design details such as ruffles, bows, hearts or flowers. This gets extended into a pastel rainbow colour scheme with lots of shiny bits!

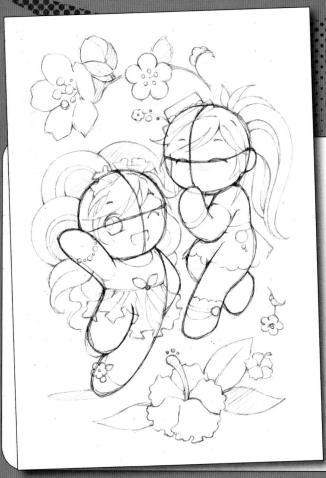

1 I start with a rough sketch of the head and body proportions, shown here in red. The head is a virtually perfect sphere: I simply dip the outline at the front inwards slightly to create a facial profile. I only begin adding details once I'm completely happy with the body language and dynamics of the image.

2 I like to vary the line widths quite a lot when inking because this makes line art visually stimulating, which in turn reflects the emotional state of a chibi picture. It helps make them cuter to look at. When drawing more than one character, I also avoid giving any two the same facial expression, for variety.

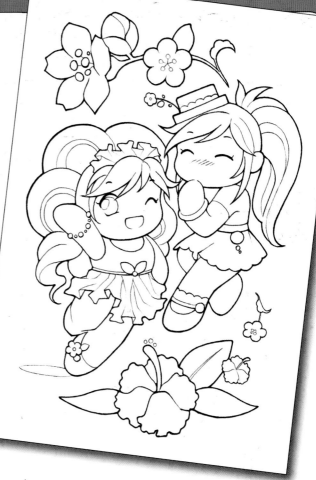

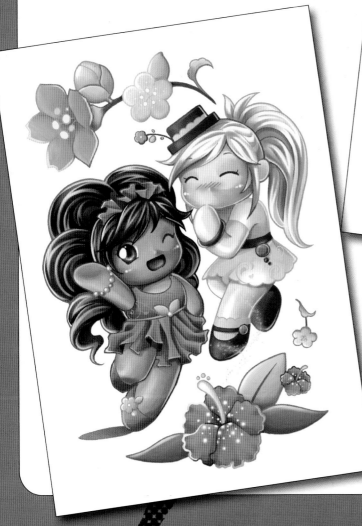

3 Chibi illustrations are fun and bubbly, so I love using a bright palette. Pastel shades, rosy cheeks, shine and sparkle also enhance the cuteness of the image. Black outlines often appear slightly harsh in this context, so I've coloured them in to create a sense of 3D. For a twist, you can put cute chibis in a scary setting.

ARTIST **PROFILE**
MADELEINE ROSCA

COUNTRY: Australia
WEB: www.clockwork7.mangafolio.com

Madeleine is a freelance illustrator, and has created three volumes of the popular manga series Hollow Fields. She's currently working on a new series.

PHOTOSHOP
THE MUSIC OF LIFE AND DEATH

A bright and eye-catching manga illustration isn't so difficult to create once you know the techniques. Madeleine Rosca is your guide

Having worked in manga illustration for several years now, I've learned a thing or two about colouring my images in Photoshop. I love coming up with cool character designs, but sometimes the plain white background behind them just doesn't cut it, so I've gradually started incorporating decorative designs into my backgrounds. I've always loved bright colours and rich, intertwined art nouveau-style borders so, to help my artwork

stand out, I've created a style that combines my interest in both. It's bright, snappy and draws the viewer's eye towards the work, using a couple of Photoshop's more basic tools to achieve some gorgeous tonal and compositional effects. And I'm going to show you exactly how to do it in the following workshop. For this demonstration, I'll be using Photoshop CS3, as well as my trusty little Wacom Intuos 3 tablet.

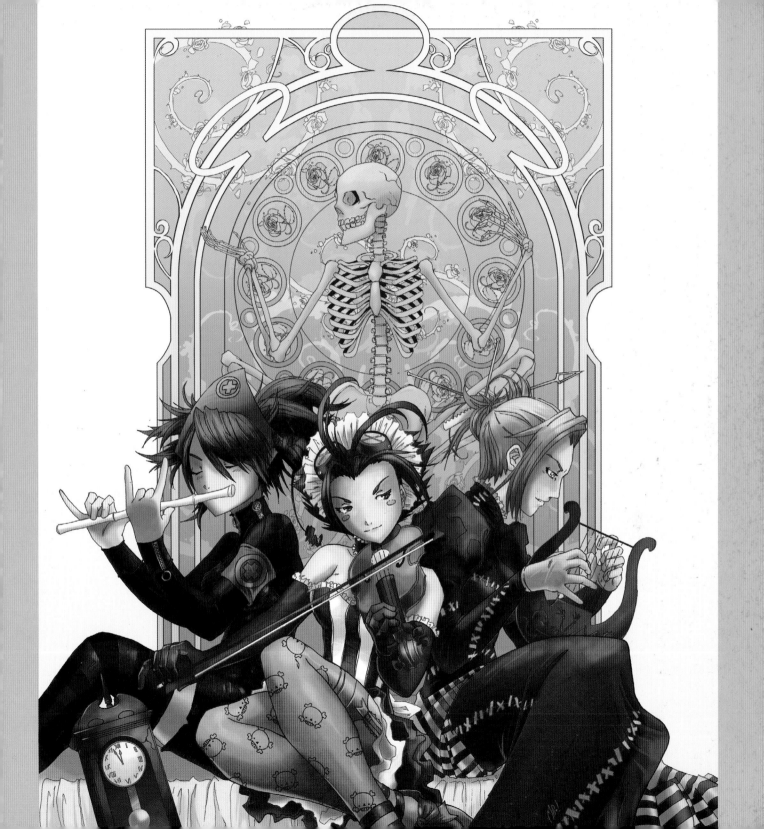

1 SKETCHING THE THUMBNAIL

I start by drawing a thumbnail sketch of the image, which helps me decide on the characters' poses and the position of the contents in the background. I'll keep referring to this throughout the process.

2 INKING THE MUSICIANS

Following my thumbnail sketch carefully, I produce an ink drawing of the foreground characters, which I then scan in. I like to make sure my drawings are relatively large, so that there's a good amount of detail in the finished product when I print them and they're considerably smaller. I scan in the drawing at 600dpi, then reduce that to 300dpi to work with. Even for a cover image, 300dpi looks just fine and prints well, but I wouldn't recommend going any lower. It's always better to have more resolution than you need, rather than less.

3 STRENGTHENING THE LINE ART

With the line art on screen, I start to prepare it for colour. In order to get the lines looking clean and strong, I choose Image>Adjustments> Levels. The White and Black Sliders at either end of the Levels graph are the most important: I slide them close together, somewhere around the 200-210 mark. This not only makes my drawing sharper and bolder, but cuts out any grey pixels that were created during the scanning process. Getting the line art reduced down to just black and white values is crucial for the next step – the all-important alpha channel.

 # CREATING AN ALPHA CHANNEL FOR LINE ART

Using an alpha channel in Photoshop enables me to select the line art by itself with no background around it. This means I'll be able to add colour to the lines themselves, instead of having to retain black lines, which gives my picture a sense of depth and softness. I prefer this method to many of the other common ways of colouring line art. Creating an alpha channel for the line art is simple. I choose Select>All to select the whole picture, then press Ctrl/Cmd+C to copy it. The Channels palette should be found in the same window as the Layers palette: I open it and select New Channel from the drop-down menu. Now I have a new channel called 'Alpha 1'. With that channel selected, I press Ctrl/Cmd+V to paste. I select my Layers menu once again and create a new layer, giving it the title 'Line Art'. Clicking Select>Load Selection in the menu bar, I use the drop-down Channel menu to select 'Alpha 1' and tick the Invert box. My layer now has a selection of all the line art, with no background selected. All I need to do here is to make sure my foreground colour is black, then go to Edit>Fill.

SHORTCUTS
GROUP LAYERS
Ctrl/Cmd+G
This groups your currently selected layer with the one directly beneath it in the Layers stack.

5 FLAT COLOURS

Now comes the most time-consuming part of the exercise – putting in the flats. The flat colours determine the overall colour scheme of my picture, plus they come in handy for making selections. Using a hard brush at 100 per cent Opacity, and changing the size depending on my needs, I get to work on this process.

6 ORGANISING LAYERS

I'm placing many of the different elements in this picture on to separate layers to further help me with selection. I usually organise them by character, so the names of the layers are 'character A's skin', 'character B's dress', and so on. With this many layers, it's important to organise them into groups so that I don't get lost in my Layers menu and spend five minutes hunting for one little blob of colour on a particular layer!

PRO SECRETS

USE LAYERS

Layers are your best friends in Photoshop. If you're looking to experiment with unusual highlights or shading for a picture, or thinking about drawing something new in the foreground, layers mean that if your experiment doesn't work out, you can just switch it off. When you're unsure of doing anything, do it on a separate layer! Saving a little bit of file size by using just a few layers isn't worth the agony of making a mistake you can't erase.

7 THE IMPORTANCE OF BACKGROUND COLOUR

Unless you intend to end up with a picture featuring a figure surrounded by a blank expanse of white, never colour against a white backdrop: this often makes it much harder to drop in a background later on. It's better to colour against a pale, fairly neutral hue – which I've put on the lowest layer here.

⑧ CREATING HIGHLIGHTS AND SHADOWS

With the flat colours neatly organised underneath my line art, I can now start the process of adding highlights and shadows to the image, which really begins to bring out the forms and shapes of the characters. This is a fairly simply process. For this I tend to use the Magic Wand to select the contents of a particular layer, then hide the Selection Marquee by unticking View>Show>Selection Edges. Choosing a suitable darker hue of the base colour, I begin adding shadows with a soft brush, usually at 30 per cent Opacity or less, blending the colours. I apply a similar technique when I add highlights, using a lighter hue.

⑨ THE LITTLE THINGS

For some particular effects, such as wrinkles in clothing or highlights in hair, I use the Smudge Tool. Using a small, soft brush at about 90 per cent Strength, I carefully drag out small details and smudge them into the shapes and effects I want. Reducing the Strength of the Smudge Tool enables you to create more subtle effects, but also makes it harder to control, so you might want to experiment and find a setting that gives you a decent trade-off between these two factors.

⑩ ADDING COLOUR TO THE LINE ART

With the colours all largely finished, it's now time to use the alpha channel I made earlier. With the line art layer highlighted, I choose Select>Load Selection. Clicking 'Alpha 1' in the drop-down menu and selecting Invert once more, I've now got that handy line art selection going. I hide the Selection Marquee and start colouring in the lines. Generally, I pick a darker version of the solid colour being surrounded by that particular area of line art. For example, I pick a dark mauve for the central figure's pinkish-red hair. Using a hard brush set at 100 per cent Opacity, I colour the line. This part of the work can be quite fiddly and tedious, and requires concentration. However, compare this effect (when done with some care) to other colouring methods you might have tried, and you can easily see how it softens the line art and gives the characters a special glow.

12 SHAPING THE BACKGROUND

When putting this kind of background together, the Shape Tools are your friend. This style of background can look quite tedious, but it's really just a matter of drawing it with the tools. Here, I add a semicircular arch behind the skeleton, plus a circle that's going to contain some more shapes. I put more of the borders in and shrink my original design's border to something narrower and neater.

11 STARTING ON THE BACKGROUND BORDER

Well, our manga girls are largely finished, so now we have some lovely, detailed-looking ladies sitting in front of a bland, flat blue expanse. It's time to put in the border. I start by creating another layer group specifically for the background. Then I draw in a rectangle using the Shape Tool – this is just to give me a rough guide to how the border is positioned. I also open up a file of another ink drawing I've scanned and converted to an alpha channel, leaving me with just the lines and no background. It's a picture I've scrawled of a skeleton and some flowers, which I think will look great as part of my backdrop. The skeleton adds a little bit of edginess and mystery, while the flowers are a common motif in art nouveau-style borders. I copy the skeleton over to the image and find a position for it.

DEFINING THE BACKGROUND

With most of the 'grunt work' out of the way, I can start assembling the lines with the Shape tools by drawing shapes and then using Edit>Stroke to define them. I use the Circular Selection tool to put some oval shapes into the background arch. Once I've positioned them in the way I want, I erase the unnecessary parts of the line work. I define the borders surrounding the background by adding some yellow colour beneath them – the yellow is a good contrast to the blue. (cthis to suit your background, of course).

FINISHING WITH FLOWERS

Keeping with the primary colour scheme, I import the drawings of the flowers. I make the circular rose pattern behind the skeleton a pastel pink, but leave the other, intertwining rose vines blue to avoid overpowering the composition. Keeping to a pastel colour range makes the foreground figures stand out nicely. Since the colouring of the background is so simple, rather than flattening all the background line art down and creating a new alpha channel, I use Image>Adjustments>Hue/Saturation to colour the line art layers.

FINAL TOUCHES

All that's needed now are the finishing touches: a gradient for the background to add depth and some highlights on the foreground characters. I create a new layer just under the foreground line art and use Selections to add a slight yellow haze to parts of the foreground picture – most notably in the characters' hair. This gives the picture a little more warmth and depth. Finally, I've noticed that the background is overpowering the foreground with its sheer length. If this was a manga cover image, which is where I've usually used this style of artwork in the past, a title logo would probably cut out part of this problem. For this image, however, I decide to reposition the background by dragging it down and moving the skeleton up slightly. It's easy when you lock layers together. Now the composition has a better balance, and I've got an image that looks brilliant and bright in print, which stands out to the viewer as a result.

PRO SECRETS

PRIMARY PALETTE

If you're just starting out at colouring manga art (or any comics-based line art) and you're feeling overpowered by all of the rich colour schemes that it can offer, stick to primary colours to start with, or restrict your palette to only a few colours. For beginners, it's more important to learn the basics of working in Photoshop and using the right tools, rather than flinging yourself into an incredibly difficult colour scheme, which will most likely overwhelm you!

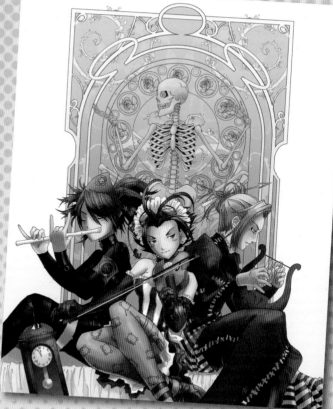

ARTIST Q&A

Q | How do I create a dynamic lighting environment in manga-style art?

A | SAEJIN OH REPLIES

There aren't a whole lot of differences between lighting in regular painting and manga-style painting. Manga can be either cartoonish or realistic when it comes to the style of painting. Sometimes it can be a little bit of both: you can skew reality to highlight and draw the audience's attention. Unless you want your audience to look at your characters' limbs or background (which you might), you should try to keep the characters' faces the brightest point, or the point with the most colour contrast when compared to the rest of the background. That way you can work the rest of the lighting around those points of interest. Make sure you don't accentuate the other background elements too much in comparison to your main elements.

TOP: Seems rather hectic without a clear point of interest...
BOTTOM: A point of interest is created with the inclusion of dynamic lighting.

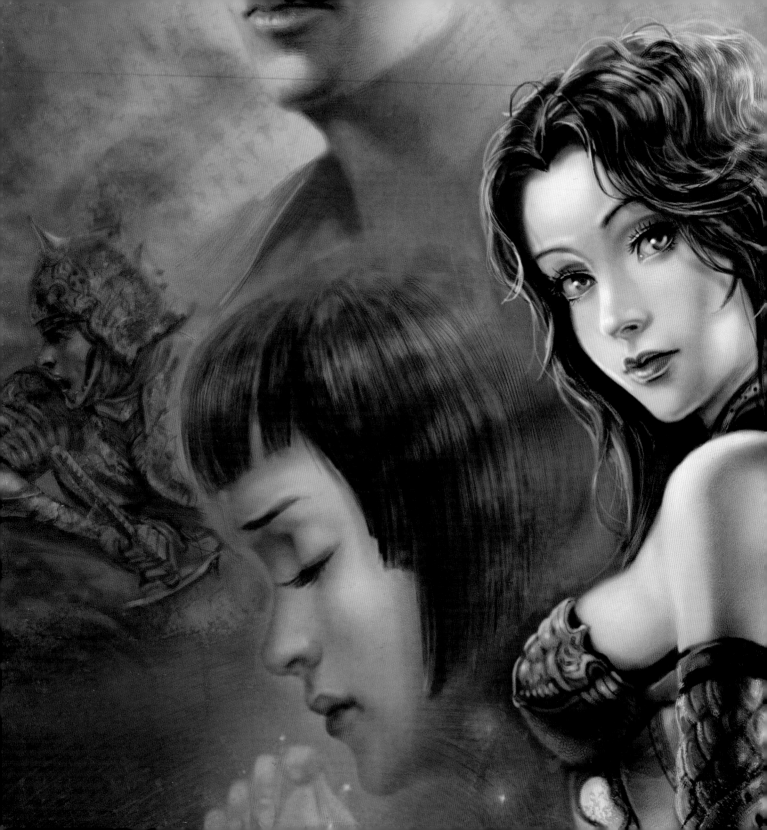

FANTASY AND SCI-FI

I've seen images where the line art seems to glow. I presume it's a digital effect, but how is it done?

A EMMA VIECELI REPLIES

Ah, I think I know exactly the effect you're referring to, and it's one I like a lot. Yes, it is a digital technique and, like most digital tricks of the trade, it's amazingly easy to do once you know how. I hope I don't kill the magic with this admission. The line art can be made to appear to glow through use of a blur filter. Duplicating lines and adding a blur to lower layers adds a touch of solidity to your piece, but to achieve the kind of glow that you're talking about, we'll be adding a far stronger blur. As with any effect, be wary of overuse – this isn't a technique that will work for all images. To answer this question I'll be using two pieces of software. Manga Studio to sketch and ink the lines, and then the image is exported to Photoshop for the colour

I know I've said it before, but Manga Studio really is the best tool I've found for inking As well as superb Smoothing and Rotate functions, it also offers a great system for getting just the right tool. For this example, I just want some nice, quick lines to apply the desired effect on to, and, as lines are going to be the entire focus of this piece, choose to use a brush pen on this occasion for some really dramatic line width variation.

2 Now in Photoshop, I duplicate my line art. I also chose to colour my lines. I'm not aiming to fully colour this piece and so coloured lines can be a nice touch. The lower layer of line art then gets a Gaussian Blur treatment – found in the Filters drop down menu. How radical a blur you choose depends on the image and personal taste. I want a dreamy mood to go with this sleepy character, so I'm pushing the slider up to around 40 – which is pretty high.

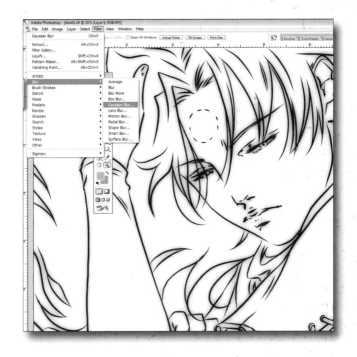

3 Adding a similarly coloured background and a few splashes of coloured brush work evens out my image a little, lessening the obviousness of the blurred layer, but leaving us with a real sense of something dreamy and hazy. The lines do indeed appear to glow. Of course you can play about with this technique to different degrees. Blur levels and Hue/Saturation will offer some fun variation. Your imagination's the limit, so have fun with it.

ARTIST **PROFILE**
CRIS DE LARA

COUNTRY: Canada
WEB: www.crisdelara.com

Cris has been an illustrator for over a decade, and specialises in portraits inspired by the classic pin-up style.

PAINTER & PHOTOSHOP

THE WAY OF THE WARRIOR

By making use of manga references, Cris de Lara shows you how to fuse Japanese comic drawing with fantasy themes

Beautiful female fantasy characters are both a pleasure to create and to look at. In this workshop I want to create a stunning, powerful pin-up warrior – a beauty who resembles Frazetta's or Vallejo's women, but with a twist. I'll be using a combination of comic and manga references to create a young, strong and beautiful girl in a magical environment. This tutorial could be broken down into two simple stages: first, creating the character concept, and second, rendering the background design, effects and colours that will accompany her.

Dealing with the character concept first, I consider the character's anatomy – the sensual, sexy shape – and her clothing. I want to emphasise things such as skin tones and muscles, concentrating on rendering, lighting and shadows. For the background, I'm thinking about something easy to draw, or that could be done with painting work. I'm going to have a magical and intense light source, such as a dimensional gateway, using effects, lights and shadows, and a good colour palette. This choice helps to give valour to my character without drawing these elements in the scenario.

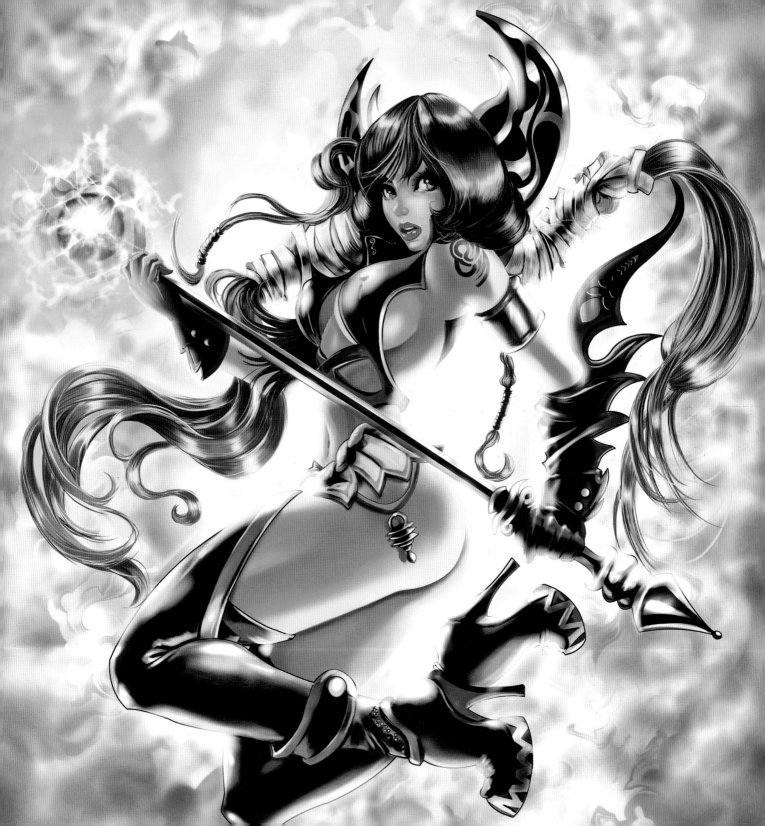

INITIAL CONCEPTS

My initial concern is to create something that shows a young, strong female character – a woman with strength and a slight sensuality, located within a magical environment. So I decide to create a kind of female warrior with an attractive physical structure, using manga and comic references. I like the sensuality we find in comics' female characters, as well as the energy from manga. I start drawing the warrior's sketches on letter paper, then use the light table to improve it.

INKING AND SCANNING

After defining her physical structure, the next step is to create my character's costume. I search the internet and look in books for female warrior images to provide me with some ideas for the clothes. In the end, I decide on something to highlight her shape and indicate to the readers that she belongs to a fantasy world. I digitalise the image at 300dpi to make it bigger (11x17in) and print it. I return to the light table to finish it and, later, digitalise it again. The bigger, inked image is the final result of my drawing process and will be the basis for my digital painting work.

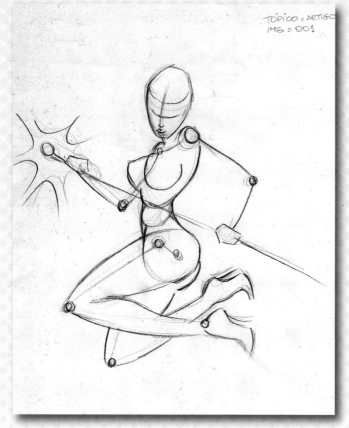

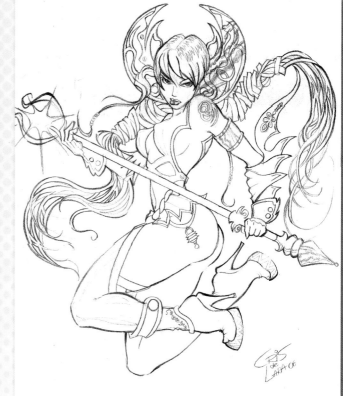

ADDING COLOUR

I work with Photoshop and Painter to colourise and paint. I think about how I want my final image to look – its colours, effects and elements. I choose the initial colours based on my reference, but I always change things while I'm working. I use flat colours and the Lasso Tool to select areas for my initial painting work and fill them via Edit>Fill (or Shift+F5) in a new layer above the layer with my drawing. This new layer is the base for all the painting work.

SHADOWS AND LIGHTING

After creating the entire image with flat colours, I need to think about shadows and lighting, in the same way I thought about the character anatomy in the drawing processes. The scenario and background will be a very important element in this image: I've decided to put a very powerful light source behind the warrior to increase the magical environment I envisaged.

I decide that the light should be white to get a better, brighter effect coming from deep in the background. Now I can start working on my warrior skin tone.

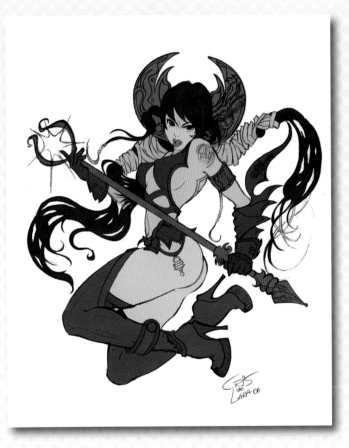

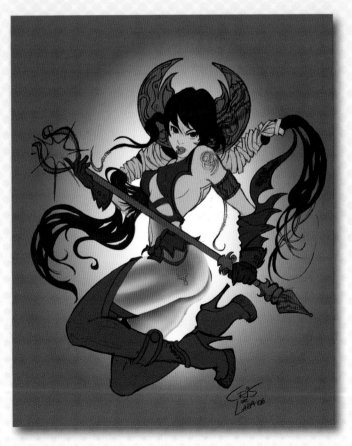

⑤ SKIN TONE

This is the start of my favourite part of colour work – creating the volumes, shades and lighting for the skin tone and muscles. I use the Lasso Tool to select all the areas of skin where I'll apply shades.

⑥ LIGHT MUSCLES

I set up the Brush Tool to get a softer brush for the areas with lighter skin tones. I choose the lighter tone and paint the lighter areas of the muscles, using my softer brush, taking care to follow the direction of the strong light that comes from behind the character.

⑦ SHADOWS

I follow the same procedure to make the shadows on the muscles. Using a soft but wider brush with a darker tone, I stress the areas on the skin where I want to improve muscle volumes. I do this for all image areas where the skin is exposed.

⑧ HEAD TWEAKS

While doing this, I realise that I'm not happy with the head's position, the way her hair falls and so on. I decide to change this before going on with the job.

In a new layer, I redraw her face and put her head in a new position. I finish this off with softer, simpler brushes, using volume, lighting and shadows, retouching the area I changed by making some tiny adjustments.

WARRIOR CLOTHES

I like the idea of my warrior being dressed in fitted leather clothes. I think they're very attractive and would improve her sensual shape. In another layer over the scanned sketch, I select an area for the clothes and fill it with a grey, flat colour. After that, I use a wide, soft brush and start work on the volume, with a lighter tone than I used before. As I used lighter grey tones to define the volume, I use the darker grey tones to stress the darker areas of the clothes.

I enjoy paying particular attention to how light falls on the clothes and where I can paint its shadows, playing with the soft brush and its opacity. To get a natural-looking kind of light and shadow, my brush was set to between 50 per cent and 80 per cent Opacity.

LEATHER TEXTURE

Next, I use a hard brush with a small diameter to add some small dots of light points into the clothes. I want to achieve a smoother, brighter texture for her leather clothes – something that's almost synthetic.

PRO SECRETS

BRUSH DISTORTION

BOUNDARIES

In my artwork, I sometimes do a thinner line around the main elements to highlight the boundaries. This is a matter of personal choice; I like this kind of 'inking' in artwork. I use another new layer over the current ones to make this line around my warrior's clothes. I use the Pen Tool set to Paths to make a closed selection, then right-click the path and select Stoke Path: I use a width of four pixels and Opacity of 80 per cent.

BACKGROUND

I use Photoshop to paint my background. I apply a flat base colour to the whole area. Then I randomly paint some dirty areas on it without worrying about the shapes, with a wide brush using lighter and then darker tones.

After getting a nice visual effect, I switch to Painter for the other effects. With the Brush Tool in Distortion mode (set Brush Variant to Hurricane), I paint several indistinct cloud shapes in the background.

 ## DIMENSIONAL GATEWAY

After filling the background, I bring the image into Photoshop again to lighten areas in the centre and darken the borders with the help of the Dodge and Burn Tools. For the centre I make a 'white fog', using a wide and soft brush to merge with the image. This is the dimensional gateway in a magical atmosphere in which I'll locate my warrior.

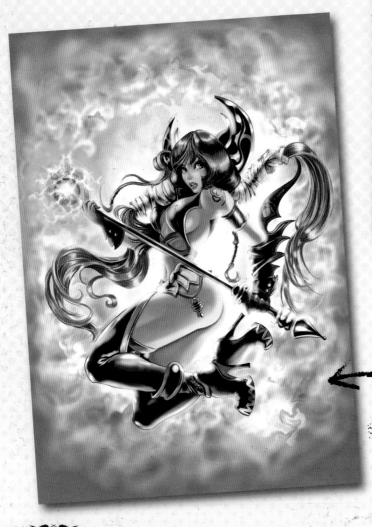

THE RESULT

To finish my work, I put the warrior image into the background image, making a few simple adjustments in both layers to merge them in one final, finished image.

ARTIST Q&A

Q How do I pick the best angle when drawing manga?

A MICHAEL CHANG TING YU REPLIES

The way to pick an angle in manga is similar to a film. It's important to pick the right angle to show what you want the readers to focus on. Different angles convey different atmospheres. For example, when you want to show someone talking seriously, angle in from the bottom of the person's face to convey authority (the same applies to inanimate objects). Choosing the right angle also helps show what direction a person is moving in – running straight towards you shows they are moving forward.

But personal style and the story are also factors to consider when choosing the angle. My final tip is to see if the angle of each panel looks good before you start adding any details.

LEFT: Angling your image under the chin gives a sense of authority.

ARTIST **PROFILE**
MICHAEL CHANG TING YU

COUNTRY: Hong Kong
WEB: www.movanova.com

Michael is the art director of Movanova, a studio that produces concept designs for videogames, animations and movies.

PAINTER & PHOTOSHOP

THE SAGA OF THE SCOUT

Michael Chang Ting Yu explains how you can evoke an entire fantasy story through a montage-style cover or poster

There are many ways to express stories. One of the most interesting ways for me is visually, through comics. Before I start to read the first page of the comic, I usually take time to study the cover and try to get a feel for the story. I think that a good cover helps to bring out the atmosphere of the story at first sight – this applies not only for comics, but book covers, videogame cases and movie posters as well. By using things such as environment, custom, expression, composition and contrast, we give the audience insight into the story being told.

In this workshop, I would like to introduce to you some important factors I have learned about making a cover or poster. Every story has a topic, and it's important to choose the right style to fit the topic. For this piece, I chose a style mixing western and eastern elements.

First, I start with the composition of the cover. The position of the characters shows their individual relationships and the importance of the characters in the story. However, a cover or poster usually needs to save some space for the title, usually located at the top of the image. This is an important point to keep in mind when you're considering the composition of the piece. After I have decided on the composition, I start adding background in order to build up the atmosphere of the story. Once that's done, I start to work out the details of each character, such as costume, expression and pose.

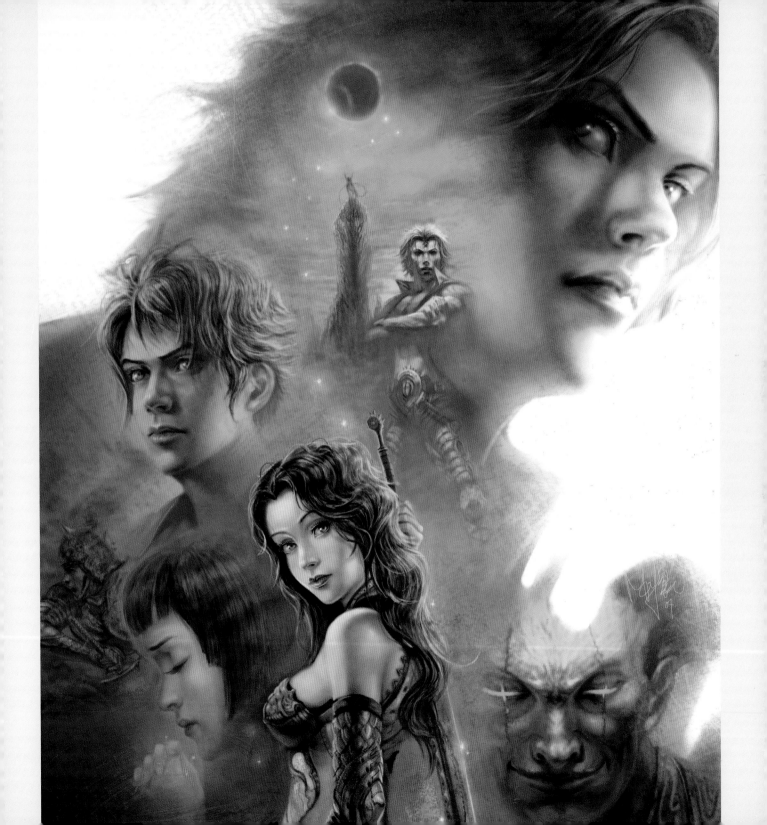

① SKETCH THE OUTLINE

After deciding on what you're going to paint, you should start with the outline. Different artists have different ways to paint; mine is to simply to do a rough sketch. By sketching only a main outline and showing a clear composition, I save time and won't limit any new ideas that come along while painting it. Of course, the more you do for the outline, the more it will help for colouring as well.

② BASE COLOUR

There are many characters with different styles and characteristics in this painting. I choose blue for the base colour: the story background will be a night battle, and blue will depict unity and the serious atmosphere. Using Painter, I create multiple new layers for painting the base colour, under which you can still see the clear outline of the base layer. I use the Airbrush to create a soft and comfortable feeling.

SHORTCUTS
SWITCHING TOOLS
B AND E
Switch between brush and eraser with two keys. Use this shortcut, as it saves a lot of time.

③ SHADOWS AND COLOUR

There are six characters in the painting, and I would like to paint each one of them individually. I'm using the Airbrush again to add skin colour to the man's face, as well as the shadows on his nose, eyes and lips. I'm doing this to make his face more solid. I leave a blue light for the other side of his face, which is the base colour I chose. That helps maintain the unity of the whole image. The skin colour also shows a great contrast with the blue. Please bear in mind that the skin colour shouldn't be in high saturation, as that will make the portrait jump out too strongly.

PAINTING THE GIRL

After the basic structure of the man comes out, it's time to start painting the girl. In the same way I painted the man, I add a light skin colour to the girl, which should be the cold colour base, a little pink and a little blue. The Airbrush is the best for painting the girl to show the smoothness of her face. Remember, a female's facial structure shouldn't be too hard, or have too many edges – it should be round and smooth.

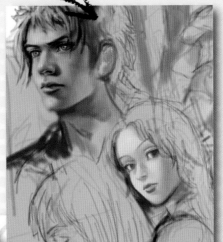

PRO SECRETS

AVOID TOO MANY LAYERS

DIFFERENTIATING BETWEEN CHARACTERS

After the structure of the girl in the middle comes out, it's time to start painting the sub-characters in the back, which are the girl on the left-hand side and the sinister-looking guy on the right-hand side. Obviously, the main character is the girl in the middle; she should appear much sharper than the sub-characters. To separate them, I add sharper colours to contrast the blue colour of the base. This will cause her to stand out from the image's other characters. I also keep much more blue for the sub-characters, so that the viewer can immediately tell who the main character is.

FACIAL EXPRESSIONS AND CHARACTERISTICS

Each character has his or her own characteristics and status in the story. I will start with the sub-character on the bottom right-hand corner. Before I start, I need to make sure I have a clear idea about his characteristics, and how I should express it with colour and facial expressions. I decide that he'll be a malicious villain and make the light come from the top of his head, creating deep shadows on his face. This gives the character a look of malevolence. Add that to his sinister smile and we get a very unpleasant-looking villain. As for the colour, I will use green and blue tones. This makes him look more demonic.

 ## GESTURES AND POSES

Gestures and poses are also very important elements to show the backgrounds and personalities of the characters. Since I only started out with a rough sketch, I can still make some changes to their gestures and poses before I add more details. At this point, in order to make them look more righteous, I change the angles of the main character's head and the man on the left-hand side. Also, I change the position of the main character's left arm to extenuate her body shape and to give her a more feminine, sexier feel.

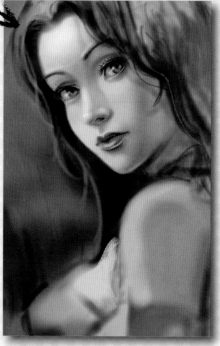

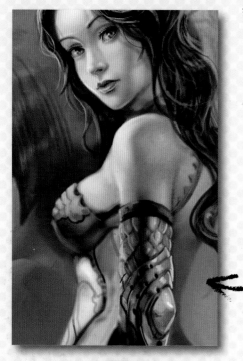

ADDING DETAILS

After everything is set, I start to add more details to the painting, such as costumes, hair, eyebrows and eyelashes. For the female faces, I click into the Brush Creator of the Airbrush and change the minimum size to 0 per cent, so the spray pressure will be very high, but the stroke will be soft. This helps to create a dissolve effect when I put shading on the girl's face. As for painting hair and eyes, I use Acrylics' Captured Bristle, which is stronger compared to the Airbrush. It's perfect for painting hair, since it shows a better stroke.

SHORTCUTS
ZOOM CTRL/CMD + & –
This is helpful to remember if you're frequently zooming in and out to check finer details and the overview.

COSTUME

Costumes are very important in showing the background of the characters, such as their class and profession. The main character's profession is that of a scout, but with stronger armour and a weapon. I want her to be able to move fast but to have some form of defence as well. I give her a normal-sized sword, which isn't too weak or too strong.

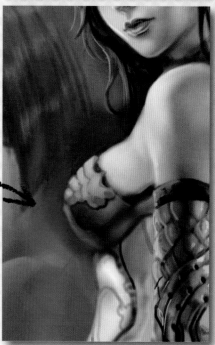

10 EVIL GREEN EYES

The green eyes of the villain at the bottom right convey not just the air of mystery, but also give him a more sinister feel. The green is also a very suitable colour for matching the background. The overall colour of this character conveys a cold mood, and the pair of shiny green eyes really stands out in the shadow.

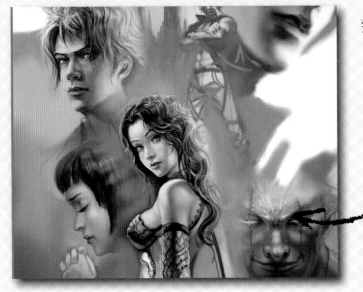

11 DEFINITION AND COLOUR ADJUSTMENT

It's almost 70 per cent done, so now's the time to define and adjust the colours. At this stage, I need to make sure the outline of each character is very clear and the colours are harmonised. Also, I have to make sure which direction the light is coming from, and the importance of each character in this painting, so everything in the painting fits together comfortably. If it does, the atmosphere of the painting will be right.

12 BACKGROUND AND PORTRAIT BEHIND

The portrait in the background is the most difficult part to paint: although he's at the back, he has an important role to play. The outline of this character is attached to the basic outline of the whole painting, so the portrait should be in the same colour tone as the background. Again, there is light that comes from the right side of his face to make him look more solid and stand out a bit more. After the basic structure is done, I start doing the background, which is a hill with a full eclipse of the sun above. This landscape is used to show the background of the story and to balance the whole painting.

13 REVIEW

The painting is now 90 per cent done. I have added all of the details such as hair, skin and costume to the characters, and the shading of the landscape. It's time to review the painting and make sure everything is well defined. Sometimes you'll find some mistakes after a load of work, so it's very important to stop and review the painting. This time I find that there's a bit too much empty space on the right side and the painting as a whole has a bit too much blue.

14 THINGS TO ADD

After looking at an overview of the painting, I decide to add a soldier about to draw his sword to fill up the empty space on the left-hand side. This also helps to build up the atmosphere with a feeling of war and excitement.

15 DETAIL OF THE SOLDIER

I use the Acrylics' Captured Bristle to create the texture of the soldier's armour. In order to make the armour appear battle-worn – he has been in many battles – rust and battle damage are necessary, so I make sure the strokes I use give this appearance effectively.

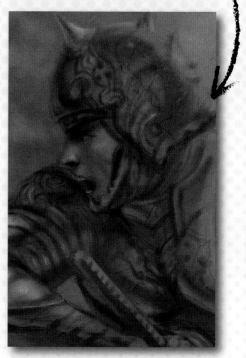

PRO SECRETS

BACK UP
Computers can crash any time while you're working on a painting. The best way to prevent losing all your hard effort is to save every five minutes. Also, it's better to save as a new file sometimes too, because the file you have saved may become corrupted. If you do this, all you might lose is five minutes worth of effort.

16 COLOUR RE-ADJUSTMENT

As I mentioned before, the colour tone is a bit too blue. In order to correct this, I bring the image into Photoshop. In order to counteract the effects of the blue, I add a contrasting yellow tone to the outside of the picture.

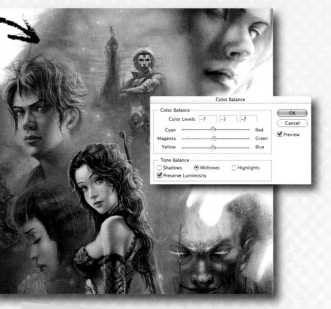

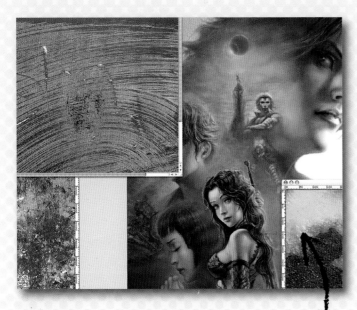

17 TEXTURE

Now it's time to add the texture to the picture. First, with the armour, I find photos of various metals on the internet as reference , especially those that are rusty or appear worn. Then, to create texture, I make several new transparent layers, slowly removing the unwanted parts, a bit at a time.

18 FINISHING THE IMAGE

Lastly, I add some stars with the Airbrush. I notice that the pink stars that seemingly rise from the main character to the eclipsed sun serve two purposes. First, the colours help to emphasise the main character and truly bring her to the forefront. Secondly, it serves as a connection between the main character and the eclipsed sun above her.

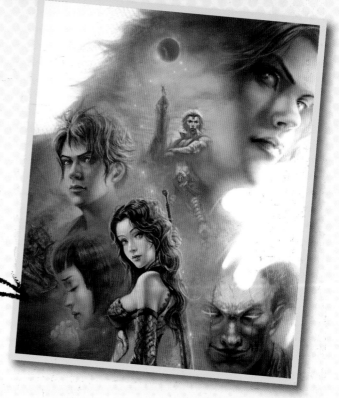

Q

I've heard that gradients can be used within a cel-shaded image. Any tips?

A

EMMA VIECELI REPLIES

There are all sorts of ways to apply gradients to a celshaded image, and none of them are too tricky. Working in layers is highly recommended, as you want to remain flexible. I'm using Photoshop in this example, but you can use the rough process in other applications.

Notice that I use an added gradient layer to amplify the light source, but also to add an atmosphere of foreboding. I select everything outside of my image, invert the selection and create a mask. Once this is done, I then add a black-to-white gradient.

Some points to note: firstly, when applying a gradient, it's important to make it work with the light source in the image and not against it. It can also make a difference where you choose to sit your gradient layer. In this piece, for example, my gradient sits on top of all of the colour layers, but below the line art. In some cases, though, it can be more effective to keep the gradient below your shadow and highlight layers. Remember that the kind of layer effect you choose will also make a big difference. In this image, I've used a Soft Light blending mode. Try changing your gradient layer to Hard Light or Overlay, and you'll see the difference immediately. Lastly, you'll want to play around with your Hue/Saturation settings on the gradient layer to get just the right feel. Why not try colouring your gradient for some really funky effects?

TOP: I apply the gradient after my base colours are in place, and before I start on my shade. Although it wasn't visible while I shaded, this meant that I knew it would sit well with my shadows.

OPPOSITE: Here's the difference a Hard Light layer effect can make. See how much easier it is to shade with the gradient layer already in place. This way you can easily marry the shading to the light source.

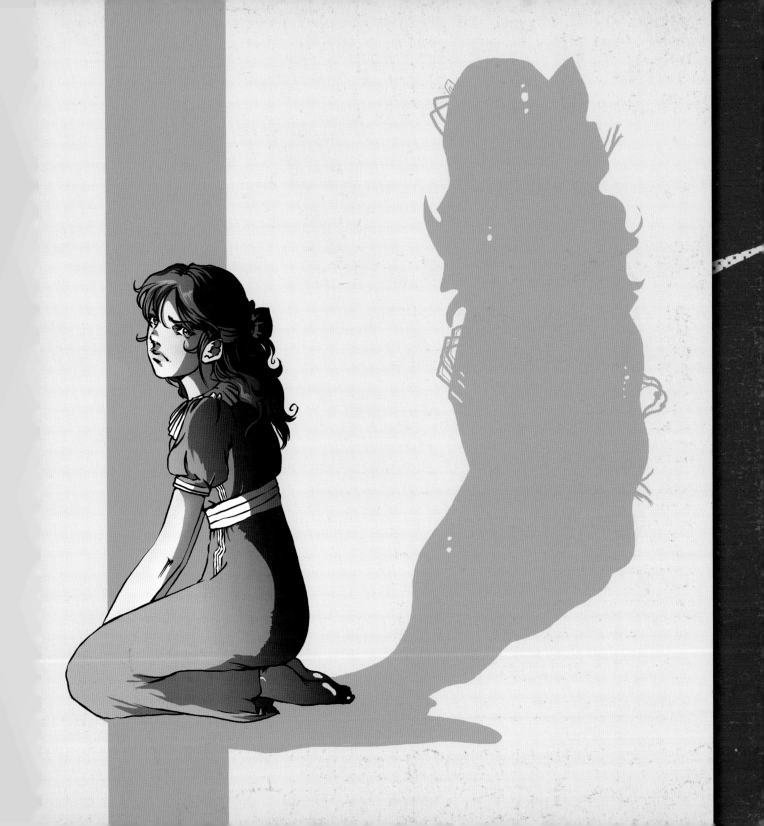

PHOTOSHOP
CREATE AND RENDER A ROBOT CONCEPT

Keith Thompson runs you through the process of creating a robot concept design, from sketches to final touches

ARTIST PROFILE
KEITH THOMPSON

COUNTRY: Canada
WEB: www.keiththompsonart.com

Keith is a freelance artist who specialises in concept art for books, movies, video games and role-playing games. He's written several books teaching the creation of concept art. His work's been featured in the Spectrum art annuals and has been displayed at the Museum of American Illustration.

For this workshop, I'm going to guide you through creating a manga-inspired robot concept, from a traditional artistic process involving pencil on paper through to the digital process using Photoshop. Note that the specific artistic techniques used in the following would simply be one way to come to something closely resembling the finished result. This is just the best way for me.

The initial step in any concept design is often nebulous and regrettably hard for any artist to detail or articulate: it's an idiosyncratic process that is often unique to the artist. There are two common approaches to the conceptual realisation of your design, and these are both applicable to cases where you have either a detailed brief or a completely clean slate to work with.

One is the on-paper shotgun effect, where you put down a rapid series of thumbnail sketches – often just simple silhouettes – and begin to home in on areas that catch your eye. Another approach is to roll detailed images around in your mind's eye before laying down a single, definite thumbnail to ensure that the visual imagery is working. The latter technique is how this design will be created.

For this robot concept, a concrete time and setting has been decided upon. It's going to be set in a relatively near future, in a post-nuclear war Europe. Despite the lack of background or additional elements, this environmental concern will run as an undercurrent through the appearance of the robot. The robot itself should match its setting with a bleak, worn and muddied impression.

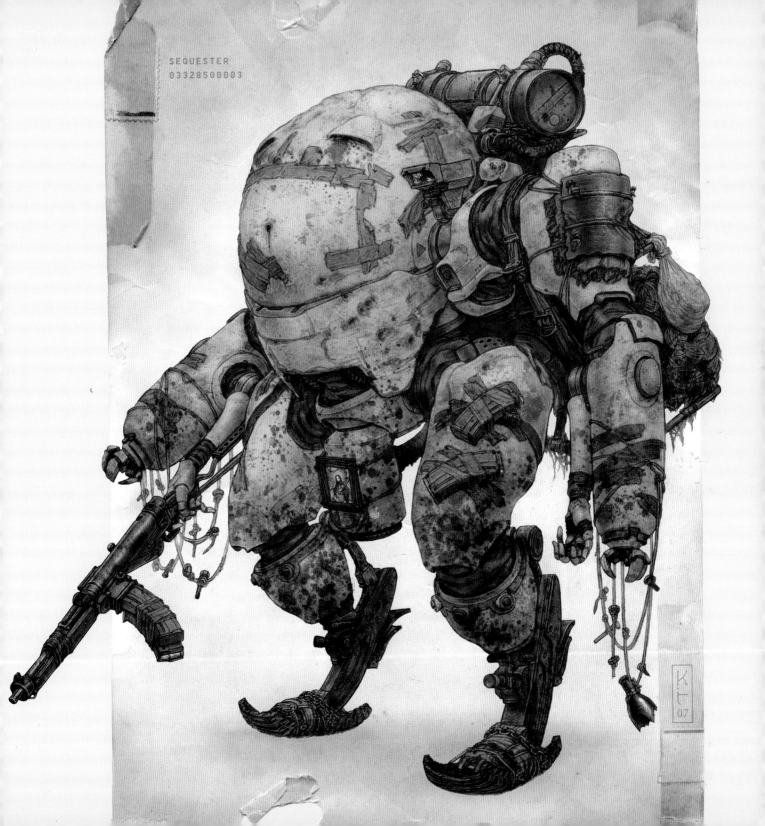

SEQUESTER
03328500003

 ## THUMBNAIL SKETCH

This is the culmination of the imaginative development of the robot. The major elements of the design are first and foremost defined by the setting of the robot. In this case, it exists in a post-cataclysmic scenario. Conceptually, this will actually encompass the relics of a technologically developed near-future, and plunge these themes into a shattered, primitivist world.

A broad, tank-like body is the central approach to the robot's silhouette and initial impression. This is padded even further with contrasting additions, which merge the technologies of two widely varying situations in one concept. The robot will be loaded down with scavenged junk, with parts of its plating buckling and additions haphazardly tied and taped on. A quick secondary thumbnail sketch explored making the robot slightly more agile, but this lost the desired feel and went unfinished.

 ## SKETCHED LAYOUT

This is the line work for the full-size design, and it'll be carried forward to the finished artwork from here. This closely mimics the thumbnail. It's possible for you to actually blow up your thumbnail, transferring it to paper to work over, or tracing it on a light table. This can preserve the proportion and gesture of the original sketch, but can also prevent you from introducing more visual sophistication in the larger depiction. Occasionally, when switching to full size, you may become aware of possible modifications or improvements: it's important not to become bogged down in blindly carrying forward specifications without giving these some thought.

SHORTCUTS
FLIP BETWEEN DODGE AND BURN
Alt/Option
Hold down the Alt/Option key when using Dodge or Burn to switch back and forth.

⬤ POINTS OF INTEREST

New points of visual interest can be incorporated into the design at every step along the way, which helps create a rich layering of depth. Certain elements that I've added, including the large sockets on the breastplate section, will be worked out in detail later – at the moment, they look a little bit like eyes.

By this stage, the major design elements of the robot are solidified, with only minor details to be added during further rendering. The real impression of the finished design should be fully apparent at this stage, and any areas that fail to please you need to be fixed before you move on from here.

⬤ SCAN THE LINE WORK

Now I'm going to scan the pencil line work in, as the rest of my work will be done digitally. It's important that the pencil work meets your standards at this stage because it won't really be possible to directly modify this line work without returning to the drawing, rescanning it and transplanting it into the digital stage. It becomes a whole job of its own.

It's a good idea to scan at a resolution higher than you plan working on. Clean up this scanned image and then convert it down to the working resolution. Depending on the type of medium and paper, it may be advantageous to scan in colour and take advantage of the ambient hue variety.

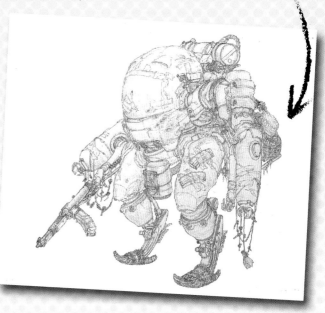

⑤ GREYSCALE VALUE

I do a mask of the character (in the case of an artwork depicting a scene, every major element may have its own mask) made with a layer and a colour fill, which I then set to an Opacity of 0 per cent. You can return to this mask by using the Magic Wand on the layer, and any modifications can quickly be made by erasing or adding to the colour fill. Shadows are loosely laid in with an Airbrush. I use a white fill set to Multiply on a new layer above, with the Burn Tool set to Highlight. Remember to keep the shading basic and consistent – it should not appear perfectly shaded at this stage, because this process is more intended to designate areas of shadow.

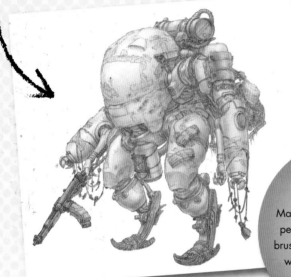

⑥ CANVAS GROUND

Now I lay an undercoat or base texture over the shaded line work. The hue of this base will affect the unity of the finished piece, so I opt for a warm earth tone. This specific texture is a composite of several layers of cracked leather and paper. I like to compose my own individual textures and build them up with use. Your choice of textures will help give a uniqueness to every piece of artwork you create.

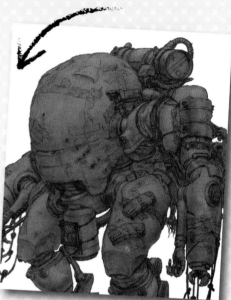

SHORTCUTS
MAP BUTTONS
Map the buttons on your tablet pen to adjust the size of your brush on the fly. Playing around with the zoom will fine-tune the brush size.

⑦ HIGHLIGHT VALUE

I flatten all the layers together and pass over the entire work with the Dodge Tool set to Midtones (in the top toolbar). Some slight fixes using the Burn Tool, also set to Midtones, are worked in during the process. This stage is as much about drawing as painting, with highlights being applied in a line to support the existing black line work. An obvious variation of hue is starting to develop and will affect the colour glazes that follow. If you want, you could work up to this point completely in greyscale, then use the Colour Balance menu to warm that with red and yellow in the shadows before proceeding to the glazing stage.

INITIAL GLAZE COAT

I create a folder in the Layer palette set to Soft Light, with individual layers within it acting as colour glazes over the shaded drawing below. Each main hue has its own named layer and each coat is a flat glaze of colour, with the only variance being slight adjustments to the individual layer's Opacity setting. Remember that using this technique will actually change the value of the greyscale underpainting, potentially throwing the composition and visual hierarchy out of whack.

FINAL GLAZE COAT

Next I create a secondary set of glazing layers that compound an additional colour to the previous glazes, adding a warmer hue in a highlighted space, or a cooler hue in the shadows.

Additionally, I create a series of layers outside the Soft Light folder. These new layers are set to Multiply and are used to introduce a series of scans of splattered paint specifically created to simulate the mud, rust and mould on the robot. I'm sure to take care on their build-up, so that a complex, multi-layered coat is created, which conforms to the curving surfaces it lies upon.

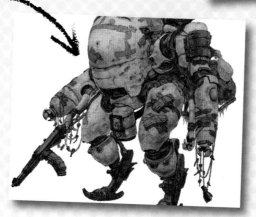

ELABORATION

The entire work is flattened again, and additional passes with the Burn and Dodge Tools deepen shadows and bring out focal points.

An old piece of paper is prepared and scanned as a backdrop and worked in behind the artwork. Take care that this backdrop supports the artwork without dominating it or clashing with it.

Whatever method you use in the conceptual stage of your project, be it a number of sketches or one focused design, make sure you get it up to scratch before going digital. It'll make your subsequent work much easier.

How do you effectively use large areas of flat colour in an illustration?

EMMA VIECELI REPLIES

In an age where digital colouring appears almost synonymous with fabulously rendered paintings and crisp cel-shading, it can feel a bigger risk for an artist to take a minimal approach than it is to dive in with a four-day-long paint job. However, flat colours are making a comeback, helped not least by the recent Japanese 'Superflat' movement seen in the works of artists such as Takashi Murakami.

There are many approaches, but in this example, I'll demonstrate how flats can be used in a Pop Art style. Working in this way requires knowing when to stop and having confidence in your inking and line work. The latter is the hardest: we artists are sensitive souls, and confidence can be a pretty tough thing to achieve.

With a flat-coloured piece, what you lose from the painting/shading, you'll need to gain in the rendering of the lines themselves and the choice of the colour palette. Width variation and sharp points become a lot more prominent, even in an example like this where the line work is not obviously visible. When you aren't relying on shadows and highlights to add depth to an image, the importance of the palette, be it muted or bold, is ramped up.

LEFT: Creating Pop Art-style images is a really effective way to employ flat colours in your work.

STEP-BY-STEP: PERFECT THE LINE ART AND THE REST WILL FOLLOW

1 Begin with those all-important inks. In this example, I've used Manga Studio. Consider how you want your finished piece to feel: leaving a few messy areas can really add life to a flat image. Otherwise, keep things crisp and smooth, paying attention to width variation and fine points.

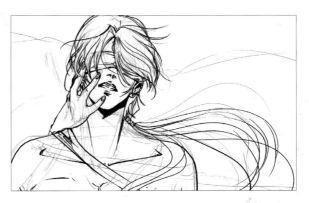

2 Separate out your line art and add colours underneath using the Fill Tool. Beginning with a base colour will help guide your palette. This is where that confidence comes in: don't be tempted to paint underneath. Trust the lines to form the picture once they're coloured.

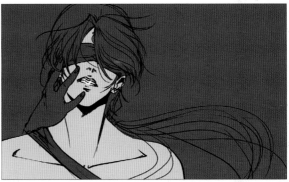

3 At this stage, the line art is about to be re-coloured or removed, enabling that base colour to take the lead. Choose what you want to keep and what you want to match up with the image colours. Here, the black areas were dispensed with and the remainder was coloured to match the hair.

WORKSHOPS

ARTIST **PROFILE**
SAEJIN OH

COUNTRY: Canada
WEB: www.saejinoh.deviantart.com

Saejin Oh is a 24-year-old freelance illustrator based in Canada. He works for Udon Entertainment, specialising in character design and manga art. His professional work includes covers for Blizzard Entertainment's *Warcraft: Legends* and *Starcraft: Frontline* comic series. In his free time he also enjoys playing games, such as *Team Fortress 2*.

PHOTOSHOP
MECHA'S HEART

Saejin Oh explains how he created this stunning image, from concept sketch to the final rendering

You don't create something out of nothing – your imagination creates something new based on what you already know. In a sense, your artwork is a mosaic of the knowledge you possess, put together in a certain order to create something vibrantly original. All that might sound daunting, but there's nothing to worry about – it's how you use your ideas that counts. Painting sci-fi enables you to unleash your creativity, bringing to life anything from weird aliens to hulking robots. The flip-side of this is you need to know how to paint different materials and create futuristic designs.

Before getting started, I like to have a clear idea of what I want to draw. Think of your work as a tree – you can always branch out with your ideas, but you'll always need a trunk for those branches to stem from. You can develop ideas and finishing touches as you draw, but you'll need to have a solid direction for your ideas to grow into, and the end point in your mind's eye to aim for.

For this workshop, I chose the subject of a female mech pilot in a bright, colourful suit. So, let's see where our imagination and that topic takes us.

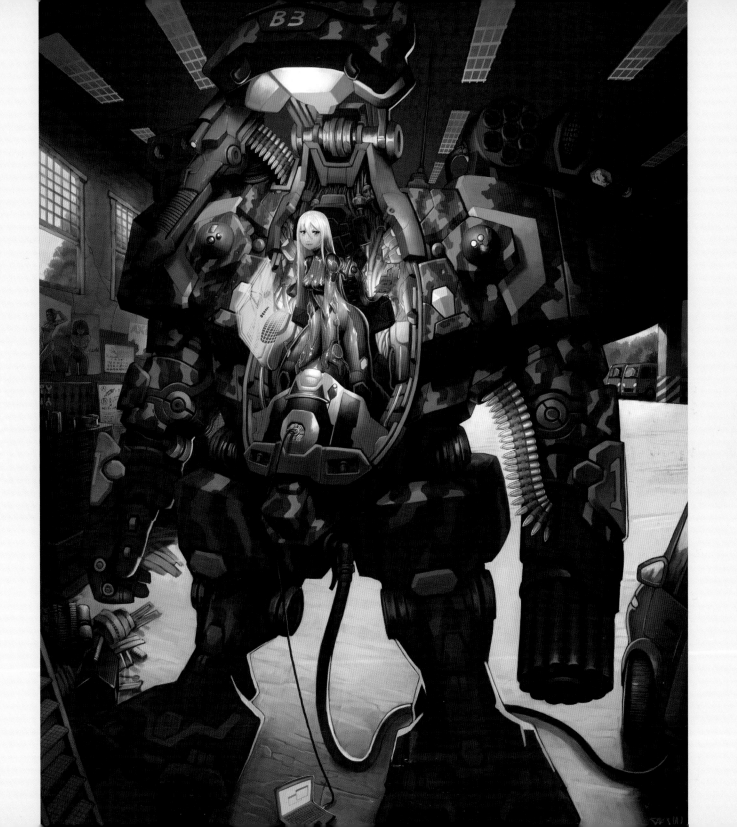

① START WITH A THUMBNAIL

Every painting I do starts with a thumbnail, outlining the goal for the finished piece. You don't need to put a lot of detail in your thumbnail: just try to clarify in your own mind what you're striving to achieve with the image.

At this stage, it's important to keep it simple and display your idea clearly. Remember, your sketch doesn't have to be structurally or anatomically sound – those errors can be mended as you develop your painting. All you're doing is getting down the design elements and creating a basic colour reference.

③ EXPAND THE VIEW

If the object you're drawing is larger than the entire canvas, you may have trouble understanding the structure of the object as a whole. I'm sure that this is a problem every artist experiences occasionally in their work. To combat it, and to restore your sense of perspective, just increase the size of the canvas until the entire object fits. You can always crop out stuff you don't need later.

Because of the canvas increase, my file size is pushing the limits, but that's fine for now. I quickly draw in limbs for my mech. It looks rather awkward, and will need adjusting as the image develops.

② CREATE A ROUGH END GOAL

Now that you have a subject and a thumbnail to develop your painting with, try going a bit deeper into the elements of the sketch. Add new ideas and remove old ones that don't work as you originally envisioned them. Modify clunky ideas as you go. At this stage, I feel that the mech design isn't working because I'm having trouble grasping the concept as whole. Fortunately for me there is a simple solution to this problem.

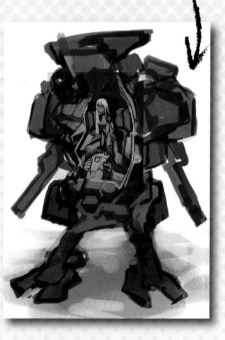

 ## DEVELOP THE IDEA

The skinny limbs aren't working well for the size of mech I'm drawing. I decide to buff the mech up and change one of the guns into a hand with an opposable thumb, adding variation to the design. I drew inspiration for the mech from modern tanks, as well as sci-fi games and movies. As a result, the design of the mech is sharp, angular and boxy. Most of the exoskeleton is well protected, as are the internal wires, hydraulics and gears. I have other design ideas popping up, but I'll hold on to those for now. Since I have the basic structure, it's now time to connect the girl and mech together.

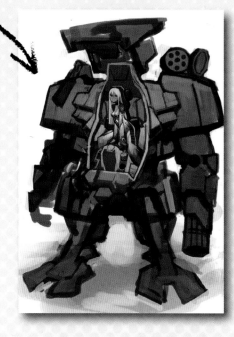

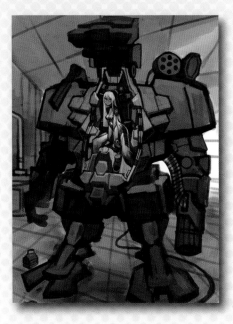

 ## ADD DIMENSION

Since I drew the whole mech without any perspective guidelines, there are bound to be errors. To find them, I quickly draw a two-point perspective on a foreground Multiply layer, erasing any lines that cross over the mech. With this indication of space, I have to choose where it will be in the composition. This means selecting a background.

As I drew the pilot with the hatch open, I can't really have her on a battlefield. After some internal debate I settle on a garage, to complement the mech's passive stance. I also sketch an oil heater on the wall, blending the elements together.

ADD COLOUR

This stage could have come much later, but I want to get a feel for the contrast of the pilot and mech. To colour the pilot I create an Overlay layer and a Multiply layer. I find the Overlay layer is great for assigning colours to greyscale paintings. You could use a Colour layer instead, but I think that tends to look dull unless you use an Overlay layer on top of it – so why bother?

After the pilot is coloured, I expand the canvas to the right to give more room for the mech's left arm and shoulder armour. I also correct some minor perspective errors as I go along. While doing this, I add rough indications of a few new ideas I've had for the mech, like belt-feed bullets, new gun designs and cockpit lights.

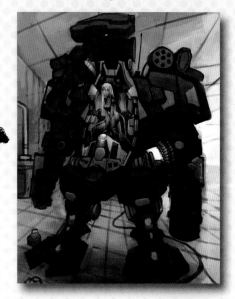

7 FIX PERSPECTIVE LINES

I'm not particularly organised when I work, so I often end up going back to correct perspective after my initial rush of ideas. If you can avoid getting caught up in your sketch stage then I'd suggest drawing with correct perspective from the outset – it saves plenty of redrawing time later. As I correct, I think about improving my mech design, adding some weaponry and moving elements after my tweaks.

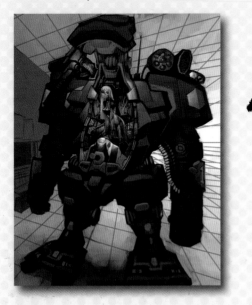

8 ADD A ROUGH BACKGROUND

I've already decided that the mech will be in a garage or repair shop, so I do a quick internet search to get some real-life references. From the reference, I draw in a red toolbox and fuel pumps. I also add some people to create a sense of perspective, but end up removing them later because they clutter the image. During this process I get a few more ideas, mostly for the mech's navigation mechanism. If you look at the top side of the hatch, there's no obvious peek hole for our pilot to look through, indicating this mech is a fully digital machine that gives the pilot a monitor-feed of what's going on outside. To allow for that, I add sensor spheres on both sides of the mech's shoulder, using UAV and other military helicopters as my reference. I also draw a few exposed wires in the interior to echo modern-day fighter cockpits.

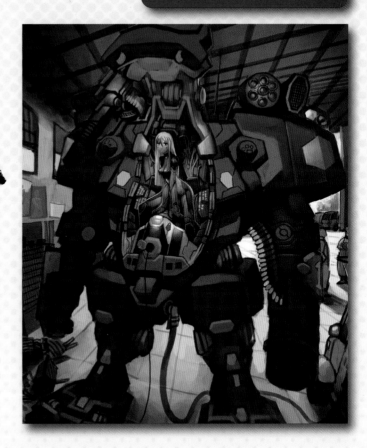

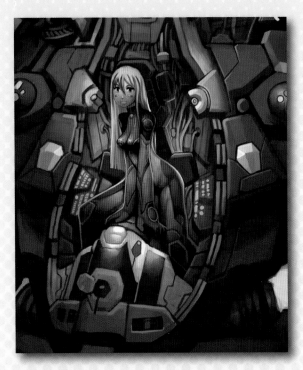

⑨ DEVELOPING THE CHARACTER

With all the elements starting to develop, I turn to the painting's central focus – the character. Because she'll be getting most of the attention, she really needs to shine. Her immediate surroundings should be interesting as well, drawing the viewer's eyes to her. The lighting and the colour in these areas are too dull at the moment, so they're the first things I'll focus on.

SHORTCUTS
UNDO TO CACHE
Alt+Shift+Z
Cmd/Ctrl+Z only performs a single undo, but this shortcut enables you to undo until your cache is empty.

⑩ ALTERING THE CHARACTER

After I've brightened the colours, I still feel something isn't quite right. I try to convince myself that it might be because all the details aren't in yet, but I know this isn't a simple detail problem: there's no quick fix. I think that the overall direction of this character design needs to take a slightly different path.

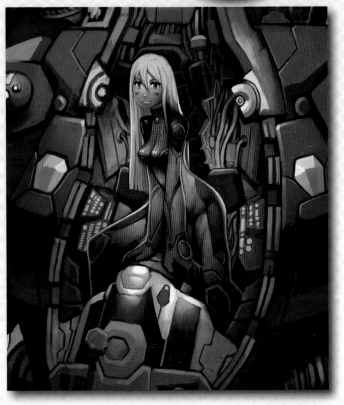

GLOSSING OVER IT

Eureka! It was the gloss – I've been painting a latex suit without a gloss. It's easy to forget the simplest facts when you're hours into a painting. Taking a break to refresh your eyes and your brain can really help to identify these discordant elements. Sadly, even with the gloss, it's still not right. She's now too glossy and her posture is awkward.

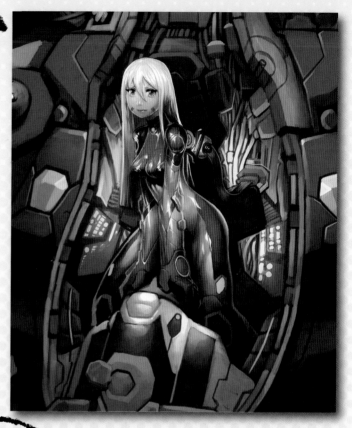

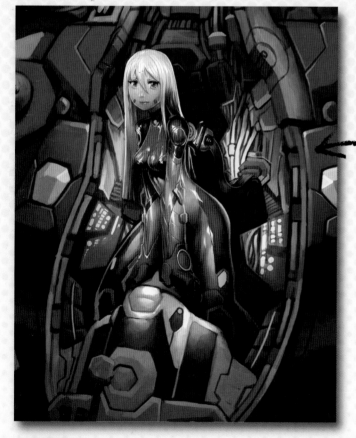

DEGLOSSING AND FIXING POSTURE

I reduce the overall glow by taking a brush and cutting out the areas that are over-glossy. I already have all the layers flattened, so using the Eraser isn't really an option. To work around this, I pick the colour nearest to the gloss reflections and tone down each part individually.

Her posture is another issue. She was off to the side in the last step, so I use the Lasso to cut around her silhouette, Copy and Paste it, then slide her over to the left. In her new position, I completely redraw her right leg and make both her arms an equal length.

Next, I work on the colour of the suit, painting it a mixture of orange, red and pink on an Overlay layer. Finally, I add a data cable, placed behind her back, to complement the design.

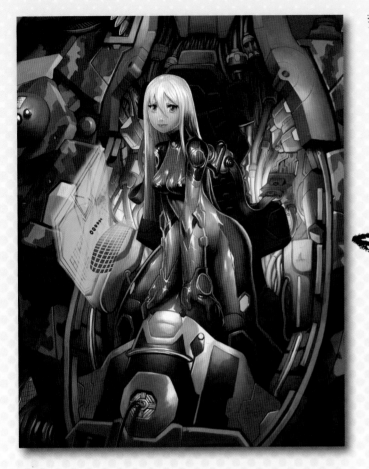

ⓑ HEAD ADJUSTMENTS

The character is almost done, but not quite. I suddenly realise that her head is too big. Every time I zoom out, her head sticks out like a bobble on top of a car antenna. I might be being a perfectionist, but in my eyes it needs to be fixed.

I use the Lasso Tool to select the head, then resize and slide it around using Free Transform. Her hair gives me some trouble because I didn't select the bottom part of it when I moved her head. I lasso each section of hair separately, resize them and try to fit them as closely as possible to the existing parts of the image. Any colour/texture differences between the sections are painted over with a brush.

SHORTCUTS
FULL SCREEN MODE
F
The F key takes you to Full Screen mode, enabling you to navigate through your painting without any restrictions.

⓭ DEVELOPING THE BACKGROUND

I got the rough background ready in step 8, but now it's time to take it further. Be careful not to cram too much in and distract the viewer, but avoid a barren look in your backgrounds as well. Cracks in the wall, pin-up posters, whiteboards and calendars are all characterful hints about the kind of people who work here.

After all of the details are done, I darken or brighten them as needed. I darkened most of my details (except for the outdoor scenery through the window) to highlight the mech and create a good contrast. Remember: the subject you're drawing must be easy to see, or you'll lose your good work in visual clutter.

 ## FINALISING DETAILS

I've achieved pretty much all of my goals at this point. All that remains is to add a few more details. I try a test patch of camo on the mech to see if it will work and redo the tricky roof of the garage to accommodate a more simplistic approach.

When finalising your painting, it helps to quarantine sections off mentally as you finish them. This kind of thinking enables you to estimate accurately when your painting will be complete.

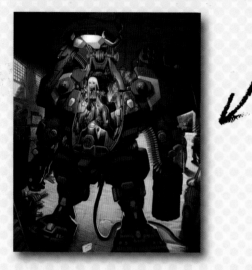

FINISHING TOUCHES

To finish up, a holo-interface, camo and a few other details are added to make the mech even more interesting. When you feel that your painting is done, save and close the file. Return a few hours later, open the file again and thoroughly examine your painting for any errors. You'll always find something you'll want to go back and fix.

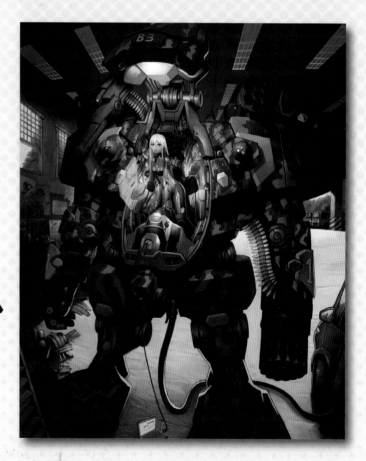

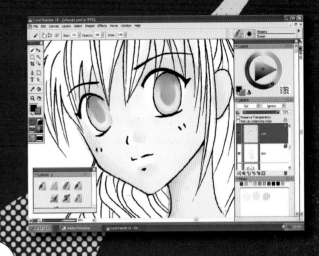

Q How do I create the delicate pastel shading that is often used in shoujo manga?

JOANNA ZHOU REPLIES

A The word shoujo describes any manga that is primarily aimed at a female audience (as opposed to shonen, which is male-oriented). Within shoujo manga, there is a popular style of delicate outlines and soft, almost translucent colouring. Before the days of CG, these images were rendered using watery inks or alcohol-based markers. However, now it's much easier to achieve the same effect with programs such as Painter.

The shoujo style begins at inking. The lines should be thin and tapered, with each strand of hair flicked separately, for example. The easiest way to do this is with a thin nib pen (the kind you dip in ink). After scanning, I open the image in Painter and set it as a Multiply layer.

The best brush to use is Digital Watercolour: this applies layers of translucent colour and I can build up subtle shading just by applying pressure on the pen tablet. The key is to keep the colours quite pale, so they complement the delicate outlines. Always remember to select Dry Digital Watercolour (Ctrl/Command+Shift+L): this enables you to use other tools, such as the Blender, for finishing touches.

Notice that the eyes have been left blank during inking. This is done a lot in shoujo illustration: a solid black pupil gives an unwanted level of staring intensity. Having the pupil rendered in a darker shade of the iris colour, as in the blues in this image, results in a more peaceful gaze, and this affects the image's mood.

Paint on a layer below your outlines. Don't worry about colour going over the lines: just remove them with the Eraser once you're done.

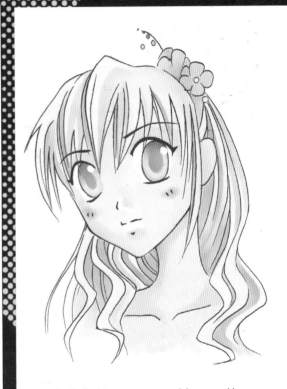

To make the final image even more subtle, you could change the black outlines into sepia using Photoshop's Colour Balance functions.

ARTIST PROFILE
PATIPAT ASAVASENA

COUNTRY: Thailand
WEB: www.asuka111.net

Bangkok-based Patipat is influenced by manga and early animé. He feels his continuous self-improvement and willingness to try new things on the canvas mean he's able to paint in a range of styles.

THE GIRL AND THE KATANA GUARDIAN

Patipat Asavasena reveals how he captured an unearthly beauty summoning the power of a demonic sword

This workshop will reveal my ideas process and the techniques that I use to create an illustration mostly in Painter, with just a little bit of help from Photoshop. As you probably know, Painter has many brushes and each one has a range of settings. This can confuse many first-time users – and I admit, in the early days I was thrown by the options on offer. But after using Painter for a while I've found my favourite brushes, and I'll give you some advice on using them here.

The idea behind the image can be summed up in three words: The Katana Guardian. I wanted to depict a beautiful, female character and a dark, fantastical creature in a traditional Japanese setting. I imagined a demon girl who was holding a katana (a curved sword used by samurai) that was home to the soul of a demon. I'll now show you how I developed a basic idea into the final artwork. Okay, enough of the preamble – let's get started!

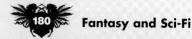

IDEA AND CONCEPT

Before I start painting, I come up with some keywords that relate to its theme. I then start to draw thumbnails in my sketchbook to explore the concept further. When everything is nailed down I start to design the composition, keeping tabs on the readability and focal point of the image. I use the primary element to lead the audience's eye – now's not the time to bother with either the anatomy or perspective.

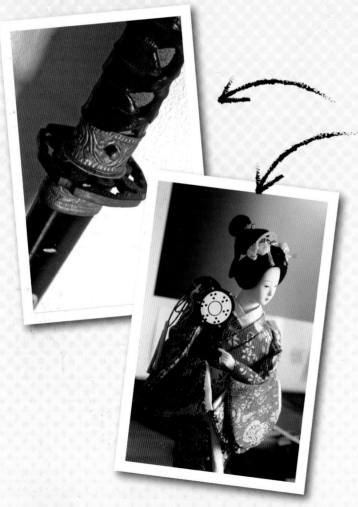

GATHER REFERENCES

Next, I need to study some reference photos for drawing the girl's pose, her kimono and the katana. Luckily, I have a Japanese doll and katana at my studio that help me to understand the composition of the piece. Studying a real-life object is preferable to simply looking at a photo. But whether it's a photo or the real thing, there's no shame in using reference sources because, ultimately, you're learning from them.

③ ROUGH SKETCH

After I've made a thumbnail sketch I scan it into Photoshop. I roughly define the character, cloth, props and background so that I can see the picture a bit more clearly. I also check the anatomy and pose of the character, making corrections as I go along. I try to get this aspect of the figure finalised as much as possible before I start painting, because it'll reduce my levels of frustration spent revising the image later on.

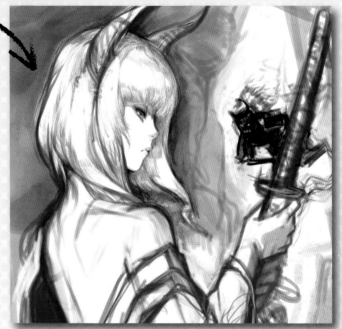

④ TIDY THE LINE ART

Although I use a digital tablet, I still prefer to use a pencil to clean up the line art. So I enlarge the rough sketch and then print it out for tracing on a light box. I use 2B and 6B pencils for the clean-up process on 11x15-inch 200gsm art paper. I think that using the traditional tool is faster than using the tablet, but you have to be careful. Because there's no undo button (!) I really need to concentrate on getting the image right.

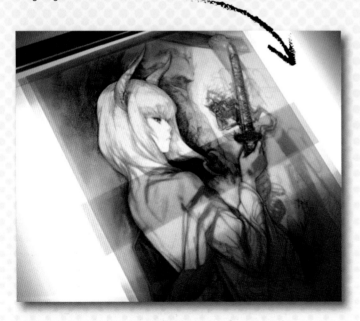

⑤ PREPARE THE CANVAS

I have to scan the artwork in two separate files because I don't own an A3-size scanner. I stitch them together in Photoshop and remove dust using the Healing brush and Eraser tool. After I finished cleaning and framing the image, I put the line art on a separate layer and set the Blending mode to Multiply.

6 COLOUR DECISIONS

Before starting any painting session I usually decide on my colour palette. I duplicate the artwork and resize it down to 658x800 pixels, then play around with the colour scheme using the Normal Round brush, the Color Balance settings and layer combination until I'm satisfied with the overall mood. If I skip this step then I might end up spending a lot of time doing the same thing on a larger canvas, which will take longer to get right, because of the increased file size. I save my work and display it on a second monitor that I can quickly refer back to.

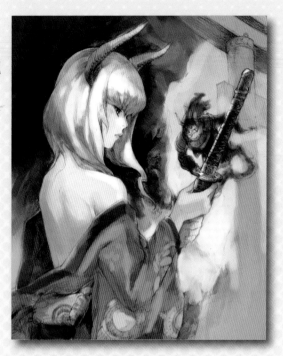

7 BASIC COLOUR I USE

I use Painter's Watercolour brush with the Simple Water setting to paint the basic colours of the image as dictated by my colour palette. I'm painting on a fresh layer, rather than the original canvas layer, which in effect means that my paint won't touch the canvas. If I do make a mistake then I can easily fix things by using the Wet Eraser tool. If I wanted to, I could apply the paint to the canvas, but I'd have to select Layer>Dry Digital Watercolour first.

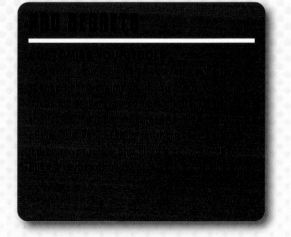

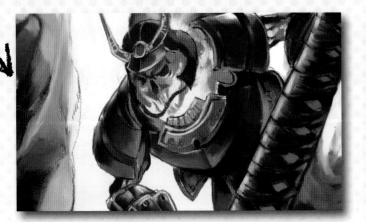

SHORTCUTS
ROTATE CANVAS
Alt+Space (PC)
Option+Space (Mac)
In Painter, rotate the canvas
into the best angle. Click
to reset the rotation.

PAINT OVER THE IMAGE

I apply the Digital Watercolour layer to the canvas and flatten all the layers. Then I use the Oil brush with the Smeary Flat setting to paint over the image. Carefully, I try to catch the flow of the stroke. I use the large-size brush to paint in big areas and gradually re-size it down when I'm focusing on the details. The key is to keep moving forward. Don't spend a lot of time painting over the same area, because it'll make the image look staid.

ADD COLOUR VARIATIONS

During the paint-over step, I usually inject variations into the colour scheme because having a large area of a single tone is pretty dull to look at. So for example, I shift the saturation in the shadow area to make the skin tone look more fleshy, and in the rock area to increase its richness in colour. I make sure that these variations are subtle and don't end up competing with the overall mood of the piece.

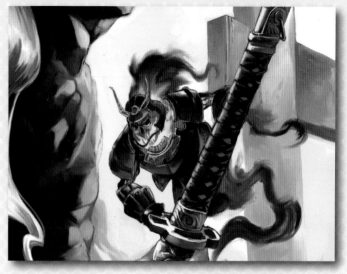

CREATE A HAZY EFFECT

Painter's Blending tools come in handy when generating the hazy effect of the devil soul's flame. I use the Water Rake setting with a small diameter to paint along the flow of the flame. I then experiment with other settings to create an interesting flame effect. This tool has a lot of settings for you to play with and the possibilities are endless.

SHORTCUTS
BRUSH RE-SIZE
Ctrl+Alt (PC)
Cmd+Option (Mac)
Drag to resize the brush or
map it to a Wacom
Express Key.

REFINE THE DETAIL

I keep refining the small detail in the background, such as the samurai armour and the katana, by using the Oil Brush with a smaller diameter. For exceptionally small details, such as the decoration on the cloth, I use the Pencil tool with the Cover Pencil setting. Then I use the Blenders tool on the Just Add Water setting to blend the girl's skin colour. This makes her flesh look softer. I've tried to keep some definition in the girl's back muscles to ensure that the character has presence in the scene.

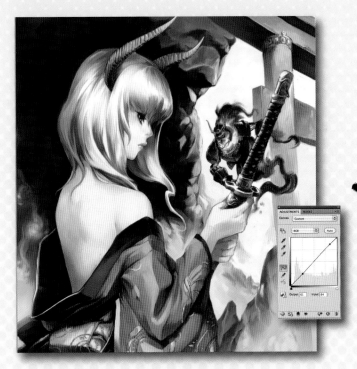

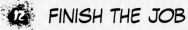
I use the Hard Round Pressure Size brush to clean up tiny details and edges. Then I enhance the mood by adding azure blue lighting with the Hard Light layer in Photoshop. I put a white glow on the character's hair to contrast it with the surrounding, then paint in some of the devil's soul in the background and make a small adjustment using the Curves tool.

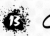 CONCLUSION

That's it. It's finally done. There's still room for more development of the image but I'm satisfied with the overall piece. I hope this tutorial has inspired you to experiment with Painter's powerful set of brushes. Now it's your turn to create some stunning fantasy illustrations of your own. Good luck!

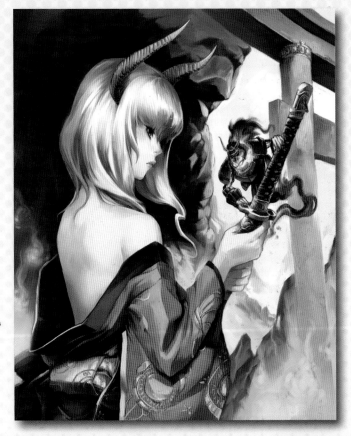

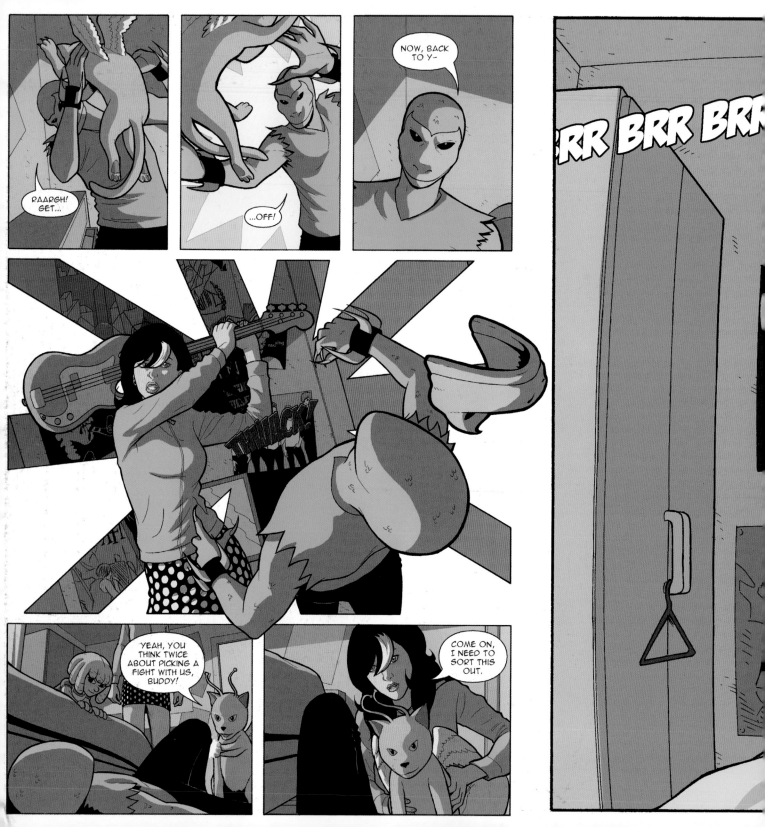

ARTIST Q&A

Q How do I add text to manga? Are there special fonts or typographic conventions to look out for?

A | JOANNA ZHOU REPLIES

Text is not only a narrative tool, but an important visual element of the page. When I add lettering to a page, my objective is to make the text look as aesthetically integrated with the artwork as possible without sacrificing legibility or clear narration.

Photoshop is the most convenient program to use. Select the Horizontal Type Tool and click inside the speech bubble where you want your text. I always copy and paste my writing from a Word document. I set my text alignment to Center and open the Character palette via Window>Character. First, I adjust the text size so the writing fits neatly inside a speech bubble. I like the Horizontally scale option: it makes a familiar font more interesting. The Horizontal Type Mask Tool is ideal for sound effects: you can stroke and fill a selection.

English-language manga text is almost always capitalised – a convention derived from western comics rather than Japanese manga. For convenience, choose a font that's upper case by default. Keep away from fonts with serifs (the little bits at the end of letters on fonts such as Times New Roman): these are difficult to read when capitalised. Avoid Comic Sans: despite the name, it's not suitable for lettering. Good manga fonts include Digital Strip and Animé Ace, which you can download at www.blambot.com.

TOP: Leading is the distance between lines. You can use to this to stretch out your text and create a better fit with the speech bubble.
LEFT: Typography should be fully exploited to enhance the dynamics of a story. Think about how size and style reflects speech, shouting or sound effects.

WORKSHOPS

ARTIST PROFILE
JOANNA ZHOU

COUNTRY: UK
WEB: www.chocolatepixels.com

Joanna is a freelance illustrator and graphic designer. She has 10 years' experience drawing manga with professional exposure in the UK, USA, Austria and Germany. She is also a member of the wellknown UK manga group Sweatdrop Studios.

PHOTOSHOP
DRAW AND INK A MANGA COMIC PAGE

Learn the basics of page composition and use digital techniques to enhance imagery, text and layout with Joanna Zhou

The increasing use of digital equipment and graphics software has enabled manga artists to cut corners on time and money. Traditionally, manga comic pages are drawn on A3 paper (297x420mm), which requires a correspondingly huge amount of ink and screentone. Paper size is a frequently underestimated factor when determining how professional the final manga will look. Mangas drawn on a smaller scale may suffer from scruffy line art, and lack detail.

This workshop uses Photoshop to create the illusion of a large scene while keeping the page size to a manageable A4 (210x297mm). It also shows you how to make full use of layers to arrange screentone, text, speech bubbles and sound effects. Being able to edit these elements individually will give you a degree of flexibility that can boost the final layout and the narrative.

An important issue to consider with manga creation is that pages should not look like they have been digitally put together. Software is there to enhance the visual appeal of the final page, but not to intrude on its content. Bad examples of digital editing would include using a symbol hose, light flare effects, perfectly smooth gradients without half-tone and too many perfectly rounded, thickly stroked speech bubbles.

Stylistic conventions such as panelling and speech bubbles differ a lot from artist to artist. The best way to find a style that suits you is to examine the visual language of your favourite manga. Deconstruct the pages to see how the artist uses panels, camera angles, text and narrative speed.

Before you begin drawing, it's vital to create a detailed script and thumbnail sketches, and to decide on your exact final page measurements.

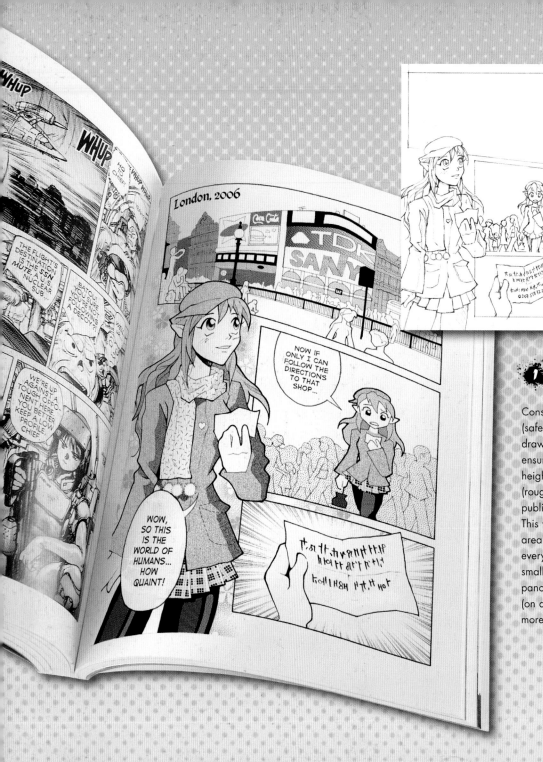

PREP WORK

Consider your page measurements carefully (safe, bleed, crop etc). The page size you draw on should be as large as possible to ensure maximum detail. You can multiply the height and width of the final print size (roughly A5, but it varies depending on publisher) by a fixed number (such as 1.5). This will give you a proportional yet larger area to work on. In this example, I draw everything to an A4 size, scalable to a smaller 15x22cm (6x8.5in). For the opening panorama, I enlarge the panel proportionally (on a separate piece of paper) to create a more detailed scene.

SPEECH FLOW

Another thing to bear in mind when laying out a page is the panel flow. Make sure the reader will see the panels and speech bubbles in the right order. Since this is the opening of my manga, I want to introduce the context and characters. Text (or an opening narrative) is useful for setting the geographical and historical location. Unless the storyline dictates otherwise, every new character should be presented in a full-body shot, as the focal point of the page. This enables you to communicate the important elements of their personality through clothing, expression, body language and speech.

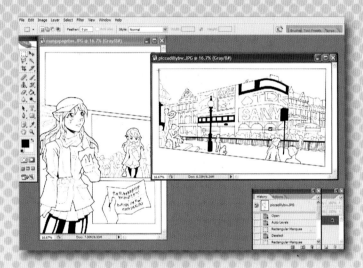

PRO SECRETS

MAGIC WAND AND TONE FILTER
As Computones works using selections, it can be frustrating when you want to tone an 'open area' that's not fully enclosed in black. So here's an advanced toning technique. Create a copy of your page using Duplicate Layer, then use a thin black brush to outline the areas you want toned. Grab these areas with the Magic Wand and apply the tone on a new layer. The shadows on the jacket, hair and scarf were done this way. Finally, just discard the duplicate layer.

CONTRAST

After inking and scanning, I adjust Levels in Photoshop to help the contrast. Now I can copy and paste my city scene into the original page. I reduce the opacity so I can see both layers and use Transform to scale the image to the size of the panel. (holding down Shift keeps the proportions the same as you scale). When the outlines are in place, I reduce the page to the print size before toning: scaling down a page after toning may result in moiré patterns, where screentone forms unsightly checkers, grids or swirls.

SHORTCUTS
APPLY PREVIOUS FILTER
Ctrl+F (PC) Cmd+F (Mac)
Instantly tones a selection to your Computones settings. This saves time if you accidentally tone the wrong layer.

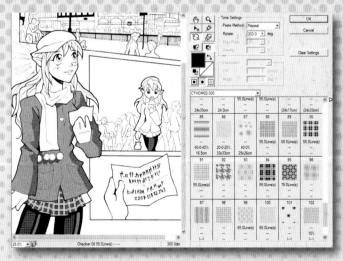

 ## TONES

I use the screentone plug-in Computones. It's a good-value toning program for beginners, offering a wide range of patterns. It's included with any book from the *How to Draw Manga: Computones* series and works only with Windows. Keep tone (and adjacent areas of tone) on different layers to enable easy editing. I select an area from the Background layer with the Magic Wand, add a layer and apply the plug-in. Alternatively, I can choose an area with the Polygonal Lasso, tone it and use the Eraser on any excess.

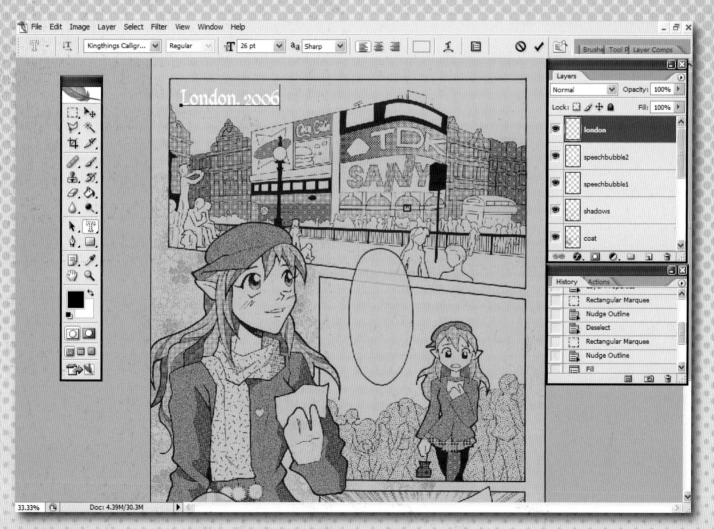

SPEECH FONTS

The speech bubbles are inserted separately so they can be re-sized to fit the text. You could draw the bubbles straight onto the page, but you may end up having a bubble that's too small for the text, or vice versa. I don't like using the Ellipse Tool to create bubbles: they appear too perfect and clash with the hand-drawn feel of manga. When adding text, try something other than Comic Sans: www.dafont.com and www.blambot.com are great for free, comic-style fonts.

RESOLUTION

As a finishing touch, I resize the speech bubbles to frame the text. The final format should be a 300 or 600dpi bitmapped TIFF – but make sure you keep a copy of your PSD file. A common error is to save manga files in Grayscale mode, which is not the same as Bitmap. Bitmap only supports 100% black and 100% white, which produces a much crisper image when printed. Stylistically, manga is designed for Bitmap, because the whole purpose of screentone is to create shades of grey using black and white dots only.

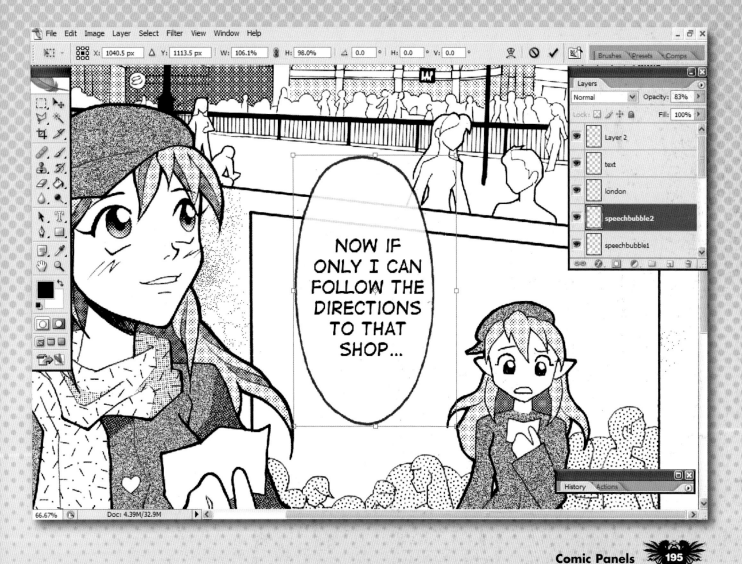

Q | Are there any golden rules I should know when laying out a comic book page?

Even before there's any art in them, the order of the panels should be obvious. Not like this page.

A | ## FIONA STAPLES REPLIES

Telling a story with clarity and making it interesting are what it's all about, so I try and keep a few things in mind. To begin with, you have to consider your panel layout, because you're telling a story first and foremost, and it needs to read as easily as possible. You don't want a reader to have to stop in the middle of a page because they don't know what order they're meant to read the panels in. Remember that we read left to right before we read up to down, so don't make the common mistake shown in the four-panel, black-and-white example above. With pages like this, the eye is tempted to go straight from panel one to panel three, which will confuse your reader.

However, it's fine to have a tall panel on the left side of the page, and a vertical stack of smaller panels to right of it, as the example page from *Mystery Society* #1 opposite shows. The larger panel anchors the sequence, and helps the reader know where to look next.

When you're drawing figures inside panels, make sure that, wherever possible, characters are arranged in the order in which they speak. This way you can avoid people reading the dialogue in the wrong order, or having the tails of your word balloons overlap (horror!).

Finally, if you're drawing a 'talking heads' scene without much action, keep things interesting by changing the camera angle and depth, or dropping a background here and there and replacing it with a colour fill. Also, try throwing the characters into silhouette, focusing on details of the environment while characters yak, or just simply packing a ton of emotion into all the facial expressions and body language.

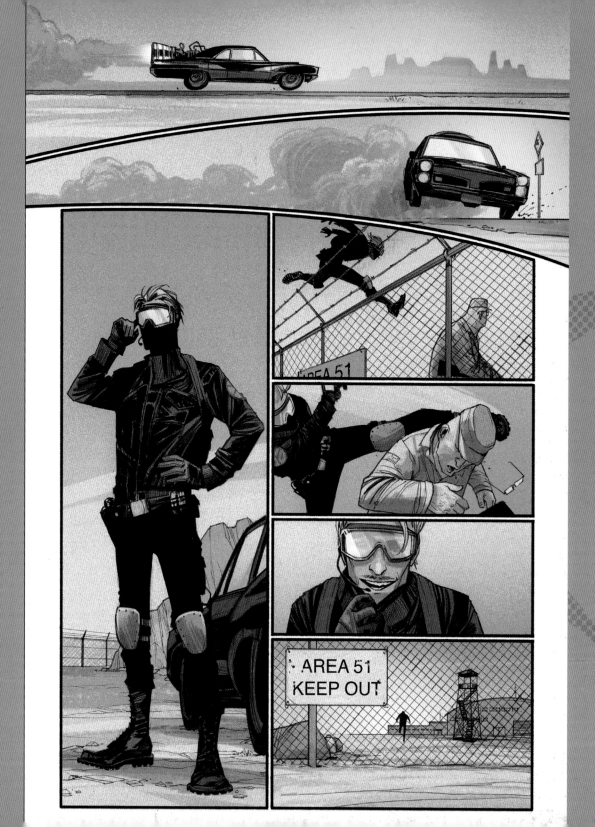

In a page from *Mystery Society* (IDW), Nick Mystery speeds efficiently into Area 51. The panel layout breaks the rules of reading from left to right, but the larger panel down the left anchors the sequence.

AREA 51
KEEP OUT

ARTIST **PROFILE**
JAMIE MCKELVIE

COUNTRY: UK
WEB: www.jamiemckelvie.com

Jamie is a comic book artist best known for his work on Suburban Glamour and Phonogram, although he's also freelanced for Marvel, DC and other major publishers.

PHOTOSHOP & SKETCH UP

CREATE A COMIC READY FOR PRINT

Find out how to make a western comic the Jamie McKelvie way, from start to print-ready finish, including first-hand advice on the traps to avoid along the way

In this workshop, I'm going to walk you through my process for creating a page of my comic, *Suburban Glamour*. We'll work right through the process, starting with the script and initial visualisation through to the finished digital file, ready for printing.

There are key differences between creating artwork for print and making art intended for the monitor: what looks good on screen can often print horribly. While everyone has their own methods for creating comic book artwork, there are some basic rules you have to follow to get the best out of your work. Throughout this workshop I'll make it clear what these are, and the reasons behind them.

The chief principle you have to consider when creating comic book art is that the art is there to service the story. All the flashy, dramatic artwork in the world isn't going to help if the reader can't tell what's happening from panel to panel.

Confusing artwork can kill a comic book story, even if it looks nice on the surface. Many artists trying to break into the industry fall down on this point so, if you want to be a step ahead of the competition, keep this in mind at all times. It's what editors and writers look for in an artist.

If you can draw action from the mundane to the exciting in a consistent, convincing and logical manner, then you have a strong chance of succeeding as a comic book artist.

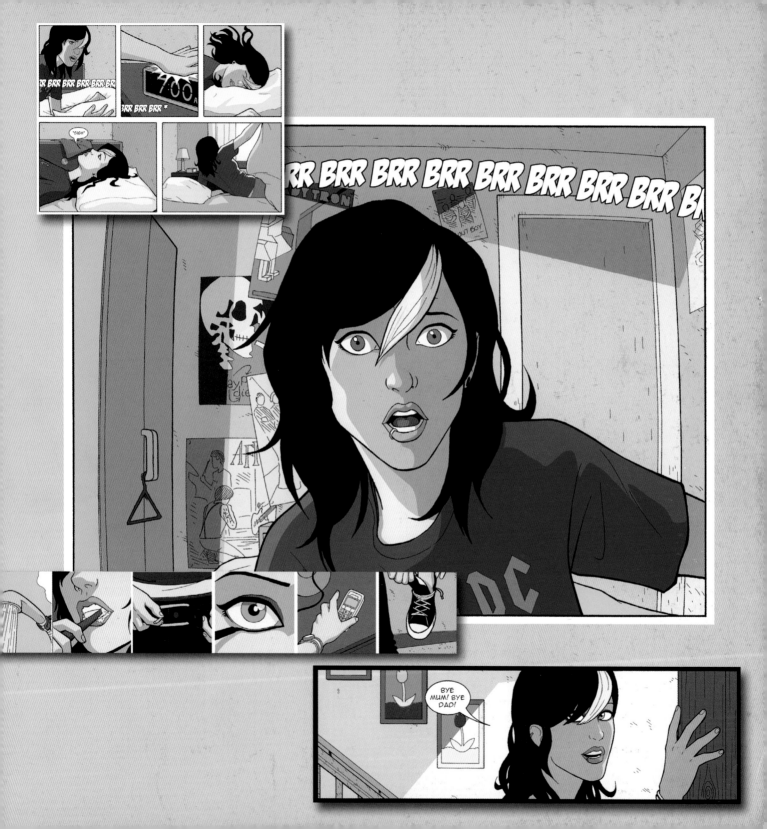

1 READ THE SCRIPT

Before a single page is drawn, I read the entire script. Objects, locations and characters that seem minor in early scenes may become important later, so you need to plan ahead and design your comic book accordingly. In this example, our heroine, Astrid, is attempting to escape from a monster that has followed her into her bedroom. On the previous page, just as the monster was about to pounce, it was distracted by Eblis, Astrid's imaginary friend.

> PAGE 12
>
> PANEL 1
>
> The lizard fights to get Eblis off him. Sally is nearby, nervously watching.
>
> LIZARD: Raargh!
>
> PANEL 2
>
> Eblis goes flying as the Lizard knocks him loose.
>
> PANEL 3
>
> Lizard turns to face the camera.
>
> LIZARD: Now back to y-
>
> PANEL 4
>
> Astrid smacks the Lizard full in the face with her bass, sending his mask flying, revealing an empty space where a face should be.
>
> PANEL 5
>
> Astrid and Sally stand over the collapsed lizard. Eblis kicks the lizard.
>
> Eblis: Yeah, you think twice about picking a fight with us, buddy!
>
> PANEL 6
>
> Astrid picks up Eblis.
>
> ASTRID: Come on, time to sort this out.

3 RULING OUT THE PAGE

My comic book artwork is drawn on Bristol board at 150 per cent of the final comic book page size. I get the board directly from my publisher, with handy guidelines already printed in light blue ink. You can buy similar board online. Using a set square and the ruler on the drawing board, I measure out the panels on the page.

SHORTCUTS
ACTUAL PIXELS
Ctrl/Cmd+Alt+0
Zooms into the image at 100 per cent. Useful for close-up checking of lines and large inked areas for gaps.

2 LAYOUTS

The first thing I do is the layout. This basically means looking at the number of panels as written in the script and planning how they'll sit on the page. There are numerous things to consider when doing this: the flow of the story, the overall design of the page and so on. Important moments often deserve a larger panel. In this case, it's clear that panel four is the focus of the page and so deserves the largest space. Many artists include rough figurework on their layouts, to get a better feel of the overall page and see how it works. Even though I don't always do this, I would recommend it. If you can see mistakes in the storytelling early on, it can save you a lot of hassle further down the line.

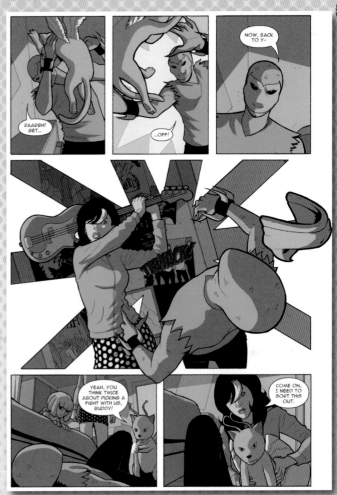

THE SKETCHUP MODEL

Making a 3D model of the environment where the story takes place has several benefits: using a model for reference helps keep locations consistent, and so more believable; moving around the 3D object enables you to consider and plan your angles; and it also enables you to produce solid work with greater speed. In comics, you'll often be required to draw a page or more a day, and any tool that helps this along is of value. In this case, I have a rough model of Astrid's bedroom already designed in SketchUp. As you can see, it's quite basic, which is all you need when deciding on viewpoint angles and so on. When using a SketchUp model, I have two options: having the model onscreen next to me when drawing, to get an idea of where the lines should go on the page; or exporting a 2D image of the model that I can transfer directly to the page. Here, I decide to have the model onscreen when drawing the background of the small panels, but for the large panel I choose to export a 2D image. You can do this in SketchUp via File>Export>2D Graphic. I then open this in Photoshop, and re-size and crop it as needed. To transfer it to the page, you have several options – printing directly to the board, lightboxing or the method I use: first, I create a new layer over my 2D graphic and fill this with a light blue colour. In the Layers palette, I hide the image layer and change the fill layer's blending mode to Screen before making the image visible again. Next, I flip the image horizontally. Printing the resulting image on an inkjet printer gives me a print-out I can rub onto the artboard using a soft pencil.

 ## PHOTO REFERENCE

The key to photo reference is not to become a slave to it. Use the reference as an aid, but don't trace it or you'll end up with a static, lifeless page. You'll also run the risk of just mimicking the image without getting a grasp on the fundamentals of anatomy, movement and perspective. I use myself as the reference for all the characters, which forces me to consider the underlying anatomy as I adapt the photograph to fit the necessary characters.

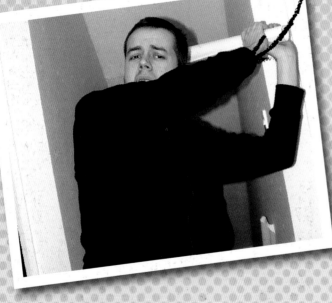

BASIC FIGURES

With the reference on the screen next to me, I pencil the basic figurework on the page, starting with a skeleton then building up the rest of the figure. I use a blue lead pencil for this.

PRO SECRETS

FLATTING TOOLS
The BPelt plug-in system can be found at www.bpelt.com/psplugins/flatting.html. It comes in two parts: the MultiFill filter and the Flatten filter. MultiFill fills every area of white on the page with a different colour. In practice, it's less distracting and just as quick to fill the areas with the colours you want, but the Flatten part of the plug-in will save you hours of work.

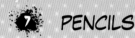

PENCILS

I use a 2H mechanical pencil to complete the pencilling. With the basic figures in place, I concentrate on the characters' expressions, clothing, hair and so on. I pay close attention to the emotion of a character and also how movement affects their hair and clothes. As you can see, Astrid's swing has caused a twisting motion in her clothing and hair. I draw the monster's arm and mask extending past the panel's edges. This gives the impression that he's breaking out of it, adding to the feeling of action.

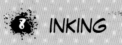

INKING

To ink, I use Rapidograph pens of varying thickness. I generally like to vary line weight depending on how close an object is to the 'camera'. The closer something is, the thicker the linework, especially on the 'boundary lines' that form the outside edges of an object or a major component of an object. I start by inking all the thinnest lines on the figures with a .18 nib and then switch to a thicker .35 pen, and work on the heavier linework. Building up the lines by using a thinner pen than the final line weight gives me greater control, although this does mean it takes longer than if I was to just make each line once. The monster and his mask are closest to us in the middle panel, so they get the thickest linework on the page.

SHORTCUTS
PREVIOUS FILTER
Ctrl+F (PC) Cmd+F (Mac)
Activates the last filter you used. Useful if you're flatting a bunch of pages in a row.

PANEL BORDERS

As I start inking the panel borders, I suddenly realise I can make the middle panel more dramatic by using the border itself as part of the action. So I quickly rule out some lines in pencil radiating from the moment of impact and then ink the panel border accordingly.

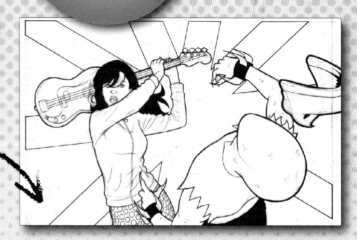

⑩ BACKGROUND INKS AND BLACKS

I ink the panel backgrounds next. Generally speaking, these have thinner lines than the figures so that the characters stand out, although this rule can be bent if an object is closer to the camera than the characters. Once all this is done, I fill in the large black areas with a Pentel brush pen.

⑪ SCANNING

Many fledgling comic artists think that scanning a page in greyscale and then darkening the lines via Brightness/ Contrast is enough. While this looks fine on screen, it will print as a muddy mess. To achieve sharp, clear artwork, the line art has to be a pure black-and-white image. If you've got an expensive scanner, you can scan in Lineart mode. However, most of us don't have expensive scanners, so see 'Get good scans from a cheap scanner' below to learn how I get a good result.

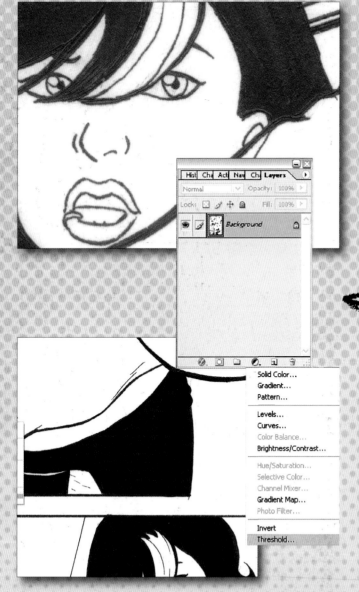

PRO SECRETS

GET GOOD SCANS FROM A CHEAP SCANNER
Scan in greyscale at 1,200dpi, then increase Contrast by 15. Next, apply Unsharp Mask with Amount at 500 per cent, Radius at 1.3 and Threshold at 3. This sharpens the linework considerably. Finally, go into the Layers palette and create a Threshold adjustment layer set to around 130. Play with the values at each stage to achieve the best result from your scanner.

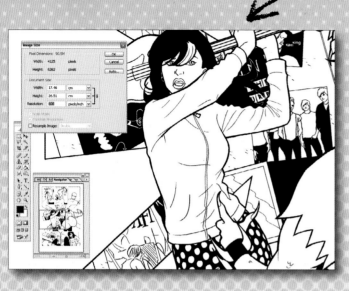

12 RE-SIZING

I want to end up with pure black-and-white line art, 600dpi at comic page size. I re-size the image, first by changing the dpi from 1,200 to 400 (Image>Image Size) with Resample Image ticked, and then un-ticking Resample Image and changing the dpi from 400 to 600. Doing this results in a final image that's two thirds the size of the original scan in terms of actual print size, but at 600dpi instead of 1,200.

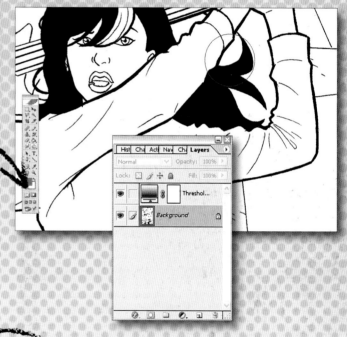

13 CLEAN-UP

Invariably, I need to do some clean-up on the image, so I select the Background layer (with the Threshold layer still above it, if you used my 'cheap scanner' technique), and use the Erase Tool (E) to get rid of any marks. Some of the linework, and especially the large black areas, might be a little broken up due to inconsistent ink, so to fix these areas I run the Burn Tool (O) over them, set to Midtones and an Exposure of 50 per cent. This darkens and evens out the necessary areas of the image. Once all this is done, I flatten the layers. I also draw the images on Astrid's posters using the Pencil Tool (B).

14 CONVERTING TO CMYK

Next comes colour flatting. This means laying down the flat blocks of colour on the page ready for the colourist to do their work. Firstly the image needs to be converted to CMYK (Image>Mode>CMYK Color). However, the problem is that to achieve a dark black on screen, Photoshop defaults to a black made of all four inks – 75C 68M 67Y 90K. This looks great on the monitor, but if this was sent to the printer it would cause a mess: in industry-scale printing, it's common for the colour plates to slip.

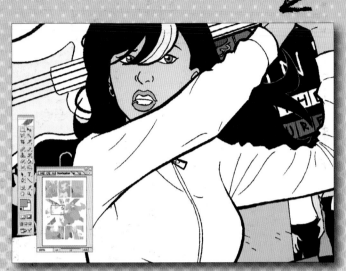

15 GET FLATTING

I go into the Colour Picker and change the CMYK settings to 0C 0M 0Y 100K, then use the Fill Tool (G) to make the line work black (making sure the Contiguous button is unticked). Then I duplicate the Background layer (Layer>Duplicate Layer), before hiding the duplicate in the Layer window. On the Background layer, I fill in the basic colours using the Fill Tool (this time set to Contiguous). Next I use BPelt's MultiFill and Flatten plug-ins (www.bpelt.com), which remove the black linework and expand the colour areas until they meet. Now if the plates slip, you won't end up with white gaps between the lines and the colour. Make the linework layer visible again and set it to Darken.

16 COLOURING AND TRAPPING

Here's where I cheat and send the file off to my colourist. If you're colouring yourself, this is where you apply the correct colours and shading, taking into account light source and mood. You'll note that in the middle panel, my colourist has opted for dramatic colouring on the background, to heighten its effect. Once he's finished colouring, he 'traps' the image – another vital step to ensure good printing. This is where the black is underlaid with blue to give it a nice, dark colour. Firstly, select all the linework using the Magic Wand (W), then contract the selection by two pixels (Select>Modify>Contract). Move to the lower Colour layer, erase the selection, then fill with a strong blue consisting of 80C 40M 20Y 0K. Contracting the selection before doing this fill ensures that if the plates slip, the blue won't show. Finally, flatten the image.

17 LETTERING

Unfortunately, lettering would require a whole separate workshop to go into it in any depth! There are, however, many workshops available online if you want to investigate further. Lettering is usually done in Adobe Illustrator, but today's Photoshop has many of the same vector tools, so can function perfectly adequately as a lettering program.

ARTIST Q&A

Q

How do I achieve that classic Japanese, woodblock print inspired look in my artwork?

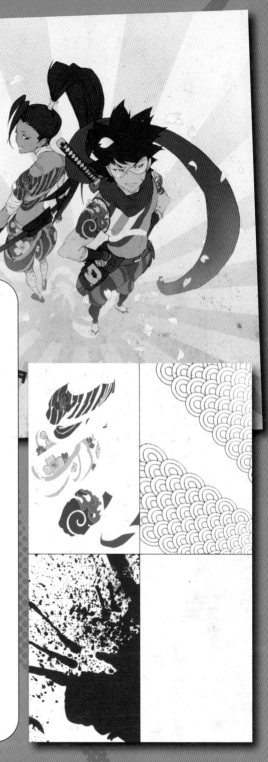

A | MICHAEL CHOMICKI REPLIES

Classical Japanese woodblock prints, also known as ukiyo-e, possess certain elements that make them very distinct. Besides the obvious unique drawing style, the ukiyo-e print possesses very fine line work, beautiful texture and an application of flat, washed-out pigment. It's these things I'll pay special attention to.

When I create the line art for the characters, I always keep cleanliness and finesse in mind. I'm always paying special attention to keep the lines fine and flowing, while at the same time making sure to avoid any random sketchiness, which would ultimately detract from the desired look and feel of the illustration. Upon scanning the completed drawing into Photoshop, I proceed to clean up the linework, and then colourise it, using Hue/Saturation.

Next, I move on to texture and colour. For texture work, I tend to do two things, the first being the use of custom patterns, such as those found in the background and on the characters. I usually create these Japanese-inspired patterns by either using Photoshop or Illustrator, depending on the complexity of the pattern. The second way to generate texture is through the mixing and overlaying of various photographic imagery. For example, I may mix up a photo of watercolour paper, a cracked, concrete surface, ink splashes and some plaster to create a somewhat vintage paper feel. Finally, I'll apply a palette of colours in pastel tonalities. I find that these usually work best when trying to mimic a bit of that ukiyo-e look.

TOP: I apply textures throughout the artwork by using Photoshop layers, layer opacities and layer effects such as Multiply, Overlay and Soft Light.

BOTTOM: These are some of the textures that I used in the artwork. The top right texture, along with the bottom two, can be found in the background.